MUSULMAN PAINTING

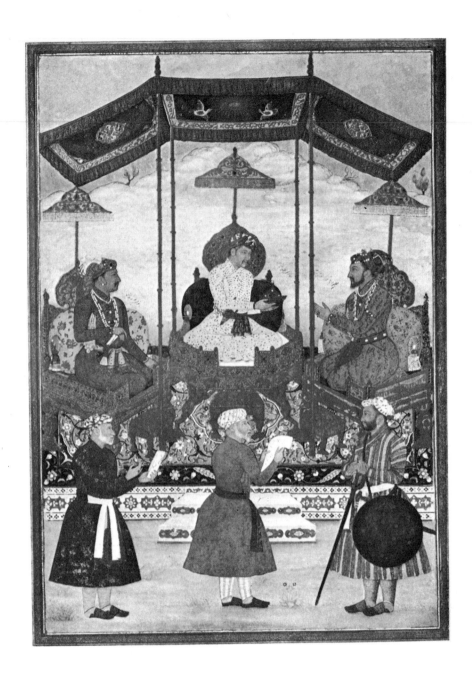

PLATE I

Frontispiece in colour. Portraits of the three Emperors: Akbar in the centre, Jahangir on the left of the picture, Shah Jahan, right. The Emperor Akbar still preserves the Turkish type of his father Humayun which Jahangir and Shah Jahan have lost. He is represented holding out the crown to his grandson; his throne is supported by figures in imitation of Italian motives; in front of the throne are, from left to right, Shahnawaz Khan, Khan-i Azam and Asaf Khan. This splendid composition, executed about 1630 at Delhi, is signed on the right-hand stool with the name of Bichitr. (Album of Shah Jahan, Chester Beatty Collection, London.)

MUSULMAN PAINTING
XIITH—XVIITH CENTURY

BY

E. BLOCHET

TRANSLATED FROM THE FRENCH BY

CICELY M. BINYON

WITH AN INTRODUCTION BY

SIR E. DENISON ROSS, C.I.E.

HACKER ART BOOKS, INC.
NEW YORK 1975

First published by Methuen and Company, Ltd., London, 1929.

Reissued 1975 by Hacker Art Books, Inc., New York.

Library of Congress Catalogue Card Number 74-78544 ISBN 0-87817-155-X

Printed in the United States of America.

TO
THE MEMORY
OF
H. J. AMEDROZ
1854–1917

INTRODUCTION

By Sir E. Denison Ross

FEW men have had better opportunities of studying Persian painting at first hand than Monsieur Blochet, who, during his long service in the Oriental Department of the Bibliothèque Nationale, has not only had the care of one of the finest collections of Persian manuscripts in the world, but has moreover devoted special attention to the study of Persian miniatures and has published several valuable works on this subject, notably *Peintures de manuscrits arabes, persans et turcs de la Bibliothèque Nationale*, Paris, 1911 ; *Les Peintures des manuscrits orientaux de la Bibliothèque Nationale*, Paris, 1914 ; and *Les Enluminures des manuscrits orientaux, turcs, arabes, persans, de la Bibliothèque Nationale*, Paris, 1926.

The serious and systematic study of Persian illuminations is a new science and the problems which present themselves for solution or discussion are almost as young as the various theories which have lately been put forward.

Persian book illustrations—which represent almost all that is best in this delicate art—are so intimately connected with Persian literature that most of the spade work in regard to its appreciation and interpretation has perforce to be done by scholars who have devoted their lives to Islamic literature, notably the historical and poetic products of Persian writers. For we are dealing with a history which still remains to be written for Europeans, and with a literature which exists for the most part only in rare manuscript copies. Before the art critic can set about his work of technical analysis, the Orientalist must explain the political and cultural conditions under which the Persian artists worked.

A handful of Orientalists have been, as it were, bridging the gulf between the linguistic and the artistic sides of the subject, thus making possible the subdivision into schools and periods, the origins and developments of styles, and such like matters.

M. Blochet's method is that of the frontal attack, and it must be realized that many of his axioms refer to questions which are highly controversial. All he writes is stimulating and displays a close intimacy

not only with his subject, but also with the more often explored fields of art history. If, on the one hand, we feel that M. Blochet is apt to side-track us into countries and cultures somewhat remote from Persia, we at any rate cannot deny him a complete independence of opinion and originality. Moreover, the exceptionally wide erudition in out-of-the-way history and literature which he displays at every turn compensates for the frequency of his digressions. His style is provocative, but one feels that his views are at any rate his own : that the conclusions at which he arrives are reached by the study and comparison of works of art themselves and are totally uninfluenced by what other Europeans have written on the same subject.

It would be interesting to trace the story of Persian art by following the sequence in which it came to the notice of Western students and amateurs. Although the great libraries of Europe contain many manuscripts illuminated and illustrated by Persian and Indian artists, little attention was paid by cataloguers to anything but the literary contents of such books. Persian paintings of the best periods were seldom found except as illustrations to narrative poems or histories, and before the vogue sprang up for collecting such paintings they were allowed to remain where they originally belonged, just as so many of the great works of the old Italian masters are allowed to remain in the churches they were intended to decorate. Nowadays, unfortunately, manuscripts containing fine miniatures are apt to be ruthlessly torn asunder, and the pictures sold one by one. The Indians, on the other hand, developed the habit of painting separate miniatures, and it is, no doubt, such individual paintings that were first collected by English amateurs in India and brought to Europe. The finest of such pictures were those of the Mogal school painted for the Delhi court in the sixteenth and seventeenth centuries, which often rival the finest work of the great masters of Persian illumination. Side by side with them a number of other Indian schools were represented, notably the Hindu schools of Kangra and elsewhere, which differ fundamentally from Indo-Moslem style.

It was, no doubt, these isolated pictures which first aroused general interest in this subject, and it is only within the memory of the present generation that a serious study was begun of the pictures contained in manuscripts ; and with this study began the appreciation of the various masters and styles of Moslem painting which is now engaging the attention of the art student and has led to the enormous prices now set on the best illuminated manuscripts.

From a variety of causes, climatic and political, old Persian manuscripts are very hard to come by, and we have very few specimens which

viii

go back before the disastrous invasion of Persia by the Mongols in the middle of the thirteenth century.

The earliest examples of Moslem miniature painting are contained in one or two manuscripts dating from this period, and had these not survived we should have missed one of the most important links in the chain of sequence, namely, what has been called the Mesopotamian style, of which M. Blochet has so much to say.

There can be no question whence this art is derived, though, as M. Blochet points out, there are still all too many earlier links missing from the chain. The early Christian influences are perfectly evident, and these influences are quite independent of the later Italian influences which appear in so many of the finest works of the Persian masters of a much later period. These were no mere accidents, but the result of actual study under European masters either in Europe or in Persia. A totally different influence was that which came from the East of Persia and directly or indirectly from China. There is no gainsaying the spirit of the Far East in those delightful paintings of men and women, with their willowy figures shrouded by long flowing robes, with their heads slightly tilted to one side; and the culmination of Persian miniature art in the works of such a man as Bihzad seems to be reached in a happy blending of the West and East, where we find the conventional treatment of rocks and clouds reminding us of China and the graceful grouping of figures recalling the Italian primitives intermingled with Moslem buildings and Persian trees and flowers.

The basis of Persian art, as of Persian poetry, is convention; and the task the artist and the poet set themselves is not so much originality of style as perfection of treatment. Just as in their verses there is never a question of deviating from the strict rhymes and metres, so in their drawings they adhere rigidly to conventional perspective and a purposeful neglect of relative light and shade. Poet and painter, with their fixed standards and a limited range of subject before them, aim at technical excellence, and only rarely at a new idea. Just as the poets who found their medium in romantic epics took for their subject stories often told before, so, too, the artists confined themselves to illustrating anew the same episodes from the same stories. It is as if the Canterbury Tales had been re-written, with only slight variations in metre and narrative, by a dozen different poets since Chaucer and had been illustrated by a hundred artists, some taking Chaucer himself as their guide and others his successors.

And such stereotyped subjects in art go back beyond the birth of modern Persian poetry to pre-Muhammadan times, as we know from certain familiar subjects found in Sassanian poetry.

ix

MUSULMAN PAINTING

The Romantic epics are based partly on legends current in Zoro-astrian Persia and partly on stories, mostly Biblical in origin, taken from the Koran. We may compare such subjects in European art as " Saint George and the Dragon " and " The Madonna and Child ".

The only deviations from the common types are to be found in illustrations to historical works. Early examples of this must once have existed in plenty, but few are known to-day. But in the sixteenth century or even earlier, both in Persia and in India, there rose schools of painters whose business it was to portray the kings and their courtiers. But if the subjects were changed the style remained the same, and the main difference lay in the introduction of portraiture; and this, in India especially, led to the cultivation of portrait painting, of which so many beautiful examples are to be found in the European collections. In India the present century has witnessed the rise of schools of modern painting in which European and Japanese art both play a part; but in Persia the art of painting to-day seems to be dead or stagnant, and the latest monuments of the Persian school are to be found in manuscripts of the early decades of the nineteenth century.

PLATES

The illustrations are arranged in groups as follows :

All the plates except the frontispiece are placed at the end of the volume. Owing to difficulties of grouping, some of the subjects are not in true chronological order.

MUSULMAN PAINTING

I

ISLAM, at the end of the sixth and beginning of the seventh century, represented the last stage of that violent reaction which arrayed the heresies of the East against Christianity. The supreme ideal of the Arab tribes was to lead a nomad life, exempt, in their deserts, from all the needs of civilization, in absolute liberty and independence under the leadership of the elders of their clan, unwilling to acknowledge the authority and the sovereignty of the powerful empires which bordered on their frontiers, and without interest in the political organization of the neighbouring nations, with whom they maintained no intercourse. Darius, in the sixth century B.C., had counted the land of the Arabs among the provinces of his immense empire; but we learn from Herodotus that this sovereignty was merely nominal, that the Arabs were a people too intractable to be brought under a monarch's yoke, who refused to bow before a golden sceptre, and that the Great King in his palace at Susa was obliged to content himself with such few meagre presents of incense and spices as the Arab princes who lived on the frontiers of Persia and Syria, would consent to offer.

The Arab horsemen, in the immensity of their desert sands, troubled little about the majesty of kings. There was nothing that meant more to them than the vast horizons of the deserts where they galloped their steeds; they boasted of a marvellous though imaginary past, of unconquerable ancestors who had defied the power of the gods as their descendants defied the power of monarchs, who had built among the sands of the Yaman the buried paradise of pillared Iram, a memory, transposed in time and space, of the Roman colonnades of Baalbek and Palmyra; who, like the king of Himiar, confused with Alexander the Great, had climbed the tableland of Persia and had led from there a formidable expedition against Central Asia and built Samarkand beyond the Oxus. They counted no happiness greater than the possession of a swift and shapely horse, of a pretty woman under her felt tent, a well-tempered sword-blade, a cup of golden wine to drink when the day was cloudy and the heavens dark.

1

MUSULMAN PAINTING

The Achaemenidae never dreamt of trying to impose respect for their sovereignty on the Arabs, any more than on the Altaic tribes, the Sakas of Central Asia. Towards 508 B.C. Darius was so ill advised as to conceive the wild design of an expedition to impose his laws on the Scythians, on the Slavs who lived beyond the Danube on the steppes of Southern Russia, with the aim of wreaking exemplary vengeance for the invasion of the Turks who had ravaged Iran in the seventh century. The expedition ended in disaster; the Slavs retreated before the Persian armies, laying waste their lands, and they would have continued these tactics as far as the shores of the Hyperborean Sea had the son of Hystaspes conceived the wild thought of driving them to their lairs.

This experience was enough for the King of Persia, and he was tempted no further either in the south against the Arabs, whose sovereign he professed to be, or against the Turkish horsemen of the Far East, who were no more subservient to him than the Arab clans; it was better to acknowledge the rebuff than to persist in a mistaken policy and obstinately continue the useless struggle with a people who revolted against any sort of civilization, who held death to be a lesser evil than the tyranny of kings, and whom it was impossible to overtake in the vast spaces where they galloped their horses.

Alexander, the conqueror of the world from the shores of the Great Sea to the steppes of Central Asia, saw, with legitimate anger, these nomads elude his laws; he conceived the design of taming these indomitable horsemen and making them feel the weight of Hellenic supremacy; he sent Nearchus in a celebrated expedition to reconnoitre the landings of the Peninsula; but death put an end to these plans, which, like the expedition of Darius beyond the Danube, would have ended in cruel reverses for the Macedonian.

The Seleucids, the successors of Alexander, and the Arsacid Parthians who won back the kingdom of Persia from Greek rule, were too busy to interfere with the affairs of the Arabs or to think of annexing the Arab deserts to their domains. Twenty-five years before Christ, the Roman armies had to renounce the idea of bringing the Yaman under Caesar's domination.

From the beginning of the Christian era we may date a change; the birth of the new faith in the countries of Hither Asia made profound modifications in its religious organization; it created, between the Iranian lands where Mazdaism flourished, and the Syrian provinces where Christianity was growing up, an irreconcilable antagonism which rapidly attained its climax.

Rome and Persia, along an immense frontier, struggled for the

possession of Hither Asia. Rome, in her Syrian provinces, meditated the conquest of Iran, or, at least, of the whole of Western Iran, to be organized on her own lines and exploited for her profit; the Persians defended their independence in a war which lasted nearly seven centuries and was ended, on the eve of the Arab conquest, by the expedition of Heraclius, who pillaged and devastated the northern part of the Sassanid kingdom; it exhausted both antagonists and destroyed their power, leaving them inert and defenceless on the day when they were attacked by the Arab forces, and their empires collapsed like a house of cards before the invaders. Rome and Ctesiphon alike sought to draw the Arab tribes within the orbit of their policy and to secure them as allies in a struggle, in which the very existence of the two adversaries was at stake. The Arab alliance was, in this war, of paramount importance, since it carried with it the conditions which were essential to victory; their tribes were not only inhabitants of the sands of the Yaman, the Najd, the Hadhramaut; they also ranged the deserts which lead up from Arabia to Northern Syria, between Palestine and Mesopotamia; Arabia, in fact, the country where the clans of the Tasm, the Jorhom, the Thamud, the Tayy, wandered, lay like a wedge driven into the vast Roman possessions; it was a menace to the flanks of the King of Persia, which could thus be turned. Whichever of the two sovereigns could attract the Arabs to his side would, at one blow, destroy all his enemy's strategy, but neither one nor the other, neither Rome nor Ctesiphon, could dream of imposing their laws on them by force of arms; the least imprudence on either side might throw the Semitic tribes into the arms of the enemy and lead to swift disaster. It is owing to this circumstance, as much as to the impossibility of their neighbours reaching them, that the Arabs owed the tranquillity which they enjoyed for long centuries, and that they escaped the scourge of war which devastated their frontiers.

The Greek Emperor and the King of Persia, not being able to force the Arabs to become their adherents, attempted to win them through their religion. Byzantium tried to make them Christians; Ctesiphon to convert them to the worship of the Sacred Fire.

Throughout the centuries of antiquity the Arabs practised the star-worship of the Sabaeans, the final phase of the astrolatry of the Chaldean Empires which were indebted to it for the invention of astronomy; they adored the Planets, the Seven Wandering Stars which travelled the Celestial Highways as their horses' hoofs trampled the tracks of the Great Desert; above all they worshipped Astarte, the full-breasted Aphrodite who inspires men with desire; they

called her Allât, 'the Goddess,' and the Black Stone of the Kaaba was her symbol; besides Astarte they worshipped anthropomorphic divinities or deified animals; in the third century of the Christian era their religion was cruel and savage to a degree, and down to the eleventh century A.D. they admitted, without any feelings of revulsion, the horror of human sacrifices.

Christianity and Mazdaism fought for the conscience of these peoples who possessed no national religion, but whose rudimentary, vague and indefinite beliefs varied with every tribe, and who offered an excellent field for foreign propaganda; they had been subjected to the influence of all the religious formulas of Hither Asia, to Sabeism, heir to the monstrous errors of Babylon, then, a hundred years before our era, to Judaism, and lastly to Christianity, while, in the east of the peninsula, Mazdaism must be added to the list. At the end of the third and during the fourth century, the Christian faith made a few converts in the Yaman; in the fourth century, here as in Rome, we see it enthroned among the Ghassanids and at Hira, whose monarchs lived in the most cordial relations with the kings of Persia, so much so that Yazdagard I entrusted to one of them, Noman, who had just embraced the Christian faith, the formidable responsibility of the education of his son, Bahram. Bahram was helped to re-conquer the sovereignty of the Sassanian Empire by Mundhir, the son of Noman. These relations of the Arab clans with the two powerful empires that disputed the sovereignty over Asia, threatened to destroy their ancient independence by reducing their country to the position of a Roman colony or a Persian protectorate; the Ghassanids in Syria, the rulers of Hira in Lower Chaldea, were already the lieutenants and the vassals of the Basileus, Emperor of Constantinople, and of the King of Kings. These tribes had, it is true, long ago deserted the peninsula to settle in countries which the clans of the Yaman or of the Tihama did not look upon as Arab land; it was none the less evident that the example of the Ghassanid princes and of the King of Hira created a troublesome precedent, of which the Greek Emperor and the Persian King could take advantage with the tribes of Arabia proper; moreover all the north of Arabia Petrea owned obedience to the Greek Emperor, the shores of the Persian Gulf and the south of the peninsula recognized the authority of the Chosroes, who had conquered the Yaman in the sixth century, and the shores of the Red Sea south of Mecca that of the King of Abyssinia. There was born in the Arab tribes then a feeling of reaction against this peril, imminent on the north as on the east, and this took the form of a religious movement which swept the people into a Holy War against the nations who threatened their

4

thousand-year-old independence; it was preached by a man animated by an ardent nationalism, an invincible hatred of the foreigner.

The conversion of the tribes, first to Judaism and then to Christianity, had accustomed the Arabs to the conception of a single Divinity, relegating the extravagances of the Sabaean star-worship to the limbo of outworn and obsolete beliefs. Mazdaism, fire worship, had hardly left a trace among the clans of the Yaman; Iranism was nowhere successful in its struggle with Hellenism; among the Arabian sands it was unable to oppose the progress of Christianity, and all the influence of Iran was concentrated on her eastern border and the struggle with Hinduism which severely limited its progress. Muhammad, who was born about 570, perfectly understood that the chief opponent of Arab independence was Constantinople and the orthodox form of Christianity; in his struggle to win the throne by means of the altar he was led into the same error as lay in the Oriental heresies which had sprung up against the dogmas of Byzantium; he took over the errors of Mani and Marcion; that of Mani with its opposition of the Genius of Evil to the Principle of Good, a conception not to be found in primitive Christianity and which reduces the divinity of Jesus to the rôle of a prophet sent on earth to fight against the Spirit of Darkness.

Muhammad developed these errors in the spirit of Sabellianus, in the theory of Samosatenism, following the idea of Arius, who denied the doctrine of the Trinity and proclaimed and taught almost identical aspects of the same dogma. Sabellianus declared that the Father, the Son, the Holy Ghost, are three names, three methods of referring to a divine Monad, absolute in His Unity; the Samosatenians said that Christ is not God; Arius that God cannot beget, since the Divine Substance is absolute in Unity. He continued the aberrations of Montanus, which were, to a certain extent, taken up in modern times by Swedenborg. Montanus taught that the revelation of Jesus Christ was not final, since a revelation to him personally had followed that of the Son of God; he claimed that he had received the revelation of the Holy Ghost and that the Paraclete was made manifest in his own mortal shape; he condemned the pursuit of riches, pleasure and science, and banished art and science from his Republic, in order to limit man's intellectual effort to conceptions which approximate him to nothingness. Immediately after his escape from the King of Persia's prisons, Mani, who was the successor of Montanus and exaggerated his doctrines, proclaimed himself to be the Paraclete whose coming is predicted by the Evangelists. So also, in 1850, did Hung Hsiu-ch'üan in China when he provoked the terrible insurrection of the Tai-ping who

5

were the degenerate descendants of the Manichaeans of the Middle Ages.

Islam, indeed, is nothing but a reaction against Johannine Christianity, the first of the Gnostic sects to return to the Jewish doctrine of the Parousia, only with an extension of the Messiahship to Muhammad. Manichaean communism was not shocking to nomad Arabs, whose property was limited to the possession of a few valueless objects; it offended Western ideas; in the twelfth century the French treated the descendants of the Manichaeans as 'poblicains,' just as Louis XIV, not without reason, considered the sects which sprang from Catholicism, Jansenists as well as Protestants, as Republicans. Islam remains a sect of Christianity, as is shown by the names of Jesus, Joseph, Mary, Zacharias, which could only be found in a Christian form; it is evolved out of Judaism, on which it is based, but is different and inimical to it, as is shown by the circumstance that, though the Musulman year is based on a lunar reckoning, its week corresponds day by day with the Christian week, the same day being Sunday, Monday and Tuesday in Islam and in Christianity.

And the name of Muhammad himself, Ahmad, is only a translation of Παράκλητος, heard as, in the pronunciation of the later periods of Hellenism, Παρακλυτός, Paraclitos, with complete confusion of the η and the υ; therefore Moslems teach that the name of Muhammad is, in Syriac, Mothamani; in Greek, Parakletos; in the Pentateuch, Tabtab; in the Gospels, Midhmidh; in the Psalms, Parakletâ, which is the Syriac form of the Greek Parakletos; in the Koran, Makikâ; in Heaven, Ahmad; on earth, Muhammad; in Paradise, Kasim; in Hell, Dai.

The Jews, more than anyone in the world, held definite opinions on this question; they have never admitted for a single instant that Islam could be an aspect or reformation of their beliefs; as we know from two Byzantine historians, Theophanes and George Cedrenus, they have always held this doctrine and have always had the most precise and definite perception that Islam is a sect evolved from Christianity, is indeed in its essence absolutely Christian, declaring that Muhammad is the Christ whose coming is predicted in Holy Scripture.

Cedrenus did not hesitate to write that Islam is a Judeo-Christian syncretism, in the composition of which Muhammad took from the Jews the conception of the Oneness of God, from the Arians the Word and the Creating Spirit, from the Nestorians the denial of the Divinity of Jesus Christ. Among the Moslems of Persia we find traces of a very ancient custom, according to which, when a child is born in an Iranian house, the midwife traces with a sword on the four walls of the room

6

where it first saw the light, four lines which are supposed to represent the perimeter of a tower within which she imprisons Mary and her Son to prevent their coming to trouble the Islam of the new-born infant. This custom shows that the Moslems of Persia are perfectly aware that the principle of Islam is a reaction against Christianity, while they are undisturbed by Mazdaism, which was the official religion of Persia before the Arab Conquest, and are in no way afraid of its influence. The political and religious movement which had presided over and led up to the birth of Islamism persisted in the Asiatic world, so much so that, in 713, a false Messiah appeared in Syria and deceived the Jews. Muhammad's earliest biographer had kept remembrance of intimate relations between Islam and Christianity; he relates that a Christian monk, named Bahira, discovered in Muhammad the signs of Prophecy, when as a child he was travelling to Damascus. Bahira revealed to him the greatness of his mission, which manifestly signifies that Muhammad took the idea of his reformation from the Nestorian faith.

Even Eastern Christians tell that Bahira is the author of the Koran; this claim, if exaggerated, is not so absurd as it looks; Muhammad did not know how to write, and he could not appeal to Arabs to write the Book; for they would have betrayed his secret. That is why he was obliged to have recourse for help to Nestorians and Jews. Clearly the Koran is not a single writer's work. In the seventh century Jews were very powerful in Arabia and were the Prophet's worst enemies; they saw clearly Islam was dangerous for them, and, not being able to hinder it, they tried to monopolize it; the protagonist of this policy was a celebrated rabbi, Kaab, who told Muhammad the whimsical stories of the Bible which are found in the Koran, and which made him believe his mission bespoken in the Sacred Book; several chapters of the Koran begin by mysterious letters which are only initials of Hebrew words by which Kaab indicates that he wrote them by Muhammad's orders. Those relations between Islam and Christianity explain their absolute incompatibility; in spite of Father de Foucauld's ravings, they establish two irreducible forms, and all that Islam takes from Christianity is decidedly lost for Christ's Faith.

The conversion of the Arabs to a belief which was a variant of Christianity broke the tradition of the tribes and led them into ways which, up till then, had been strange to them; Arab civilization before Muhammad and the civilization which was born from his efforts, are two absolutely different formulas bearing no relation to each other; the names borne by the Moslems after the coming of Islam do not recall those of the Arabs who were the contemporaries of the Sassanians,

7

their descendants forgot them and adopted names used by Christians, so that the knowledge of the best Arabic of the tenth and eleventh centuries would fail to help anyone to understand the Arabic spoken by the poets of Paganism.

Islam, in fact, from all points of view, religious, scientific, literary and artistic, in the Asiatic provinces of Syria, in Persia, in Iran, is only the carrier of the tradition of classical civilization to the lands of the Far East as far as the Pamir, where the influence of the Celestial Empire, of the Chinese world, begins. This circumstance explains why and in what way it is easier and simpler for us to penetrate into the thought of the Musulman than into the subtlety of Far Eastern ideas, into the labyrinths of Hinduism or the hieratism of the Chinese; we rediscover in Islam the simplicity and rectitude which characterize the classical spirit. Doubtless the elements which it borrowed from Greco-Roman civilization have become altered, but it has only carried on in Asia a tradition which took its birth in Constantinople, which created Byzantine form; it accentuated it, but not more than did the other sects which derived from Christianity, from the faith of the Basileus, Emperor of Constantinople and Sovereign Lord of all the world. The spirit of Musulman ornamentation can be discovered in the Byzantine decoration of the Double Gate at Jerusalem, in the godroons of the cupola of St. Sergius at Constantinople, long before the time of Islam; the tendencies and idiosyncrasies of Mesopotamian painting and of Persian illumination are revealed in the works which were born before the flight of the Prophet to Medina, at the hands of artists of the Late Empire who indicated in their brilliant compositions the direction to be followed by their Asiatic disciples.

The Moslems did not carry these exaggerations, which finally brought the perfection of classic art to degradation, much farther than had been done by the subjects of the Greek Emperor; they avoided the endless complexity of the Hindus till the distant time when they borrowed from them certain subjects, certain conceptions alien to their own spirit and which remained isolated in the body of their thought and had no real influence on the evolution of the Musulman spirit or on its development; they distrusted these wild imaginations in the same way as we distrust them because their thought belongs to the same cycle as ours, because it follows the same tracks, holds the same conceptions and is evolved from the same norms in accordance with tendencies and laws derived from the Greco-Roman genius at different stages of its development and through transpositions due to Christianity and to a sect closely related to it.

Islam found itself, at its beginning, drawn into the same opposition

to Byzantium as were the heresies born in the Asiatic provinces of the Roman Empire ; maintaining it too with even more relentless severity, since, while waging war in the sphere of religion it waged it also on the actual battlefield. This reaction against Christianity, materialistic, anti-idealistic and anti-artistic as it was, this lower aspect of Manichee-ism and Montanism, inevitably found itself, in every department of life, in opposition to all those things which were the pride of Christianity ; the Christians kept Sunday holy ; since Muhammad could not substi-tute Saturday, this being the Sabbath of the Jews who were no less odious to him, he went further back in the series of days to Friday ; he forbade all artistic forms and solemnly cursed all poetry, not sus-pecting that, in this, he was a follower of Plato ; Islam, inheriting the Jewish prejudice against the reproduction of living forms, condemned sculpture and painting. His worshippers exhibited no liking for science, which they regarded as an unprofitable thing whose only aim and result were to turn man aside from the sole ideal he ought to pursue in this world, the knowledge of the Creator.

II

THE Koran has not recorded these prejudices of Muhammad against all the manifestations of the human mind; this does not prevent their having been present in the spirit of Islam at its beginning. The Tradition formally forbids the representation in painting of anything but inanimate objects, trees, flowers, houses. Tradition in its authentic parts, those which are accepted as such by Musulman expositors, faithfully represents the thought of the Prophet, deprived of the literary form in which he clothed it; it is beyond doubt that it corresponds with Muhammad's cast of mind; the Prophet realized perfectly that the arts and sciences had not been invented for Bedouins of the Great Desert, that they would never succeed in practising them, a thing above their powers, that the representation of the human figure lay far beyond their reach, and that it was better to paint tents and palm-trees than to carve on the rocks of Arabia horrible formless drawings, supposed to represent men. It was certainly these prudent considerations which wisely influenced the Jewish lawgivers, when they forbade the Hebrews painting and sculpture; it was certainly better never to handle the sculptor's chisel than to carve in stone monstrosities like the Assyrian and Phoenician divinities; it it always a proof of tact and intelligence to call a thing forbidden when one is incapable of doing it, not to mention the fact that men are very prone to disparage and forbid in others what they themselves cannot do.

In the same way and for the same reasons, we find that in the West, between the end of the sixth and the last year of the eighth century—for two hundred years under the rule of the Merovingian princes—the Latin manuscripts contain no painting animated by the representation of the human figure, no picture illustrating the scenes and histories whose episodes are described in the text. The artists of those far-off times, like the Arab illuminators up to the end of the tenth century, contented themselves with the multiplication of ornament, the execution of which in geometrical lines was much less difficult than that of animated scenes; it cost them infinitely less effort to arrive at a result very much superior to what they would have

10

obtained had they attempted to imitate the perfect work of the Roman painters or the artists of Byzantium ; this tradition, as we can see in the illumination of the second Bible of Charles the Bald, was still a living one and persisted unimpaired to the Carolingian period. Moslems, in the countries where Arabic was spoken, faithfully obeyed this prohibition ; they realized that it was useless for them to try and force their talent, and that a life confined to material cares fitted them much better than the occupations of the mind. Tradition has handed down the severe words pronounced by the Prophet when he forbade the Faithful to play chess on the same grounds as he forbade painting, and it solemnly curses those who push contempt for poverty so far as to be served on finely chased gold plate. Moslems accepted all these sentences as equally authentic and important; yet, with the possible exception of the early years of the dynasty of the Omayyad dynasty of Damascus in the eighth century, these prohibitions have never prevented the Commander of the Faithful from playing chess or drinking ruby-coloured wine out of gold cups decorated with patterns in relief ; matters less difficult than the study of geometry and very much more within every one's reach than painting or the rhythms of poetry.

III

THE Arabs of this date, the end of the sixth and the beginning of the seventh century, possessed no artistic formula other than the rhythm of their poetry; poetic inspiration, rhythm, cadence, verse, eloquence are born spontaneously in the mind of man; these brilliant qualities are found among the peoples who have least artistic tradition, among the Turkish clans, among the Altaic races who know neither how to read nor how to write, in a shape which seems better when their ignorance is greater. A Mongol historian of the seventeenth century has preserved for us, in a very mediocre chronicle, the speeches made by Chingiz Khan on his deathbed and by the last Mongol Emperor when he realized that he had lost his crown; and there one feels in the splendid form of a rhythmical and cadenced prose which exactly resembles that in which the Prophet expressed himself, the breath of inspiration which fired the orators of Classical Antiquity and the Chinese Emperors of the ancient dynasties, whose words have been preserved for us by Ssŭma Ch'ien.

The Arab tribes, under their felt tents, knew no other mode of artistic expression, could conceive no other, did not believe that the verses they sang could never be imitated by the poets of future centuries; and Muhammad went to sleep his last sleep in a miserable mosque made of the trunks of palm-trees, with a ceiling of boughs which had been stripped of their leaves, while, eighty years earlier, the Sanctuary of Mecca had been rebuilt by Byzantine architects in the Greek technique of the Late Empire which was identical with the Roman style.

Islam, as constituted by the Prophet in the Koran and as defined by Tradition, is a rudimentary form of civilization. It exactly suits the few needs of nomads who possess neither fixed homes nor government nor codes of law nor national cohesion; its norms were inadequate for the development, the evolution of a vast empire which gathered under the shadow of a single standard different nationalities, opposed in spirit and of divergent ideas. The meagre and monotonous framework within which the Prophet originally enclosed it cracked on every side and burst in pieces the day after his death,

12

when his immediate successors, the Orthodox Caliphs, quitted the desert on their march to conquer the world. In order to live and to organize their domains, the Moslems were obliged to borrow all the formulas which nourished the empires they had ruined; in their utter powerlessness to originate any conception, any idea, which should be wholly their own, they copied, without understanding, in a debased and bastard form, all the norms which had belonged to the Chosroes and the Caesars. During nearly a century the Caliphs saw themselves reduced to striking their coins with the stamp of the Persian monarchy engraved with the effigy of the last of the Sassanians, Yazdagard III, whom the Arab generals had compelled to fly to the Celestial Empire, seeking in the Chinese capital for aid against the armies that came up from the West to conquer his kingdom, and Khusrau Parviz, who had failed to conquer the lands of the West and the Arab desert; later on, in Syria and Mesopotamia, their successors imitated the stamping of Byzantine coins. Musulman rule was superimposed on to the classical civilization of the Late Empire in the towns of Syria, in Egypt, in North Africa; it weakened the vitality of its formulas, cramping it daily more and more till it was finally extinguished.

In its beginnings, Islam was a reformation which depended on the Koran and on Tradition; it was nourished on the divine word and the maxims of the Prophet without experiencing any intellectual craving for the ways of art or of science; it constituted a religious form, savage and implacable, ready to shed blood for a trifle. Theorists like Zahabi and Ibn Taymiyya, not to mention the Persian jurists, are unbearably doctrinaire and limited in outlook; all Moslems in the first centuries had exactly the same mentality as the ulamas of Constantinople, the mujtahids of Teheran, the marabouts of Kairawan or of Tlimsen; they were ignorant and wished to be ignorant of history, geography, philosophy, the science of mathematics and all forms of art whatsoever, their only study was the sacred Koran and the Muhammadan Tradition; they considered and pronounced before the tribunal of their own minds, that all besides is, in the highest degree, vanity, art is corruption, literature an illusion, science a mystification. Islam, reduced to these absurd premises, could never have survived without the transformation which it owes to the Mystics, who spiritualized it through the influence of modifications whose essence is Christian, or without the Christians themselves, to whom the hateful doctrinaires of Islam scornfully abandoned the charge of the arts and sciences.

The Oriental Christians lived under the yoke of the Caliphs in material conditions which were infinitely less miserable than we are

13

tempted to believe and much freer than legend tells us ; in Syria and in Egypt they continued to live in the Roman tradition of the Late Empire, exactly as they had lived in the reign of Diocletian or of Justinian ; they continued to illuminate their Gospels and to decorate their chapels with frescoes, to think like Byzantines, which no one in the world could prevent their doing, and not like Orientals ; at the worst they were obliged to cover the too conspicuous practice of their ritual habits with the veil of prudence; but the great fact is that they carried on the work of Byzantium, that is to say, the work of Rome, the thought of Athens, when they translated it into Arabic, just as they had perpetuated it when they translated it into the Syriac tongue, and attempted to clothe it in Semitic forms. Up to the end of the tenth century everything in Islamism which lay outside the strict confines of Koranic study—the arts and the sciences—were and remained the exclusive appanage of the Christians who lived under the Musulman yoke and were the descendants of families who, for nearly a thousand years, had lived under the Greek rule of the Seleucids or the Ptolemies, of the Romans, of the Emperors of Byzantium, under a classical influence ten centuries old.

IV

IT is an extraordinary fact that up to the year 699 all the records of the Caliph's administration were written in the Greek language by Greek functionaries, that is to say, by Christians; the Byzantine historian Theophanes tells us in his chronicle that, in this year, the Caliph al-Walid forbade, in the most formal fashion, the agents of the Treasury to write the official records in Greek, and commanded that they should be set down in the Arabic script, always excepting the figures, since it is impossible in the Arabic notation to write 1, 2, 3, $8\frac{1}{2}$ or $8\frac{3}{4}$; this peremptory order was the reason why Christian scribes and accountants remained in the Government offices, where Theophanes notes their presence about the year 805.

The Omayyads, who succeeded the first four Vicars of the Prophet, the Abbasids, who transferred to Baghdad the spiritual power of the Caliphs of Damascus, very early realized that Islam would not continue to survive in this isolation, in this intellectual desert; they saw that a vast empire cannot be governed in the same way as a clan of nomads, that the Caliph could not make his home under a tent of camel's hair like the Emir of the tribes that roamed around Mecca, that it was necessary for them to create arts and sciences and to relegate the Koran and Tradition to the realms of the ideal; they made these the exclusive appanage of a class of scholars very learned, but wholly impervious to things of the mind; these scholars they left to their books, their commentaries and their barren meditations, while persons more active and less limited intellectually were entrusted with the task of grappling with the realities of action and government.

It was during this period, then, which followed the time of brute conquest by the sword, when Islam was feeling the urgent need of organization if it was to survive, that the Musulman princes had their sumptuous temples and vast palaces built and ordered their subjects to translate into the Arabic language the works of Hellenic science, the books of the mathematicians and the philosophers, utilizing the versions made by the Christians of Syria from the third to the sixth century.

15

MUSULMAN PAINTING

They found this as difficult a matter to bring about through their own efforts, at the end of the seventh and beginning of the eighth century in Damascus, as Noman, son of Imr al-Qays and King of the Arab Christians at Hira in Lower Chaldea, had found it in 418, nearly three centuries earlier, when he desired to build the celebrated stronghold of Khavarnak, and had to commission a Greek architect, whose name Sinimmar is a transcription of the Hellenic form Severianos; as difficult as the Arabs of Mecca found it, when they wished, shortly before the time of Muhammad, to rebuild the sanctuary of the Black Stone, and found themselves obliged to hand the work over to Greeks and to the Copts, the Egyptians of that time who depended on Byzantine technique.

The Dome of the Rock at Jerusalem, with its immense cupola covered with sheets of lead in the Byzantine fashion, was built in the year 691 by the orders of the Omayyad Caliph 'Abd al-Malik; it imitates in the most perfect manner the technique of Sta. Costanza in Rome, which was built by Constantine, through the intermediate example of St. George of Ezra, which was built in the reign of the Emperor Justinian; the mosaics which decorate the walls of the Dome of the Rock depict, with great perfection, enormous foliage springing from golden vases after a model that is essentially a Christian form and which we find again in the mural decoration of the Basilicas of the Eternal City: it is derived through a series of simplifications conformable to the Musulman spirit, from Roman decoration, the pictures of living beings having been eliminated and those of plants only being left; the presence in the constants of its plan of the number of the Trinity is enough to show that the architect who worked in the Holy City for the Musulman king was a Christian. So also the cruciform plan of the mosque of Sultan Hasan at Cairo (about 1350) in the form of a Greek cross imitates the celebrated type of Byzantine technique, that of the Holy Apostles (sixth century), of St. Mark at Venice, before its restoration, of St. Front at Périgueux, of the Panthéon at Paris. The Arab historians have preserved for us the exact information that at the very beginning of the eighth century, al-Walid, the son of 'Abd al-Malik, Caliph of Damascus, sent to demand in a threatening tone that the Basileus, the Emperor of Constantinople, should send to him in his dominions, craftsmen who could build him at Damascus and at Medina over the Prophet's tomb splendid temples, which the Commander of the Faithful desired should rival the magnificence of Rome and of Constantinople.

Moslems have spoken with enthusiasm of the brilliant mosaics which covered the high walls of the Mosque at Damascus, whose golden

16

sheen lit up with its deep glow the darkness of the naves ; they represented in their rainbow-coloured surface, ramparts of fortified towns, monuments and trees, copying cartoons of the mosaics or frescoes of the Late Empire from which the Christian artists who worked for the Lord of the Orient eliminated, as at the Dome of the Rock, all human figures, all living forms, the representation of which was strictly forbidden to Moslems and impossible on the walls of their sanctuaries.

And the roofing of the Roman Basilica which was set up at Medina over the tomb of the Prophet, and which was the pride of the Prince of Damascus, is supported by two rows of porphyry columns with gilded Corinthian capitals in the style of the columns in the Mosque of Omar at Jerusalem, and nearer in technique to the Temple of Jupiter at Athens than to Sta. Sophia at Constantinople or the churches of Ravenna ; the Musulman architects did not work with such jealous care and they built their sanctuaries, the Mosques of Amru at Cairo (mid-seventh century), of Tunis, of Cordova, upon colonnades whose shafts and capitals had been stolen from the Roman temples ; this they did as much from economy as from their knowledge that it would be impossible for them ever to achieve as much themselves. We learn from Theophanes that, when this same 'Abd al-Malik conceived the project of rebuilding or rather of restoring the august sanctuary of Mecca, he commanded that the pillars of the Church of St. Gethsemane should be removed and transported to Mecca ; it needed all the zeal of a Christian named Sergius, who was Mansur's secretary, joined to the efforts of another Christian named Clesus, to make the Caliph of Damascus abandon this design. The predominant influence of Christian technique can be found in Islam at every period ; the mural decorations in marble in the little Mosque al-Burdaini, in Cairo, built in 1630, in the reign of the Turkish Sultans of Constantinople, reproduce the celebrated technique of the Cosmati, which is found a thousand years earlier in the most ancient churches of Rome and Ravenna—at St. John Lateran, the Mother of the Churches, at San Paolo on the road to Ostia, at San Lorenzo fuori le muri, in the Baptistery of the Orthodox—combined with a decoration composed of crosses which runs along its walls.

Less severe rules and less rigid principles were applied to the decoration of the royal palaces under the rule of magnificent princes, whose pomp could not long be contented with the strictness and simplicity of the precepts laid down by the Koran ; already the Omayyads of Damascus had not scrupled to take liberties with the religious law which the Orthodox Caliphs would never have permitted themselves. The dearest wish of their successors, the Abbasids, was to dazzle the world by the luxury and splendour of their court, and they spared

2

nothing which might, in the eyes of their people, testify to the greatness and the power of their Empire ; the walls of one of the residences of Harun al-Rashid, the prince of the Thousand and One Nights, at the end of the eighth and the beginning of the ninth century, were decorated with plaques of glazed faience on which human figures can be seen, done in a manner and a style which are very close to the technique of the paintings found in much later years, in the second half of the twelfth century, in the illuminations of Mesopotamian manuscripts.

It was only fifty years later, in 847, that the Caliph al-Mutawakkil billah decorated his palaces in Samarra with mosaics in which living figures occur, the representation of human personages in the acts of their life which, up till then, had been forbidden by Tradition and had only been found in subsidiary decorations of glazed faience on the friezes of walls, as a framework. At that date, the kings of Islam found themselves exactly in the same situation as the Sassanian monarchs in the fourth century ; they copied either Christian or Babylonian models : thus al-Mutawakkil ordered to be built in Samarra a minaret in the form of a Chaldean zigurrat.

If the Musulman princes were able to allow themselves these artistic fancies in their sumptuous homes, it was not so with their subjects, and the art of figure-painting, the illustration of the text of books, continued to be forbidden up to the very end of the tenth century.

V

WE know through the explicit witness of a specialist of great learning who spent his whole life in publishing the works of ancient authors and collecting materials for writing the history of the book in the Musulman world, from the technical as well as from the literary point of view, that, in the year 989, the decoration of manuscripts by paintings and designs illustrating the narrative was an unknown practice in Baghdad, the capital of the Abbasid Caliph, the metropolis of Islam. In the treatise he wrote on this subject he scarcely mentions the headpieces and the frontispieces ornamented with heavy decorations made up of a combination of geometrical forms, which were traced, painted and illuminated by calligraphists, who were careful not to introduce any representation of the human figure; and his silence is more eloquent than the assertions of an Arab traveller who claimed to have seen about the year 900, in the palace of the King of China, who showed them to him, a series of pictures representing the prophets of Islamism, Noah, Moses, Jesus Christ surrounded by the twelve Apostles, and Muhammad mounted on his camel. If it is difficult to believe that an Emperor of the T'ang dynasty, at the end of the ninth century, should have deigned to keep in his Treasury such objects, which had not a shade of importance for a man of his race, it is altogether unlikely that he should have taken the trouble to show them and comment on them to a poor Arab merchant, travelling on his own business and at whose approach the doors of royal palaces were certainly not usually flung wide. But travellers' tales are proverbially false, as all explorers and all travellers know; the best of them have not escaped this sad fate, as witness Sa'di in his Bustan, where he tells us, among other glaring improbabilities, that he mystified a Brahman of the town of Somnath in Hindustan, whom, in the simplicity of his ignorance, he makes a follower of the Zoroastrian faith; not to mention the fact that everything Moslems tell us about China before the time of the Mongol conquest and the beginning of the fourteenth century, is a tissue of inventions and lies, the yarns of ignorant sailors who had seen the Celestial Empire through the smoke of taverns, when their ships had strayed into those distant regions.

19

MUSULMAN PAINTING

It was after this date (989), during the last years of the tenth and the beginning of the eleventh century, that Musulman life began to be regulated by less severe, less narrow principles; the rigid attitude of the first Believers had become, at this time, more than three and a half centuries after the Prophet, merely an irksome memory which it was wiser not to evoke; the only people who still remembered it were the theologians and jurists who, like all those who uphold a rigid tradition and preach its integral observance, were beginning to be looked on as antiquated and tedious. By the eleventh century the austerity of early times had given place to slackness, to concessions, to compromise with the spirit of Muhammadan law which were encouraged by the loose life led by the princes of Islam in their palaces at Baghdad, by their residences in Samarra, and by the political and religious convulsions which had shaken the Caliphate to its foundations; an omen of the dark days of its decadence in the hands and under the rule of incapable princes, up to the hour when the remains of their authority and their power definitely vanished before the Mongol horsemen who emerged from the steppes of the Far East to override the Kingdoms of the West.

It was at this date, towards the year 990, or the year 1000, that the Musulman scribes of the great cities of the Caliphate, at Baghdad, Kufa and Bassora in Mesopotamia, at Jerusalem and Damascus in Syria, took courage and attempted to copy the illuminated paintings in the books of the Christians, such as the Syriac Bibles and Gospels translated from the Greek text of the Old and New Testaments, containing illustrations copied by artists brought up in the Christian faith, from pictures made in former centuries, in the workshops of the Late Empire.

Fresco painting, like the book illustration derived from it, was always very limited and very rare in the domains of the Pontiff of Baghdad; it remained, in spite of intellectual development, in spite of the trend of ideas toward greater freedom, a forbidden technique to which was opposed the authority of the high personages who embodied the knowledge of the truth according to the law, for these veiled their faces at the sight of an illuminated Arab manuscript, just as the ulamas of Constantinople or of Shiraz, at the beginning of the nineteenth century, when their eyes fell on an illuminated Bustan or on a Divan of Jami, adorned with sumptuous miniatures.

The art of carved work and sculpture is, to-day in Syria, at the beginning of the second quarter of the twentieth century, the exclusive appanage of Christian craftsmen who have handed it from father to son, from time immemorial, since the time of the Late Empire, even since Roman times, or the period of the Seleucid rule. In A.D. 1313,

20

the Sultan of Egypt brought Christian marble-cutters from Damascus to Cairo, in order to build in his capital-town an exact reproduction of a famous monument of the Syrian metropolis, called Kasr Ablak, whose stones were alternately white and black, manifestly a Syrian Christian work. The Moslems are wholly ignorant of this technique, which is for them an unfamiliar art; they did not learn it in the seventh century, at the time when they snatched the provinces of Syria from the rule of the Byzantines, because they felt no need of it, and because, since the Christians undertook this kind of work, it was wholly unnecessary for them to be at the pains of acquiring it. Book illustration is so intimately allied to mural decoration that it was most probably, at first, the exclusive prerogative of the Christians, and afterwards of the Syrian families converted to Islam in the seventh and eighth centuries who had preserved intact the intellectual outlook and way of thinking of the Byzantines of the fourth to the sixth century. Finally it became the speciality of certain Moslems who were not embarrassed by religious scruples and put themselves to school with the Christians and became their disciples. One of the most remarkable of these artists, whose work will be described on Plates XXIV–XXXI, Yahya, son of Mahmud, descendant of Kuwwariha, of the town of Wasit (1236), was, as his ancestor's name sufficiently indicates, descended from an old Aramean family which had professed the faith of Christ at the time when Syria obeyed the laws of the Byzantine Caesars and who in the thirteenth century worked at Baghdad for the Abbasid Caliph. The example of this artist shows, in an incontrovertible manner, that in the Arab-speaking provinces, in this mid-thirteenth century, when the gallop of the Mongol horsemen thundered along the frontier of the Caliphate, custom ordained that the calligrapher should illuminate the book which he had just copied. The persistence of this tradition on the eve of the fall of the sons of Abbas, allied as it is to the tradition of the carved work which Moslem artists of the Syrian provinces entirely abstain from and leave to the Christians, shows that painting in the thirteenth century was considered in Islam as an altogether secondary art, as an aspect of calligraphy and, what is more important, that the Moslems of the old stock were indifferent to it, that they left the care of it to the Christian painters, or to those of their co-religionists who were descended from old Syrian families which had practised Christianity, reserving to themselves the illumination of the titles and the initial folios in geometrical designs, as in the tenth century.

The decoration of Arab manuscripts with paintings and pictures was always greatly restricted under the Empire of the Caliphate; there was, naturally, no question of illuminating with figure-designs books of

theology or law, which in no literature, at any time, have lent themselves to such embellishments. History, in the first centuries of the Caliphate, in the Syrian and Mesopotamian provinces, was only an offshoot of Tradition; in the ancient parts, it was exclusively based on the sayings of the Prophet, the words of his companions, and on the discourses of men who had not enjoyed the happiness of actually seeing the Messenger of Allah, but who had known those who had lived in his intimate circle, who had drawn near to him, who had talked with him. This portion of history, all history from the creation to the beginning of the eighth century, was held to be as sacred as the Traditional books, and it would have been sacrilege in the highest degree to sully it by the addition of pictures; the history of later events, those which took place under the reign of the Omayyads of Damascus and the Abbasids of Baghdad, is, in the eyes of strict Moslems, nothing but an unnecessary appendix to sacred history, in which sensible men need take no interest, for it consists exclusively of a detailed account of crimes and catastrophes which, in their uninterrupted succession, make up the history of man; the character of Arab poetry was almost as narrow in its exclusions, and did not want illustration in books of verses. Painters might only exercise their talents on certain very rare works, whose profane character was so clearly indicated by the subject treated as to leave no room for doubt: books of pure literature, which consisted of anecdotes, insignificant and puerile themes, only served their authors as a means of exhibiting the virtuosity with which they could handle the richest and most difficult of spoken languages in the world—the 'Assemblies' of a grammarian of Bassora at the end of the eleventh and beginning of the twelfth century, who collected under this title a series of novels, some of which are written in an unintelligible fustian, while others are senseless juggling with words; the Arabic translation of the Fables of Bidpai brought to Iran from Hindustan in the sixth century, in the reign of Khusrau Anushirwan, translated from Sanscrit into Pehlevi and from Pehlevi into Arabic by Ibn al-Muqaffa in the reign of the Abbasid Caliph al-Mansur, in the second half of the eighth century; the Arabic version of the insipid Greek novel Barlaam and Josaphat; the Arabic translations of books of Greek science, treatises on medicine and surgery, the illustrations of which aimed less at pictorial merit than at demonstrating to students the practice of their art; those of the treatises on astronomy where the severe designs represented the instruments used for observation of the stars, for measuring their movements and co-ordinates and for depicting on the sphere the forms under which the astrologers of Antiquity had represented the constellations and the Signs of the Zodiac. All these books were written

22

in Arabic, but they no more formed a part of Islamic literature than a translation of the Homilies of St. John Chrysostom or of Severus of Antioch ; the Moslem Doctors despised them all alike ; they could not conceive their holding the attention of a sensible man, even for an instant ; they professed to ignore them as useless and scandalous, and confined their studies to the sacred text of the Koran and the august Traditions.

The most ancient paintings conceived and executed in the Mesopotamian style and manner go back to the middle of the twelfth century ; they are reproduced in Plate II of this volume ; they illustrate a sumptuous copy of the translation into Persian of the Fables of Bidpai, executed at Ghazna in this same period. Musulman artists had been illuminating the books of their literature and had established their rich technique during the century and a half before this date, approximately A.D. 1150 ; the essential difference to be noted between these paintings and all pictures, all illustrations which decorated the costly books of the time of the Caliphate, lies far less in an autonomous evolution of Mesopotamian art and its formulas from the date of their creation about A.D. 1000, than in the fact that they are awkward and clumsy adaptations of the masterpieces of the Late Empire, through the intervention, first of copies and then of imitations, of the paintings in Greek manuscripts.

Already Christian artists of Jerusalem or Alexandria had, in their copies or, if we prefer to say so, in their imitations of the books of the Late Empire, weakened the nobility and the purity of the classical forms ; they corrupted the design and overcharged the palette of the painters of Constantinople; they substituted for the elegant simplicity of Roman fashion a cheap opulence, the motley and crude hotch-potch of Oriental trappings which, already in the days of Lucian of Samosata, as in the Middle Ages, constituted a ridiculous travesty overloaded with gold, colours, and embroideries like the Sunday clothes of peasants—the delight and the derision of the street boys in the cities of Asia. The extent and methods of Greco-Roman civilization always essentially differed from those of Oriental countries. The Hellenes, like the Egyptians whose heirs they were, devoted all their efforts to the delineation of the human form, and carried this to inimitable perfection ; the Greeks, in their statues and in their bas-reliefs, represent movement arrested before its evolution is complete, before its rhythm has reached an end ; Egypt, and the greatest artists of the West not being able to analyse with the eye the whole cycle of a movement, arrest it on its completion, when it reaches a dead end, even when it is at the cusp, at the point of return. This technique is essentially faulty : it

23

gives a dryness and hardness to each isolated figure and this causes incoherence and contradiction when the forms are united within a single frame; instantaneous photography and slow movement cinema pictures show us that there are few artistic moments in the evolution of a movement; it is exactly these ones which the Greeks chose; we must remember, too, that, like the races of the Far East, they have a horror of the rapid, abrupt and angular movement which the Occidentals affect, and only reproduce the aspects of a harmonious movement developed according to a continuous, unvarying and very quiet rhythm. The subjects of the Pharaohs, to an even greater degree than the Greeks of Attica and Ionia, always regarded ornament as a secondary and unnecessary element, and did not allow it to break the monumental line of their buildings. Assyria and Syria, from the outset, attempted both styles and failed equally with both; they only succeeded in producing monstrous forms; their decoration was coarse, with no sense of line, a patchwork of colour startling in tint and inharmonious in its gradations, such as savages delight in.

The Persia of antiquity was no better endowed than Assyria or the Babylonian Empire from which she borrowed the elements of her rudimentary civilization; her national art is typified by the glazed bricks of the Frieze of the Archers at Persepolis; it could not be compared with the formulas of the Apadana elaborated under the direct influence of Hellenism. Musulman Persia was far more gifted by nature, but she, too, was fully aware that the portrayal of human life was beyond her powers; she devoted them to polychrome decoration in a soft and delicate range of colour; no artist has ever been able to equal its splendour and distinction.

VI

WE must not look for the evident relation between Mesopo-
tamian paintings and works conceived under the Late Empire
in the sum total of their characteristics, nor in their general
aspect, nor in their design, nor in their colour, nor in their technique;
the mere fact might be explained by the difference in the scenes illus-
trated in the Bibles, in the Gospels, in the Menologies, and in the
ridiculous episodes illustrated from the insipid text of Hariri, or the
fights between wild animals in the fables written in India by Bidpai,
the man who had conceived the Veda. Where we, however, discover
a positive connection between the Mesopotamian paintings and the art
of the Late Empire is in some secondary details which, though appar-
ently unimportant, bear witness in microscopic points of significance to
a like defective technique applied to a like faulty manner, any poses
which are as strange in the Musulman books as they are in the Gospels:
the fashion in which the folds of stuff ripple in the draperies of
the persons portrayed, a feeble reproduction of the admirable folds in
the robes of light silk on antique statues, the touch, the handling, the
infinitesimal details of studio technique, only to be recognized by those
used to wield a brush. A whole academic dissertation would not throw
light on these obscurities unless we had before us reproductions of these
antique works; to describe them is useless and it is still more useless to
compare their descriptions; the examination of the figures collected in
the Plate XII will amply suffice.

The fact that the paintings executed in Mesopotamian studios,
whose style spread through all that part of the East subject to the
power of the Caliph of Baghdad, are simply imitations, clumsy and
enfeebled copies of the pictures in Greek books, is fully established by
the coarse decorations of a Persian manuscript executed in 1272, at
Caesarea, in Cappadocia (Plate XXXIV), at the end of that thirteenth
century which saw the power of the Abbasids crumble to dust before
the Mongol armies.

The artist who, in a naïve and rudimentary fashion, illustrated the
treatise on Astrology and Magic which these paintings adorn, copied to
the best of his ability, and according to the traditional technique of

25

MUSULMAN PAINTING

Mesopotamian painting, the pictures which explain the text of a treatise on magic written and illuminated at a very early date, about the tenth or eleventh century, in the province of Baghdad or in a Syrian town; the figures animating certain of these pictures are copies, grotesquely interpreted, from figures that appear in the illustrations of Bibles or of Gospels, in mosaics or in frescoes; here the genii of Musulman eschatology are quite clearly copied from the angels of the paintings of the Late Empire, in the very postures in which they figure in the illustrations of sacred books and on the walls of Basilicas, in the same colouring as that used for the illumination of the Gospels and the Old Testament, with this curious and interesting detail that the artist who executed them in a Mesopotamian studio, about the year 1000, copied Greek models so scrupulously as to reproduce a tiny detail of the technique of the Late Empire by marking a red dot on the cheek of his figures to represent the projection of the cheekbones; the Persian painter has religiously imitated this in his coarse illuminations.

It is a remarkable fact that the Mesopotamian illuminator, while he succeeded passably well when he set himself the modest task of copying, to the best of his ability, Roman models of the Late Empire, became grotesque as soon as he tried to be original and to represent Musulman genii in images of his own invention, outside the Byzantine tradition. The fact is typical and can be observed at all periods and from the shores of the Atlantic to the countries of the Far East; witness the deplorable example given by the Exhibition of Decorative Art in 1925; it wished to free itself from the bonds of Classical art and foundered in incoherence, sinking to the level of negro art by way of proto-Assyrian formulas analogous to those of the monument commemorating the battle of Leipsic, or the medals struck by the Germans in 1917 to celebrate the torpedoing of the *Lusitania*.

It is beyond question that, on the day when we lose the few remaining Greco-Roman elements which survive in and give life to the formulas of our civilization, those formulas will disappear and be annihilated; thus in the thirteenth century, a skilful architect, Villard de Honnecourt, gathered together in a parchment note-book a series of sketches dealing with the construction and decoration of Gothic cathedrals; when he is copying the monuments of Classical Antiquity the design of his compositions is excellent; it is still satisfactory when he reproduces the forms in Carolingian paintings which are copies of Roman pictures; it is puerile, exaggerated, almost grotesque, when he deserts the tradition of the Empire to interpret the methods and sentiments of the thirteenth century.

26

MUSULMAN PAINTING

It is rare to find in Musulman books illustrations which betray as definitely and as clearly the decisive influence of the technique and manner of the Late Empire; but fairly numerous examples may be found, in order that we are authorized to assert that these resemblances are not fortuitous or fanciful : the Birth of Muhammad in the manuscript of the Arabic version of the Chronicle of Rashid ad-Din is a copy, made about 1310, of a Greek Nativity, while a picture representing Abel killed by Cain, made in 1295, in a treatise on Natural History, shows a certain relief and other characteristics which are derived from those of an illustration in a Greek book.

There are many reasons to account for the rarity of documents which would palpably establish the direct transition of Greek art into the form it took in Islam ; Musulman art clothed itself in forms essentially different from those of the art of the Late Empire, conceived and born in a quite alien spirit and under the influence of fashions which had no parallel at Constantinople ; the people of Damascus, Baghdad and Ghazna had fashions of clothing and of head-dress, ways of eating, sleeping and living, which were not those of the subjects of the Greek Emperor. Musulman forms clothed Byzantine technique in such a way as to disguise it and to conceal its characteristics under the tinsel and motley of the East ; we must strip them of their carnival dress if we are to find them again, as, in a masquerade, it was only necessary to strip off the turban and jubba of a Constantinopolitan Greek, to see that the subject of the Byzantine emperor had been disguised as a slave of the Caliph of Baghdad.

It is, of course, natural that we should recognize the Byzantine origin of this Oriental art more easily and more quickly, when the paintings in which we seek it are very ancient, and illuminate manuscripts copied at an early date, before the inevitable transformations and alterations had reached such dimensions as to make the characteristics and the norms of the primitive model unrecognizable. Such events are very rare, for the essential differences between the two civilizations led almost immediately to such a divergence in the two styles, that we only recognize their common origin in certain details, whilst we find its entirety in the unity of method and technique. It is a remarkable fact that the decorator of Cæsarea, at the end of the thirteenth century, having laid his hands on a very ancient Arabic book, decorated with paintings conceived in the most archaic manner imaginable, directly copied at the very beginning of Musulman art from Greek pictures, did exactly imitate in their smallest details the forms in which divine beings were represented, as a Turkish craftsman about 1650, when he exactly copied the paintings of a manuscript of al- Biruni which

had been illuminated about 1310 ; it is certain that the Persians in that distant city of Asia Minor, on the frontiers of the Greek Empire, a few days' march from the Christian capital Nicea, were more capable of understanding the paintings and forms of the Roman decadence without enfeebling them and without misinterpretation, than the artists of the great cities of the Caliphate.

Musulman painters rapidly made a stylization of these archaic forms in the same manner as the Syrians ; we could follow all the stages and modifications of this transforming evolution if we possessed examples of the whole series of intermediate stages, or at least the principal ones, which led the Byzantine prototype and reduced it to the forms of the fourteenth century, in which a traditional memory of the technique of the Late Empire can still be recognized in certain details, unmodified by the brush of the Persian artists, or less modified than others, like the figures of angels and stars which Moslems borrowed from Greek technique.

The transition of the style and artistic formulas of the Late Empire to the methods and practice of Mesopotamian studios on the banks of the Tigris and the Euphrates, was effected in two stages, directly from Greek paintings to those which illuminated the Syriac books containing translations from Christian books, and then from Syrian paintings to Mesopotamian illustrations. One of the stages in this second phase which shows how Greek forms were translated into the Oriental technique is found in the clumsy and naïve illuminations of a Coptic ' Gospels ' which are copies, made at Damietta in 1180, of the pictures of a manuscript which contained the Syriac translation of the Four Gospels ; the technique of these Christian paintings, executed in Egypt, on the banks of the Nile, at the end of the twelfth century, shows an intermediate stage between that of the Syrian pictures which are derived through inadequate copies from Greek illustrations, and that of the illuminations in the oldest manuscript of the Assemblies of Hariri. The figures that appear in these coarse decorations are the same, and are shown in the same attitude, as those that animate the paintings in Syriac books ; they wear turbans made of cloth of gold and Oriental robes crude in colouring, moving against a background of Asiatic furniture and utensils ; these are painted in a careless and summary manner and are indifferent in their colouring ; they are made by craftsmen without talent, without imagination, without culture ; this is particularly conspicuous in one of the paintings which represents the Treachery of Judas, a reproduction in its main design, though in a poor and bastard form, of the Roman cartoon of the mosaic of Saint Apollinare Nuovo at Ravenna (first half of the sixth century), which we may rediscover in a

painting illustrating a Greco-Latin 'Gospels' of the twelfth century in a much more refined form, so that it is impossible to see it as a glorified and perfected version of the crude image of the Coptic 'Gospels,' whilst it is clear that their formulas and style are an obvious and unmistakable corruption of the technique of Rome and of the Late Empire.

The formulas of Christian art, in the provinces of Hither Asia at every period, after the Muhammadan conquest as well as under Greek rule, reproduce, more or less successfully, the formulas of Byzantine art, as is shown by the technique of a picture, painted at Cairo by a Copt, in the second half of the eighteenth century, the frontispiece of the romance of Barlaam and Josaphat. This picture is an indifferent version of a painting in a Greek manuscript of that insipid work, dating from the thirteenth or fourteenth century, but the sacred character of the two persons represented, Barlaam and Josaphat, forbade the craftsman to change their original forms or to modify them to suit the taste of the day—a thing he felt no scruple in doing in all the other paintings in this work, where the fancy seized him to dress the women in the costumes of odalisques of the eighteenth century.

These very indifferent illustrations are evidently related to those of Mesopotamian manuscripts and to the pictures in the Coptic 'Gospels' of 1180 ; it is an important fact ; the initial picture of the book shows that all the decoration in this romance of Barlaam and Josaphat is derived, through an unknown number of intermediate stages, from that of a Byzantine manuscript ; their presence in a book which was illuminated on the banks of the Nile, six centuries after the Coptic 'Gospels' and the characteristics they exhibit, shows that the paintings of this 'Gospels' and those of the Mesopotamian manuscripts are derived from the same source, which is the illuminations in Byzantine books.

The illuminations in Syriac books are more finished than those in the Coptic manuscripts, but this is due less to the ability and skill of the artists than to the merit and quality of the originals that they copied. The style of the Republic and the Early Empire is a faithful reproduction of Greek tradition in the epochs which followed the Classical period ; its technique gave birth to Christian art, and through this to Oriental art ; its style is displayed under two aspects, which differ according to the quality of the execution, the worth of the artist and the amount of care he bestowed on his work ; the first, most perfect, style has preserved the essential qualities of Antique art ; the attitudes of the figures are noble, their movements are rhythmical, their gestures few and considered : this style can be seen in the ancient mosaics of the Eternal City and of Ravenna which represent the perfection of this

art, since they are the decoration of official monuments of the Empire; its characteristics mark, too, the paintings of the most gorgeous manuscripts, which disappeared in the time of the Iconoclasts, but whose illustrations served as models in the ninth century for the illuminations in a collection of the Homilies of St. Gregory; for the pictures which decorate the finest illustrated books of Carolingian times, such as the Bible of Charles the Bald; for the Russian icons of the Middle Ages, and the Roumanian icons of the seventeenth and eighteenth centuries.

VII

THE second style does not mark any special or independent stage in Roman art, it is only a more or less careless version of the first, and its relative worth varies according to the craftsman's concentration on his work; it is, in its essence, a form of hasty and commercial reproduction, in which the design and colour of the ancient technique have deteriorated; its characteristic feature, apart from a general lack of finish, lies in the exaggeration of the movements, which become more violent and brusque the more careless the artist: these exaggerated movements are contrary to the essence of Classical tradition; they are due, not only to hurried execution but also, and most of all, to a want of taste, to the substitution of Roman for Hellenic taste. Between the third and fifth centuries Hellenism formally died; the basis of civilization, its essential elements, with the exception of law, are Greek; up to the end of the third century in Rome, the official language was Greek, and Latin was only preserved through the fact that, in the fourth century, the power fell into the hands of the Christians, poor people who knew no Greek; the language of Byzantium is Greek, but the spirit is Greek no longer; Byzantine history may be written in that tongue, but it reflects the thoughts and the method of Livy and Tacitus, and not those of Thucydides; in the Byzantine Empire the spirit is no longer Greek, it is Roman, that is to say, the decadence has begun.

This style is seen indistinctly from the third to the sixth century, in Latin illustrations and Greek paintings which, at so early a date, cannot be separated; at the same time, up to about the ninth century, they constitute an identical formula, an identical stage in the artistic evolution of the Empire; the paintings of Latin books, the mosaics and frescoes of the Italian Basilicas at those far-off dates, embody certain moments in the development of the artistic life of the Empire, while the corresponding stages in the Eastern Provinces disappeared under the Iconoclasts and are completely unknown to us. This, at a first analysis, makes the relations between Western and Eastern painting incomprehensible to us by disguising completely the history of the art of the Late Empire.

This technique became formalized and frozen during the course of

31

ages ; it ends in the style of the seventh and eighth centuries, and of later periods; in the Byzantine style, which, with a few exceptions, was always more finished in the mosaics and frescoes which constitute the official form of art, than in the illustrations of books where it has a private and secondary character, only important because it allows us, in spite of its imperfections, to study the evolution of painting.

The process by which the norms of the Roman style of the Early Empire were corrupted and reduced to these summary forms, is exactly the same process as that which, in Persia, in the schools of Tabriz (Tauris) and Ispahan between 1550 and 1580 did, in the same way and through the same errors, completely corrupt the precious style of the illustrations made at Tabriz and at Kazwin, in the beginning of the sixteenth century. Under these conditions of commercial reproduction the style depends far less on the intrinsic worth of the model than on the manner in which the craftsman carried out his work : thus in the sixth century, the paintings which decorate the Pentateuch of Tours, bastard in design, with a colouring in whose unpleasing tones we may still recognize that of the frescoes of Pompeii, are copies of very ancient Roman paintings of the third or fourth century, but do not show the exaggerations which we notice in the illustrations of the Genesis of Vienna (extreme end of the fifth century), of the ' Gospels ' of Rossano and Sinope (sixth century), in a quite different gamut of colour.

The paintings of the Syriac books have been copied from Greek paintings, conceived in the first style, which illustrated Greek books of extremely finished workmanship, while it is obvious, at the first glance, that the illustrations of the Coptic ' Gospels ' have been copied, and spoilt in the copying, from paintings conceived in the spirit and method of the coarse designs in the ' Gospels ' of Rossano and Sinope.

The style which was evolved, quite at the end of the tenth and the beginning of the eleventh century, in the provinces of Syria and in Arabian Iraq, out of the imitation of the technique of the Late Empire, and which became the style of the Caliphate, was maintained almost unchanged until the second half of the thirteenth century, and survived in Iranian countries after the fall of the Abbasids ; it remained, during all this time, the secret of the descendants of those artists who had created the method about 990, on the banks of the Tigris and of the Euphrates. The tradition was preserved in their studios in Baghdad, Kufa and Wasit, and the monarchs of Islam sent for these artists to work at their Court and to paint the frescoes of their royal palaces. It was two Mesopotamian painters whom the Minister al-Yazuri, commanded to come to Cairo that they might be employed in the service of his master, the Fatimid Caliph, and about A.D. 1250, it was a Persian

32

artist, a native of Shiraz, who painted in Cairo the illustrations of a Treatise of Astrology, following the norms of the workshops of Baghdad (Plates XXXII, XXXIII). The unity of Mesopotamian technique under the rule of the Caliphs of Baghdad, for nearly four centuries, is due above all to this circumstance, that its practice was confined to the tradition of a school whose disciples trained the craftsmen in all the dominions of the Caliphate.

The most ancient example that we know of this art of the Caliphate is found in the little illuminations of the Persian translation of the Fables of Bidpai, which were made at Ghazna in the depths of Eastern Persia, at a date very near 1150 (Plate II). These illustrations are, within their narrow limits, faithful reproductions of the themes of the pictures which were executed in Mesopotamia, in pursuance of the tradition, till the first half of the thirteenth century; their technique is identical in every respect, the same colouring, the same forms, the same conventions; the animals that appear in the tale of the Brahman sage Bidpai are treated in exactly the manner and style of the illuminated paintings of the Arab Kalila and Dimna, which were made in the actual domains of the Abbasid Caliph between the years 1220 and 1230 (Plates XVIII–XXIII), and in that of the lion pulling down a bull, which appears, vigorously portrayed, at the end of the tenth century on a fine golden coin of the Persian Prince 'Izz ad-Dawla Bakhtiyar (died 977). This argues a remarkable stability and persistency in the technique of Caliphate art during nearly two hundred years : it permits us, if we allow for the immutable laws of geometrical continuity which control the history of mankind as well as the world of numerals, to make the definite and assured deduction that, in the twelfth century, these forms, with certain small variations, were the very ones that took their beginning at the birth of Islam.

The world of Islam, in the far-off period of its origin, formed an unique civilization which extended from the shores of the Atlantic Ocean, from Granada, Cordova, Fez, to the frontiers of Chinese Turkestan in Central Asia. This civilization varied only in unimportant details, whether in its Eastern provinces or Western lands as far as the Sea of Darkness; the forms imported to Maghreb and into Spain in the seventh and eighth centuries persisted under their original aspects, without ever undergoing the evolution which took place during the second part of the Middle Ages in the Oriental lands from which they were roughly separated, more even by political vicissitudes than by the immensity of the distance between Baghdad and Toledo. Thus we find in Spain, almost in the last days of the Kingdom of Granada, at the beginning of the fourteenth century, graphic and decorative

3

formulas which are identical with those of the Mesopotamian provinces of the Empire of the sons of Abbas, under the reign of Harun al-Rashid, in the ninth century, and in Morocco, in the nineteenth century, forms, whose tradition is very ancient, which were brought to the Western world by the armies of the seventh and eighth centuries, at the beginning of the Moslem Conquest, and which have survived in these distant lands, almost unchanged by any evolution.

This unity could not last, and the Caliphate, in the hands of unworthy monarchs, rapidly decayed; it lost its provinces of the West in 756, and was rapidly reduced and restricted—among political and religious convulsions which brought it to the edge of the abyss, and almost achieved its ruin—to Syria, Mesopotamia and Iran, which still formed an immense dominion, whose administration would have offered sufficient scope for the activities of a prince of genius. Persia had been conquered by the sword of the Arab but never completely subjugated; and the Moslems tried in vain to assimilate her to themselves, while she provoked, throughout Islam, the explosion of heresies which shook the throne of the Caliph and destroyed the unity of the civilization which had been born around the Koran.

Persia rapidly detached herself from the Arab world, although keeping intact and unassailable her fidelity to the spiritual power of the Pontiff of Baghdad, under the temporal rule of princes who proclaimed their political independence.

The Caliphate, reduced to the Eastern portion of the world under the sceptre of the Abbasid Caliph, and the Kings of Persia, formed, from an intellectual point of view, one single dominion, possessing one and the same literature, written in the same language, Arabic, for Persian was used only by the common people; the books composed at Baghdad and at Damascus were carried swiftly up to the countries of Iran, and the works composed in Persia by the scholars of Shiraz or of Khwarazm, were soon in the hands of readers in the cities which lay on the banks of the Tigris and of the Euphrates; the Persians in the tenth and eleventh centuries made copies in the towns of Iran of the paintings in Arab books which had been illuminated in Mesopotamian studios, and this without making any change or modification in formulas which were foreign to them and of whose origin they were ignorant.

Persia, at that date, did not possess any artistic formula which was peculiarly her own, a creation of her national genius, whether in the domain of architecture, or in that of painting; the Sassanians, whose dynasty had fallen in the middle of the seventh century, under the blows of the Moslems, had bequeathed to the descendants of their

subjects nothing but the memory of a mediocre civilization which still vegetated under the domination of Islam, as we know from a Pehlevi inscription dating from the beginning of the eleventh century, found in the dome of the tomb of the Persian Ispahpat Abu Ja'far Muhammad, son of Wandarin Bawand, who professed the faith of Islam (1017–1021). Iranian civilization, from the third to the seventh century, neither knew nor possessed any formulas or any norms in the realm of art, other than those which the Sassanians had borrowed from the late Empire ; the architecture copied Roman motives, decorative and sumptuous motives of the Eternal City ; the White Palace at Ctesiphon was a development of the formula of the triumphal arch, adapted to domestic uses certainly never imagined by the engineers at Rome [1] ; the classical model can be traced without difficulty in Sassanian sculpture, and the painting which, at that date, was merely the projection on to a vertical plane of the polychrome sculpture, betrays a similar origin.

Moreover, the area of these artistic manifestations was, in Iran, a restricted one ; they were only found within a narrow zone, compassed in the west by the Roman frontier where stood the monuments sculptured in stone under the Chosroes ; their technique and architectural style are manifestly borrowed from the technique of the schools of the late Empire ; the rest of the Sassanian monarchy on the east only knew the Iranian technique, which was derived from that of the Empire of Chaldea in remote antiquity ; its monuments were of baked brick, its houses of unbaked brick which had been dried in the sun ; the ornamentation of the buildings in baked brick was meagre and limited in form and consisted of a few frescoes, whose style recalled that of the bas-reliefs of Naksh-i Rustam and of Tak-i Bustan, in the west.

At all periods since the dawn of history, throughout Asia from the shores of the Mediterranean to the coasts of Corea, construction in stone is a classic method, the method first of the Greeks, then of the Romans, then of the Byzantines ; the architecture of China, of India and of all the kingdoms of the Far East is typified by the house of wood ; the architecture of the Empires of Chaldea and Mesopotamia, after their overthrow, that of Persia, from its beginning, is of unbaked brick with herring-bone insertions in baked brick to strengthen the construction. The use of stone in Assyria, at Babylon, is borrowed from the technique of those Ionians of the coast, who had succeeded the Achaeans against whom the Hittites fought in

[1] It is as the result of a similar evolution of the architectural mind, that, in 1925, the plan of a building to house the Ministry of Mines and Forests at Belgrade implies the development and adaptation of this same formula of the triumphal arch.

35

the thirteenth century B.C. This technique of stone and marble was a luxury with the Hellenes, and its cost was crushing; the Greeks used it only for their temples like the Egyptians; at the same time, both methods had been invented on the banks of the Nile and in the Ægean world; like the Egyptians they built their houses in unbaked brick. In the Sassanian period, Rome introduced into Oriental countries the technique of building with baked brick, which in Italy, since the Etruscans, was a native style, and that of building in rubble-work with blocks of unhewn stone, the practice of using which is an intermediate state between the employment of brick and that of the blocks of stone and marble whose regular courses constitute the monuments of Classical Antiquity.

At the end of the tenth century and at earlier dates, the Persians would have sought in vain, through the whole extent of the monarchy, from the peaks of Zagros to the banks of the river of Herat, at the confines of the Iranian territory, for the memory of a technique which would have helped them to create a new series of artistic formulas, as the Aramaeans of the Mesopotamian provinces had lately succeeded in doing; they were obliged to wait till the Arab books, illuminated in the workshops of Wasit or Mosul, had had time to reach the Iranian kingdoms; the Moslems of the Persian cities had no scruples about copying these paintings which embellished the text of manuscripts decorated within the domains of the Commander of the Faithful, and the Iranian princes would have been ill advised to show themselves more severe or more rigid than the Vicar of the Prophet; they shut their eyes to this infraction of dogmas which was infinitely less grave than the scandalous conduct with which the sovereigns of Islam dishonoured the faith of Muhammad.

The fall of the Abbasid Caliphate before the armies of the Mongols entailed the disappearance of the Mesopotamian technique; painting in Iraq, in those provinces where Arabic was spoken, in Mesopotamia, in Syria, did not survive the terrible upheaval which destroyed the unity of Islam and blotted out its name from the list of the nations of the world, reducing it to the position of a faith professed in common by peoples of many different origins and aspirations, divergent if not contradictory, and depriving Islam of all political significance.

With the annihilation of the Abbasid dynasty, the annexation of the rich provinces of Mesopotamia to the kingdom of the descendants of Chingiz Khan, who had come from the plains of the Far East to enslave the West, the sovereignty over Asia by a blind destiny had been committed into the hands of princes who detested the Moslems; these princes, either Buddhists or Christians, and having wives who pro-

fessed Christianity, allowed the disciples of the Cross all the liberty they had formerly enjoyed under the rule of the Greek Emperors. These circumstances removed from any fault the Christians might commit that character of blasphemy which was attached to their paintings in the time when the Caliph was reigning in the metropolis of Islam : in the times of Hulagu, of Abagha, of Arghun, the Christian artists and the Moslem painters, at Baghdad or at Kufa, had only to cast all fear away and give a free rein to their imagination and their genius in order to create the masterpieces forbidden to them under the sceptre of the Commander of the Faithful.

It was exactly the opposite that occurred ; Mesopotamian art perished through the fact that the craftsmen through whom it lived had no longer a shadow of imagination because they were content to devote their powers to copying dead formulas which had nothing more to say to them, which they no longer understood ; they could not refresh their imagination from an art which was itself decadent and whose output was growing more and more rare in the cities of the East, outside the frontiers of the Byzantine Empire.

Towards the middle of the thirteenth century when the manuscript of the Assemblies of Hariri was illuminated (see Plates **XXIV–XXXI**), Christian art, which had sprung from Byzantine art, in Syria and in Mesopotamia, in the hands of artists who were careless and certainly clumsy, reached its end and fell into decadence ; the few and meagre Musulman formulas were not only incapable of renewing themselves, they were incapable even of finding support or revival in a technique which was degenerate and on the point of disappearing. Mesopotamian art vanished from the lands where Arabic was spoken, as an obscure and foreign craft, as a bookish and artificial importation which answered to no real need and did not satisfy the aspirations of those who practised it ; it left nothing behind it, no body of rules to inherit and carry on its brief traditions, which shows that, although in the twelfth and thirteenth centuries it flourished in the schools of Mesopotamia, yet it was a foreign system, which was imitated, though its origins were unknown and its development and evolution impossible to follow. When no more models could be found to copy, its practice became impossible and it came to a sudden end in the midst of the cataclysm which was provoked by the Mongol Conquest, after having vegetated for two and a half centuries, in the course of which it was responsible for the illumination of a few books ; it left in the history of humanity an infinitely small memory of the most meagre development and artistic evolution ever recorded.

VIII

WE must turn to the Eastern parts of the world to find the style and formulas which are the true heirs of Mesopotamian art, and which succeeded to the style of Iraq in the second half of the thirteenth century; the Western provinces which had formed in Syria and in Egypt the domains of the Commander of the Faithful, from the second half of that thirteenth century which saw the avalanche of the Mongol armies crash down upon the West, had, like Arabian Iraq, completely forgotten the manner of illustrating the text of books by little pictures representing the scenes and episodes described in the text; they had scarcely known it and they abandoned it to Iran, where it found a different fortune under the brush of more skilful artists, in the books of a more intelligent people whose minds were more open to spiritual things. North Africa, to the west of the oases, and Spain, had never had any knowledge of it; they continued to ignore it completely.

After the extinction and disappearance of the art of the Caliphate in the provinces of Syria and Mesopotamia there exists in the Musulman world no other technique or style than that of the Persian formulas; nothing is to be found in Syria, nothing in the countries of Arabian Iraq; in Iraq, in the sixteenth or seventeenth century, one may by chance find, quite sporadically, a few coarse, imperfect and unintelligent copies of Mesopotamian paintings of the thirteenth century where the brush of ignorant amateurs, with no tradition behind them, has been tempted to clumsy imitation; the few manuscripts which were illuminated at Baghdad under the rule of the Mongol princes, were illustrated by Iranian artists; the few pictures painted in the ancient metropolis of Islam at the beginning of the sovereignty of the house of Timur, were conceived and executed according to the norms and principles of Persian art, and we should look in vain among their characteristics for the technical methods of the artists who decorated the "Assemblies" of Hariri or the Fables of Bidpai (Plates III–XXXI).

The Mongol conquest, the taking of Baghdad, definitely destroyed the unity of the Musulman world and an impassable barrier was created between the domains of the Tartars and those of Islam, ruled over by the Mamluk Sultans of Cairo, the masters of Egypt and of Syria as

38

far as the Euphrates, who were Mongols and Eastern-Turks, exactly as the soldiers of the Prince of Persia. The subjects of the Mongol rulers and those of the Sultans of Cairo professed, at that date, an identical form of Sunnism; intellectual conditions had remained the same as in the eleventh or the twelfth century, but the political aspect of the world had undergone a radical change, and the two Empires on either side of the Euphrates found themselves drawn into a warfare of nearly three-quarters of a century, which definitely completed the separation between Persian Islam and the Islam of the West, and led to the irreducible antagonism between the Shi'ism of Persia and the Sunnism of the western countries. From this date the intellectual and literary relations between Iran and the West weaken, apart from the fact that both of them are rapidly falling into decadence, that science is declining and only interests a few specialists who no longer feel the same intellectual hunger as their predecessors and do not possess the means of satisfying it.

In the fourteenth, fifteenth and sixteenth centuries, during the reigns of the Mamluk Sultans of Cairo, the tradition of the illustrated book was definitely abandoned and lost in Syria and Egypt; these princes, Mongol and Turk in origin, who could not even speak Arabic, claimed to be the moral and intellectual heirs of the Caliphs who had ruled with spiritual authority at Baghdad; actually, they carried on the tradition of the Abbasid Caliphate which they had gathered up on the banks of the Nile, at the moment when it was expiring by the side of the Tigris; they laid stress on its rigorousness, its formalism, its severity, till their theory of Islam became even narrower than it had been under the Pontiffs of Baghdad. It is peculiar to see the Mamluk Sultans, who were then in touch with Venice, Pisa, Genoa and Spain, exaggerating the anti-artistic tendencies of Islam, to such a degree that Copts dare not illuminate their books during the reign of these monarchs. At the period of the Mamluk Sultans of Cairo, the ornamentation and decoration of manuscripts was severely limited to the style of sumptuous carpets, woven in geometrical patterns, within a framework painted in gold, in headpieces illuminated in a heavy and dull style to the frontispieces of the chapters, which carry on the manner of rich decoration which, in former centuries, adorned books destined for the princely collections in the provinces where Arabic was spoken and in Persia; the decoration of manuscripts consisted solely in the severe grace, the supple elegance, the perfection of calligraphy in its monumental splendour, which make it much more impressive than the decadent schools of Persian painting in the sixteenth and seventeenth centuries.

39

MUSULMAN PAINTING

Exceptionally, in the middle of the fourteenth century, an artist who was not without skill should, in order to amuse the Sultan of Cairo, have copied the illuminations of a treatise on the working of hydraulic automata which had been illustrated at the very beginning of the thirteenth century, for the Ortokid prince of Diar Bakr, in Mesopotamia, under a form which can be recognized from the words of an Arab historian who wrote a History of the Kingdom of Aleppo and speaks of pictures which, at the beginning of the thirteenth century, the prince of this Syrian town had executed for the amusement of his son (Plates XXXV—XXXIX). The artist merely reproduced in a literal fashion, though with obvious misunderstandings in the process, paintings which were conceived in the pure Mesopotamian style of that period in the history of the Abbasid Caliphate; the fact seems even stranger when we observe the dexterity with which the painter used his brush, since he could, had it been permitted him, have done original work worthy of his talents; his part was evidently confined, like that of the calligraphers at the end of the tenth century in Baghdad, to overlaying with a yellow gold the 'carpets' which were displayed on the frontispieces of books. The art of painting had, however, always been known in the land of Egypt, if not practised for religious motives; in the year 1340, the populace of Cairo dared to paint on flags the torment of a minister whom the Sultan had, in the Chinese way, ordered to be tortured with his family, to force him to give back stolen money; the writer relating this event insists upon the fact that the personages were pictured with great exactitude and were recognizable at first sight; the minister, his sister, her mother dressed in silken robes and well-shod with yellow slippers, were castigated with a knout by the tormentor. The mob went along the streets with these paintings hanging from spears and carried them up in the castle of the Sultan, who manifested his indignation. Long afterwards, in the year 1470, a Turkish officer of the Mamluk militia, ordered a copy of the Roster of the Cavalry to be illuminated with pictures showing the evolutions of horsemen, in a technique which is still identical with the Mesopotamian illustrations of the thirteenth century, with a few details borrowed from Persian art.

This banning of the plastic arts, and especially of painting, in Egypt, was perpetuated under the Osmanli rule after they had put an end to the power of the Mamluk dynasty: although he was completely impervious to things of the mind, the Padishah of Stamboul never forbade his subjects to illuminate the pictures of books destined for the seraglio collections, but in the reigns of the Osmanli Sultans no book was illuminated on the banks of the Nile.

40

IX

NOTHING in the history of Iran makes Persia seem predestined for the glorious part she played in the domains of literature and of art; in Sassanian times literature was rudimentary, the language was poor even to penury, harsh and barbarous, incapable of expressing the subtleties of a complex idea, and the abridgement of the Commentary on the Avesta, made at this time, which we possess, and the few other small works which may be equally old, are contemptible, shapeless and without any literary value. The art of the Sapors and the Chosroes was a far less clumsy thing; the books were the work of Persians and, of necessity, their unaided work; the temples, the sculpture, the bas-reliefs which set forth the exploits of the King of Kings, are clearly the work of artists of the late Empire and of craftsmen trained by them.

It took Persian literature several centuries from the time of the Musulman Conquest to emerge from the darkness of Limbo. At the beginning of the thirteenth century tradition speaks clearly and precisely of a time when there was no literature in Iran, under the reigns of the Ardashirs, the Sapors and the Chosroes; tradition tells that the first Persian to put his dreams into verse was the King Bahram Gur (about 420) and that even he, who had been brought up among the Bedouins of Hira, did not think it possible to write in the language of his subjects; he thought in Arabic. At the beginning of the thirteenth century there was shown at Bokhara a collection of these poems which passed as the work of Bahram Gur; the few lines which have survived suffice to show us that, though it is possible that the Sassanian prince really wrote in Arabic, nevertheless these poems attributed to him in the Bokhara Diwan are the invention of a rhymer of the Musulman era. This legend shows that the Iranians of the Middle Ages were fully aware of the obvious fact that the origin and principle of their poetry were to be found in Arab forms and Arab influence, which means that the subjects of the Sassanian Kings, from the third to the seventh century, did not understand prosody and knew nothing of the cadence of rhythm. We do not possess a single line of the poems written by the minstrel Barbud at the Court of his master

Khusrau Parviz (about 600); all the works of this celebrated musician who charmed the leisure of the King and his beautiful favourite Shirin, are lost, for no author under Islam troubled to copy the inelegant form of his verse; Barbud was the first to introduce the principles of prosody and the cadence of rhythm into Iranian literature. It is clear from the few facts mentioned by Musulman biographers about this writer that he based them on an imitation of the metres of the Arabs, who were neighbours of the Persians in the south-west portion of their Empire. This invention remained an isolated thing and nothing came of it; the Sassanian dynasty only survived the death of Khusrau Parviz a few years and no attempt of this sort, and in this spirit, was made again till much later. A very able poet, called Abbas of Marv declares in one of his poems (about A.D. 800) that no one before him, in Musulman Persia, had given a rhythmic form to his songs; he had a few timid successors in the course of the ninth century, but Iran had to wait till her technique had perceptibly freed itself from the grip of the Arab style before she could witness the marvellous flowering of a Pleiad of poets who wrote their harmonious verses at the Court of the Samanid princes at Bokhara and at Ghazna, in the palace of the Ghaznavid Sultans, their successors on the throne of Persia. The last of these poets was Firdawsi, who, in the second half of the tenth century, put into verse the heroic deeds of Iran, using an epic form so perfect that one can only compare it with that of the Iliad or of the Aeneid; the rhythm of the poetry, now as at all other times in the history of Iran, is infinitely superior to the cadence of the prose which still recalls the heaviness and inelegance of the language spoken in Sassanian times.

The Musulman Conquest which had subjugated Persia and brought it under the rule and sovereignty of the Commander of the Faithful, had spread the use of the Arab tongue over all the tableland of Iran, from the mountains of Zagros on the borders of Mesopotamia to the frontiers of Turkestan; Arabic relegated Persian, which was derived from the Pehlevi of the Sassanians, to the inferior position of a popular and trivial idiom in which it was not allowable to express literary ideas; the Persian language in the seventh and eighth centuries was hardly adequate for such uses; it retained too much of the poverty and harshness of the language spoken under the Sapors and the Chosroes; it sufficed for the use of a people ignorant of the subtleties of literature, to whom elegance, grace, rhythm, were meaningless and strange conceptions, who could only express themselves in concrete terms and were unable to rise to abstractions.

The wealth of Arabic was very different; the complexity and variety of the inflexions and its suppleness made it, like classical Greek,

42

one of the most perfect instruments ever given to man for the expression of the most delicate shades of his thought; the syntax and construction are sometimes a little stiff; it lacks at times the wonderful flexibility of the language of Plato and the Alexandrines, but it can render the most subtle conceptions of the human intellect in a form which is far more logical than that which can be expressed in Indian idioms, and thanks to the multiplicity of its forms and the strength of its grammar it was equal to developing the deepest abstract thought. The Arab horsemen in their sandy plains had, for centuries, given to their poems, whose accomplished rhythm was an imitation of Hellenic measures, a noble and majestic form, the secret of which is lost to their successors in the cities of Mesopotamia and Syria, who have never equalled it. The most modern of these were composed shortly before the illiterate Prophet proclaimed his mission; the most ancient are hardly much older, for, if we except certain reminiscences of Semitic antiquity, the records of Arab tribes do not go back much further than to about the beginning of the Christian era, instead of to those legendary times in which Arab historians would have us look for the origins of their race; these poems and the Koran are the incomparable jewels of Arab literature; putting aside the Tradition, whose original form has unfortunately been corrupted, everything else from the eighth century with the Omayyads of Damascus, goes to make up the rubbish to which the grammarians rightly pay no attention.

These brilliant qualities reacted during three centuries upon the modes of Iranian thought and upon the manner in which they were expressed; the Persian language accepted all the vocabulary of the Arab into its lexicon, but, since it already possessed all words answering to concrete conceptions, it chiefly made use of the Arab words that express action, marking the variants of its moods, and abstract ideas, for which the Persian vocabulary was inadequate. These borrowings could not enrich the Persian grammar, but they accustomed the Iranians to a complexity of thought which was absolutely unknown among them in Sassanian days; at the same time they were making attempts at rhythm in verse in imitation of the Arab poets, whose works were read in Persian cities just as they were read in the towns of the Caliphate. The Persians of to-day could not expel Arab words from their vocabulary without immediately condemning themselves to the loss of the power to express any abstraction, any idea belonging to civilized life, and being reduced to the expression of concrete facts. Greek had not been able to exercise a like influence on the language of Persia; in the period when the Sassanians presided over the destinies of Iran, Greek was the official language of all those

provinces of Syria on the frontiers of the Empire of Chosroes which were under the Greek power. But Greek was not spoken in Persia and had not passed the frontiers of the dominions of the King of Kings as Arabic did in Musulman times; Greek had its definite place at Court and in the administration of the Sassanians, the inscriptions of Ardashir (third century A.D.), are set out in Pehlevi and in Greek, in imitation of those which King Darius (508 B.C.), had cut on the shores of the Bosphorus, in which he enumerated in Persian and in Greek the names of the peoples he was leading to battle against the Scythians. Pehlevi was so faulty a language and its script so difficult to decipher, that the registers of the Persian army under the Sassanians were written in Greek on ox-hide skin; but this is the extent of the influence of Hellenism on Iranism in the domain of literature, and political circumstances prevented it from growing deeper or from counting, like Arabic, as a factor in the budding and blooming of Persian letters. The domain of art offered an easier ground, more accessible to its efforts; the influence of the Hellenic genius on art shows what this influence would have been in the domain of ideas if Greek and Greek literature, under the ægis of Christianity, had been spread throughout the Iranian lands, as Arabic and Arabic poetry were spread under Islamism; a thing which nearly came to pass several times under the Sassanians.

X

THROUGHOUT the first centuries of its existence, from about A.D. 990 to about 1270, Persian painting, in an Iran which was, at any rate morally and spiritually, subject to the House of Abbas, had no norms and knew no technique other than the methods of Mesopotamian painting, from which it was derived; it developed very slowly during the first centuries of its existence because, in those distant times, it did not possess the individual style, the independent technique which were being evolved in accordance with fixed norms and immutable laws. In those times Persian painting consisted chiefly of imitations, of copies, of paintings made as decorations for Mesopotamian books rather than of any creations personal to the Iranian artists and belonging specially to them; there was then so little Persian art that when, towards the middle of the tenth century, in 943, an Embassy from the Celestial Empire arrived on a visit to the Prince of Bokhara, Chinese artists, in the suite of the ambassador, illuminated the translation into Persian verse of the Fables of Bidpai which had just been finished by the celebrated poet Rudagi. These paintings aroused great enthusiasm among the subjects of the Samanid prince, who had never seen such marvels and who, at this date, in the middle of the tenth century, had no understanding of the ornamentation of manuscripts or the style of pictures. Chinese technique did not last in Transoxiana, but was introduced there in this manner, sporadically and by a chance of history, through the agency of one or several members of a diplomatic mission; we should look in vain between the twelfth and the fifteenth century for a painting carried out in the distant countries of Transoxiana which imitates those with which, in 943, the poem of Rudagi was illustrated or which even recalls a memory of them. It is clear that they constituted an exceptional manner which remained an isolated thing, that their authors did not repeat them and that they had no pupils; thus no one beyond the Oxus was capable of carrying on the tradition of these paintings which conformed to the canons of ancient Chinese art, with a dark monochrome technique and a minimum of colour. Five centuries later, about 1437, like political circumstances produced a like result, and a Persian artist, at Samar-

45

kand, in order to illustrate a book destined for the library of the prince of Transoxiana, copied some Chinese paintings which had been brought to Eastern Iran by Embassies, which were exchanging the Sons of Heaven for Timurid princes (Plates **LXXXVIII–XCIII**).

Persia, under the rule of dynasties subject to the Caliph of Baghdad, possessed no individuality ; she based her ideas on copies of works which originated in the Arabic-speaking provinces and had been carried up to the kingdoms of Iran ; this was true in all spheres of life and applied to literary matters as well as in the domain of science ; in those far-off times there existed neither a political frontier nor an intellectual barrier between Persia, Mesopotamia, Syria or Egypt ; books written at Baghdad, Damascus and Cairo were brought into Iran and at the same time works originating in Qum or Shiraz found their way down to the banks of the Tigris ; the teaching was the same at Cordova, at Fez, at Damascus, at Kandahar. Thus it would be useless to attempt to discriminate between the styles and manners of Musulman painting at the time when the descendants of Abbas were in power, since it it is not even possible to do so in the spheres of literary history and of science which have been more closely studied and are far better known to us.

These conditions, generated by the political status of Islam under the rule of the succession of Pontiffs who sat upon the throne of Baghdad, continued to exist for a certain time after the destruction of the Caliphate owing to the strength of inertia and to the momentum acquired, after the Mongols had installed themselves in the palaces of the Vicar of the Prophet and in the royal residences of the Saljuks. The fall of the Caliphate and the decline of the Arabic-speaking world after its subjection to the Mongol yoke, the extinction and disappearance of the Mesopotamian schools and of the studios of Iraq, Syria and Egypt, these were circumstances which gave Iran back her independence and definitely freed Persian painting from the grip of the technique of the eleventh, twelfth and thirteenth centuries.

XI

THE Iranian style, as soon as its methods were liberated from the influence of the Mesopotamian manner from which it took its birth, became at once an independent entity, assuming a much more varied and refined form than that of the painting of Iraq; it underwent, during the next two hundred and fifty years, in a field very different in its vastness from that over which the studios of Baghdad and Kufa had presided, a rapid evolution, leading on to perfection and leaving far behind it the limited ambitions of Mesopotamian art during the two and a half centuries of its existence in the Empire of the Caliphate.

This evolution of Persian technique and of the Iranian style was wholly independent of the political circumstances among which it was produced: the Mongols allowed their Musulman subjects in the provinces of their Empire to conduct their own affairs in their own way, as they had done in the days of Ghaznavid and Saljuk rule, under the sovereignty of the Commander of the Faithful. They would have found it difficult to act otherwise or to interfere: the Mongols arrived in the Western world as poorly endowed as the Arab conquerors, six centuries earlier, had found themselves, when they left the sands of the Yaman and of Hadramaut for the Byzantine provinces and the highlands of Iran. Up to this date, the Mongols in Mongolia on the frontiers of the Celestial Empire had been under the direct influence of China and had never imagined that there could exist in the lands of the Setting Sun other forms of civilization, other ways of thought or rather of expressing thought, of clothing, or of action; the hold of China on the heart of their tribes was too ancient and deep-seated a thing for it to be possible for them to shake it off and, escaping from Chinese influence, to adopt the customs and habits of the Moslems. Nor had they any wish to do so; the Mongols, whether Christian or Buddhist, hated the followers of the Prophet, but they were unable to suppress them in the countries conquered by their own sword and even had to employ them in the work of administration.

Moslems, under these princes, enjoyed far greater freedom than Christians under the rule of the first Caliphs, because their conquerors

professed complete indifference in the matter of religion, took no interest in the beliefs of their subjects and never had any thought of converting them, either to Buddhism or to the Christian faith; they showed favour to the Christians; Arghun, indeed, conceived the mad project of making Islamism disappear from the face of the earth, but they never prosecuted any individual Musulman on religious questions, which, for them, did not exist.

The Iranians carried into their decorative art the qualities which gave lustre to their literature. There are no two entities in the world more different than Arab and Persian literature; their outward appearance, the number and nature of the subjects treated, above all, their script, give them an air of resemblance, of similitude, which creates an illusion; the spirit and ideas they express diverge sharply and no common measure exists between the way of speech, mentality and forms of expression of a Bedouin of the Hijaz and those of a Persian of Shiraz. Arabic, like Latin, is essentially a juridical language; the inviolable framework of its grammar gives it a great security in expressing abstract conceptions, in matters where elegance and delicacy of form would be useless and mistaken, where precision and meticulous exactitude are the qualities needed; all Arab literature is concerned with jurisprudence and theology, which are both based on the same premises, the text of the Koran and of the Tradition; Arab poetry, even in pre-Islamic times, remained descriptive; it was always opposed to lyric effusions and to the flights of epic narrative; Islam, in this field, possessed only tales of chivalry written in prose, which recall, in their vaguely diffuse story-telling the inextricable and fantastic plots of The Thousand and One Nights; history, when composed by Arab writers, soon became a detailed account of the trifling events of daily life, the correlation of which always escapes them; their books of law and theology are crushed beneath a mass of commentaries, super-commentaries, glosses, scholia and commentaries on glosses, which all offer a literal and material interpretation in contrast with the mind and intelligence of the original author, without troubling to understand what he has written.

Persian characteristics are the very opposite of this; they lend themselves wonderfully to lyric rhythm and to the metre of the epic; it is precision and exactitude that the Iranians lack most; they allow their minds to wander freely in the domain of fancy and of the imagination, a thing the Moslems living to the west of their country never permitted themselves, never conceived, looked upon as an inferior form of thought. It would be useless to attempt to translate books of Musulman law into Persian, as futile as to try the translation

48

of the Pandects and the Digest into Italian. The legal treatises which have been written in Persian are modern, valueless summaries; their use is confined to *gens du monde*, to amateurs who wish to get a superficial idea of this abstruse science; no specialist would ever think of going to one of them for the solution of a special case.

The attention paid to exactitude by Arab authors of the first centuries went far beyond the intellectual needs of the peoples who lived in the lands of Iran; the scholars in Persian cities in the Middle Ages, reading only Arab books and unable to conceive the possibility of expressing thought otherwise than in Arabic, induced in themselves a borrowed mentality so that they might more nearly resemble the scholars of Mesopotamia, Syria, and Egypt. This was the height of their ambition, the climax of their desires; they forced themselves to conform to the spirit of Arabic and accepted its discipline, but they made no proselytes in a country where, at the Court of the Samanids and the Ghaznavids, lyric poetry was beginning to find its place as the supreme and essential form in Persian literature. No one but the special student in jurisprudence and theology would take the pains to learn Arabic, far less to read Arabic books in the dogmatic form in which they had been written; about the year 963, the Samanid Prince, Mansur, was obliged to order that a Persian translation of the Commentary on the Koran and the History of the Nations of the World written in Arabic, by Tabari, should appear without its critical apparatus, the heaviness and complexity of which disgusted the Persians.

This intellectual state had reached its apogee when the Caliphate collapsed. Persia at this time, in every sphere of life and in every field, had given birth to the great men who made her literature famous; poetry had received its most perfect, most admirable expression from the pens of the Pleiad of Turkestan, had, with Firdawsi and Nizami, accomplished its destiny. The decline had already begun and all the formulas from which Iranian thought drew its life, all artistic norms, were in a state of rapid evolution of over-refinement and complexity, which was to culminate three centuries later in absolute bad taste and decadence. If the Caliph had remained on his throne at Baghdad, suzerain over the Kings of Iran, would this revolution have taken place in the same manner and passed through the same phases? The ideal of the Moslem, whether on the banks of the Tigris, the Euphrates or the Nile, whether in Morocco or in Spain, is unchangeable stability in the study of an eternal dogma, in which the intelligence and processes of reasoning should take no part; in Arabic, as in Chinese, the word that means 'to invent something' also means 'to be guilty of the crime of *lèse majesté*'; the Persians would not submit to this mechanical game which

put automata in the place of intelligence and which makes Arab literature unreadable; they tried to understand, to find an explanation for that which is often inexplicable, in a word to create; they went exploring in the world of Transcendence and fell into Mysticism, while the writers of Arabic were left in Theosophy and Esoterism.

XII

ALREADY in the middle of the twelfth century, at Ghazna in Eastern Persia and a century later, about 1250, in its countries of the West, the Iranian artists, in order to enlarge their composition, introduced into the Mesopotamian setting of their paintings adventitious themes which they took from their surroundings, from the Hindus, the Turks, the Chinese, the Mongols; doubtless these illuminators only reproduced types which were familiar to them and which they had daily opportunities of seeing in the streets of their towns. Indeed, the painters of Mesopotamian workshops were used to seeing exotic types about them: Baghdad in the thirteenth century was a Cosmopolis where men of every nation jostled each other; Turks formed the greater part of the Caliph's Guard, so much so that, in the first years of this century, the Commander of the Faithful chose to put on a tunic of goatskin, such as his Bodyguard wore; but it would never have occurred to any craftsman in the capital of the Caliphate who was engaged in illuminating the collection of Hindu fables by Bidpai, to represent the King of India and his minister under any other aspect than that of a Musulman Prince in conversation with a Cadi.

The artist who, in the middle of the twelfth century, made the illustrations for the Fables of Bidpai (Plate II) in the distant town of Ghazna, has introduced into the Mesopotamian setting of these tiny pictures certain elements foreign to Islam, in order to translate themes and illustrate episodes which belong to another civilization than that which grew up between the Tigris and the Euphrates. A Turkish personage, clothed in a silken robe, ornamented with the Chinese design of the circle of the Two Principles, Male and Female, represents one of the officers of the Court of the Prince of Ghazna, who was Turkish by origin and surrounded himself with soldiers of his own nation; Hindus adorned with brilliant muslins and covered with necklaces of sparkling diamonds as they appeared about 1150 in the States of his master, represent the King of the Indies and the Brahman who wrote the Veda. The introduction, in the middle of the twelfth century, of these Hindu themes into the

51

setting of Mesopotamian painting is of great importance, for it has preserved for us a memory of the vanished technique of Rajasthana at the beginning of the twelfth century. All traces of the Rajput style of this far-off time disappeared centuries ago with the books which they illustrated; the oldest Hindu miniatures known do not go back beyond the second half of the sixteenth century, in the reign of Akbar; their testimony, joined to that of the much more modern pictures of the seventeenth and eighteenth centuries, traditional copies of the paintings of the thirteenth and fourteenth, allows us to establish the important fact that the Hindu style in the Middle Ages represents a slow evolution from that of Antiquity as illustrated by the frescoes of Ajunta, from the second to the fifth centuries, the technique of which links them to the methods of the Greco-Bactrian, Greco-Hindu Schools, and to the norms of the workshops of Gandhara and Indo-Greek States since the fourth to the first century B.C.

Hindu technique at the end of the Middle Ages, both under its Buddhistic and its Brahmanical aspect, had great power, like the sculpture, which also took its beginning in Hellenic methods. After the sixth century it declined; the Buddhist style became eclipsed and disappeared from India at the same time as the doctrine of Sakyamuni; the Brahmanical style did not, in the hands of the Vishnuites, preserve the tradition of the Buddhist schools which migrated, to exercise their talents in Central Asia and in China. There are many reasons for this; Brahmanical legend, if we except the plot of the Mahabharata and of the Ramayana, is much less human than that of Buddhism; these two epics are an imitation of the themes of the Iliad; if the part played by the Gods is grander in them than in the Hellenic epic, the action however is carried on within the limits of humanity and never exceeds the scope of the artist's means, unlike certain scenes in the Odyssey or in the Paradiso of Dante. We find, therefore, in the art of Rajputana, pictures which give a very powerful representation of the episodes of Rama's fight with the Demon King of Ceylon, Ravana. The representation of the figures of the Hindu Pantheon under their animal form or under the aspect of human beings of monstrous shape, was repugnant to the taste of the Greek artists and their pupils in Gandhara and Jalandhara, who preferred to dedicate their talents to the translation of the serene conceptions of Buddhism; only the placid and poetical legend of Rama was sympathetic to the simplicity and nobility of the Greek genius, and so it is illustrated as we find it in the schools of Jammu and Kangra, a number of pictures showing the charming episodes in the life of the hero, while the exaggerations

52

MUSULMAN PAINTING

of Vishnuism and the monstrosities of Jainism hold no temptation for any Hellenic artist.

By the time of Akbar the decadence was complete; in the Rajput paintings made in his reign we find hardly anything to remind us of the brilliant tradition of the Ajunta frescoes; the forms are heavy and inelegant, almost vulgar, the colouring dark and dull and reduced to a few elementary colours distributed in an awkward and clumsy fashion; the technique of Rajasthana would have completed its evolution in the beginning of the seventeenth century and disappeared in the plains of Hindustan if the painters of the North-west had not seen in their studios Persian paintings of the fifteenth and sixteenth centuries, brought there about 1520 by the Timurid princes who came to these countries seeking refuge and created an empire in them; they imitated the brilliant manner of these pictures; the stimulus of their technique brought about a rapid renaissance in the studios, giving to the Hindu forms their forgotten grace, and brilliance to their palette, creating the masterpieces of the seventeenth and eighteenth centuries.

The introduction of Hindu forms into a Mesopotamian setting came about naturally at Ghazna: Ghazna, in 1150, was the capital of a kingdom which was far more Hindu than Persian; it by no means implies the influence, which indeed has never existed, of Rajasthana technique on the methods of Musulman artists; the dynasty to which the Prince of Ghazna belonged had, at this time, half-way through the twelfth century, lost the western provinces of Iran; and these losses had been largely compensated for by the fact that it reigned over all the north-west of the peninsula, at Lahore and on the banks of the Indus; it was quite natural that a subject of the King of India who was acquainted with the lands of the Punjab should use his knowledge in illustrating the episodes of the Hindu legend with pictures executed in the studios of towns ruled over by his master.

We should seek in vain among the little pictures of the Fables of Bidpai for the smallest influence, the least reminder of Sassanian influence; with the exception of certain formulas in a very restricted field, there is no transmission from the Sassanian manner to the Persian style; Sassanian art was so poor that its heirs would indeed have been poverty-stricken if they had had nothing else to depend on, if they had not drawn upon a storehouse whose riches originated in the classical world; the Persians of the second to the seventh centuries passed on to their successors in Islam certain formulas through the means of sculpture and glyptics; but these were quite insignificant. The ceramics of Musulman Persia during the centuries of the early Middle

53

Ages, immediately after the Conquest, copied, to a certain extent, the technique of Sassanian silver vases, decorated with relief, and ivory carvings; in all civilizations pottery is the goldsmiths' work of the poor, and the cups and porringers of the tenth and eleventh centuries, with their schematic decoration and their strange and barbarous forms, represent memories of the ornamentation that embellished the silver dishes and vases of the Chosroes. These pieces are less antique than certain scholars wish us to believe them; they do not date from the eighth century; they belong to the time when the Buwayhids, in the west of Persia, shook off the yoke of the Caliphate and presided over an attempt at a national renaissance which sought its inspiration in the art of the Sassanians, from whom these princes claimed descent. We still find in the figures which animate their drawings, the definite reminder of a favourite technique of Byzantine art, the large spot of colour on the cheeks of the figures to mark the projection of the cheek-bones; certain of these pieces, of a brilliant white or a pale shade of yellow, with designs in which we still feel the plasticity of the relief, translate the technique of carved ivory, of those pierced ivories, some of them with a conventionalized representation of the human figure, made towards the end of Antiquity, in the reigns of Sapor or of Khusrau Anushirwan.

The Iranian artists of the Middle Ages, or at any rate, some of them, sought for historic exactness when they wished to represent the personages in the Mazdean epopee. They attempted, naturally enough, not to show the Chosroes in the dress of the Caliph's generals, nor in that of the Turkish kings who ruled over the land of Iran till the Mongols came to lay it waste and cover it with ruins; the artist of Ghazna has drawn Khusrau Anushirwan under an aspect (Plate IIa) which, to a certain extent, recalls the bas-relief of the grotto of Tak-i Bustan where the King Khusrau Parviz is depicted; it is possible that he was inspired by the portrait of a monarch of the Sassanian house which figures among the paintings made on rock near the " Village of Anushirwan's Daughter," close to Ghazna; these paintings are a cheapened translation of the mighty bas-reliefs which were sculptured in the West, under the direct and immediate influence of the Roman tradition, but it is impossible to see here any influence whatever of the traditional methods of the Sassanian schools on the development of Musulman art.

XIII

IT is with the Ghaznavid princes in the tenth century that the fashions of the Far East made their appearance in the provinces of Iran, where they were to stay for six hundred years and to inspire Persian painting with a manner, or rather the appearance of a manner, the illusion of methods which were to deceive critics as to their origin. They were introduced by those Turkish horsemen who, for many thousand years, had careered along its frontiers, full of treacherous intentions, and who, about the year 970, left the service of the Prince of Bokhara to come to Ghazna and found there a powerful dynasty. From the dawn of history the Turkish tribes lived in the steppes of Central Asia between China and Iran, whose conquest was their dream; the history of the Celestial Empire in ancient times is made up of tales of struggles with these Barbarians; the vicissitudes, the shocks, the reactions produced in the bosom of the nations living in the north of Asia, brought about the great migrations of the Aryan races, the movements of nations towards the West of the world, the Barbarian invasions which destroyed the Roman Empire, the Caliphate and the Byzantine Kingdom. Their wars with Iran are less well known than those with China. Persia has no chronicles, and we know nothing of the anxieties which the Altaics may have caused the rulers of the Persian and Medic clans in the days of early Antiquity. Persia only appears in history in the eighth century with Dejokes; the story of the Kingdom of Anshan and the first Achæmenidae are as unknown to us as those of the Elamite Empire, but its annals begin with the mention of one of those invasions which, several times in the course of ages, set off from the Takla Makan to overwhelm Hither Asia, and lay waste everything up to the frontiers of Austria.

It was in the middle of the eighth century B.C. that the Altaic tribes, who were strung out between the Altai and the Ural mountains, were swept by a breath of panic which flung them one against another; it is not easy for us to discover if this cataclysm was provoked by the war which the Chou sovereigns of the Chinese Empire were then waging against the Huns and the Jung. The Scythians, who were the most westerly of those tribes and who inhabited

55

the valley of the Jaxartes, were so violently shaken that they sped like an arrow towards the West, sweeping before them hordes of Gauls and Cymry; the Celts fled in disorder in every direction where they might find refuge and escape from the ferocity of the Turks; some of their clans fell on Armenia, where they hurled themselves against the generals of King Sargon of Assyria, who utterly defeated them; others pushed their way further along the side of the Black Sea, but could not get beyond the Crimea, to which they gave their name, and along the western side of the Euxine, among the Slavs and the Germanic peoples who were settled there. The cataclysm lasted for almost a century and a half and covered Asia with ruins; the flood of Turkish invasion was only checked on the frontiers of Egypt after having nearly destroyed the monarchy of the Medes. After this, Asia recovered tranquillity till the second century; under the rule of the Achæmenidae no Turkish peril existed for the Western world; the weakness of the Arsacids made the Altaics bold once more; at the very beginning of the second century B.C. the Gotz, who camped on the frontiers of China, between the Altai and Lob Nor, were crushed by the Huns, who drove them into the valley of the Ili: the Gotz drove out the Saka, the old inhabitants: the Saka took flight before the Gotz as the Cymry had taken flight before the Scythians and descended into Persia, where, after fierce fighting, they took possession of the southern province, Nimroz; chased by the Wusuns, whom the Huns overthrew in the East, the Gotz evacuated Ili, invaded Persia, took possession of Bactria and put an end to the sovereignty of the Greeks in Iran (145 B.C.): a hundred and seventy years later, about A.D. 25, they conquered Kabul, Northern India and Kashmir, moved their capital to Jalandhara and founded the Indo-Scythian Empire which carried the tradition of the Greek kingdom of Bactriana into Hindustan.

Throughout the fifth century, from the reign of Bahram Gur onwards, the Sassanians were obliged to begin war afresh with the Turkish clans who wished to seize on the eastern part of Iran; they fought for the existence of their monarchy, against the tribes of the Ephthalites on their eastern frontiers; the endeavour made by the Ephthalites to repeat the attempts of the Sakas and the Gotz in the second century B.C. was a complete failure, thanks to the bravery of the Sassanian princes, but about 638 the Turkish tribes that were camped round the lake Issik-Köl, started once more on that march to the West of the world which, in several stages, led them to Iran, where they became kings; to Egypt, which they ruled; to Constantinople, where they founded a mighty empire, which lasted

up to the first quarter of the twentieth century; to Delhi, where the Great Moguls had, as their successors, Princes of the House of Hanover.

The invasion of the Ghaznavid Turks into Iran inaugurated a new era, which lasted for nearly a thousand years during which, except between 1502 and 1736, Persia was ruled by princes of Altaic race who made the Iranians feel the full weight of their power and who brought their empire to such ruin that, at the beginning of the sixteenth century, Persia, tired of their incompetence, put the charge of her destiny into the hands of an old Iranian family that took pride in its glorious Arab origin and in its descent from the Imam Musa, the descendant of Muhammad, if its pretentions are well founded and not a mere fabrication intended to deceive the Persians.

The Safavids could not do without the help of the Oriental Turks who were living in Iran. They were forced to employ them as their predecessors, the Turkish dynasties, had done, for they were absolutely indispensable to the existence of their armies; war was always an uncongenial thing to the Persians; they submitted to their Turkish and Mongol invaders without fighting; the great battles in which the possession of Iran was at stake were fought between the Turkish and Mongol horsemen of the Turkish sovereigns of Persia, and the Safavid King, Shah Isma'il, was set on the throne by the confederation of Turkish clans living in Iran, who elected him, as they would have elected one of their chiefs, in the fashion of the Altaics, choosing a stranger in order to put an end to the bloody rivalries among their hordes.

The Safavid dynasty depended on these Turkish tribes which had voluntarily accepted its authority when they understood that they had exhausted the patience of Iran, and that their destiny had, for a time at any rate, come to an end in the provinces they had laid waste; their names appear in all the mediocre histories of the Safavid kings; they held the command of the Persian armies, leaving the cares of the civil administration in the hands of the Iranians. We feel their importance growing and increasing as the power of the King weakens and decreases up to the day when the Afshars and the Kajars again take possession of the sovereign power to sink Persia into the abyss of 1925.

The civilization of these Turks in far-off times was exceedingly rudimentary and their life exceedingly miserable; they lived in their felt tents, among snow and frost, remote from art and science, using barbarous idioms which were inadequate to express any ideas or to render any conception other than those which have to do with the most material needs of existence; a great number of the elements

of these rude languages, almost all the monosyllables in Turkish, were borrowed from the language of the Celestial Empire, to which the Turks turned, having no alternative, for everything, however small, outside the immediate needs of a civilization which had been reduced to an absolute minimum, and had only just crossed the border of savagery. The English mission which explored Turkestan found, close to Turfan, the originals of the fetiches made by these Barbarians, carved by them when they were not copying Chinese or Hindu images, with rude knives from roughly-squared tree-trunks—more or less well done and more ill than well—at one end of which a series of roughly-cut features, coarsely planned by clumsy hands, made the unjustifiable claim to represent the hair, eyes, nose, mouth and beard of a creature as repulsive to look at as the idols of Easter Island or the gods of the Kaffirs, Zulus and Matebele, or the figures which may be seen in the clumsily illuminated pages of Mexican manuscripts.

The highest ambition of these Turks, and of the Mongols who shared their life in the barren steppe, was to resemble the Chinese; when they were not attempting to destroy their kingdom they were seeking their alliance; they knew nothing more august than the majesty of the Son of Heaven, nothing more splendid than the luxurious and elaborate ceremonial of the capital of the Middle Kingdom; and they copied in their steppe, as far as lay in their power, the manners and ways of life of the Chinese. The tribes of the Sakas, who, in the second century B.C., fell upon Persia, like the Huns who crushed them, reserved all their admiration for China; the Turks, who lived on the borders of the Orkhon, called it, in the eighth century A.D., 'Tafghach, the marvellous,' and this appellation suffices to show the nature of their sentiments towards the Celestial Empire, which despised them; all that led beyond their borders seemed wonderful to these Turks; about in the ninth century, we learn from the history of Ughuz that when that mythical ancestor of the Turkish nation marched against the king of the Russians, he arrived in front of a marvellous palace with a golden roof and silver windows. Whether they were Turk or Tunghuz, the Chinese, who possessed an advanced civilization, slighted these people of the steppe whom they knew through and through, who grovelled in ignorance and lived for nothing but rapine and pillage. In 521, an Imperial censor addressed a speech to the throne declaring that the Avars and Turks spent their time in devouring each other and that this was a fortunate circumstance for the Celestial Empire, since the Chinese had nothing to gain from these Altaics, who were, in truth, brutes, formidable in their audacity.

Persia was held in no such estimation among their clans; she

58

was too far from the lands of the Oriental Turks, the most important of the Altaic tribes, and the Tunghuz; the Western Turks who had their camps comparatively near to Iran, only became important at a later date, in the time of the Sassanian kings of the fifth century A.D., while the far more ancient Empire of China was all-powerful in the steppe; moreover, Persian civilization during a thousand years, between the fall of the Achæmenidae and Islam, could not shine in their eyes with such brilliance as was attained by the Middle Kingdom under the rule of the Ch'in, the Han and the T'ang.

XIV

FOR centuries the Altaics, who lived in Central Asia and in Persia, clothed and armed themselves after the fashion of the Celestial Empire; the characteristics of their races, their ethnic types, bring them singularly near to the type of the Northern Chinese, whose blood contains a mixture of many Turkish and Tunghuz elements, and give them a false appearance of being subjects of the Sons of Heaven, which may easily deceive one; so easily that, at the present day, it is possible to mistake Uzbeks from the provinces of Bokhara and Samarkand for Northern Chinese. Even now, on the roads of Southern Persia, in the suburbs of Yazd, are living populations which preserve the Mongolic type of the Altaics who overran Persia.

These circumstances give the paintings in which they are represented by Persian artists a deceptive appearance of being Chinese pictures; this illusion vanishes if their type is compared with that of the Southern Chinese, from a part where there was no such influx of elements from Central Asia, identical with or closely resembling those which appear in Persian illuminations from the twelfth to the sixteenth century, which might make a careless observer think that they have another ethnic quality than their compatriots who live to the north of the Yellow River.

And this appearance is still more fallacious in the pictures painted at Bokhara for the princes of the Uzbeks than in the paintings executed at Tabriz under the reigns of the Mongols, two and a half centuries earlier; the Shaibanids and their subjects in the middle of the sixteenth century at Bokhara are Mongols in the same sense as the princes of Persia and their soldiers at Tabriz, about 1310; but the pictures of the Mongol period in Iran in the fourteenth century appear in a setting which is still that of the Mesopotamian paintings, in a technique derived from the workshops on the banks of the Tigris and the Euphrates, in a range of colouring whose fundamental elements are those of the artists of Kufa, Baghdad and Jerusalem, with the addition of subtleties which the painters of Tabriz borrowed from Western technique. This technique had much changed about 1540. The Mesopotamian methods, if they were still the foundation of the style

60

of Persian illuminators, if they formed the base of its technique, were no longer directly perceptible in a style which had become refined and which had substituted for the broad, rather hasty touches of the masters of 1310, a fine-pointed brushwork made up of minute touches and subtleties, the very antipodes of their manner.

We find this intrusion of Turkish and Tunghuz types, of Chinese arms, utensils and equipment, in all Iranian paintings from 1150 to 1550, in the periods when Persia was living under the yoke of the Turks and the Mongols; the horsemen who pass by in the pictures of a History by Tabari (about 1230) and in those of the Arab version of the History of the Mongols (about 1310), wear cuirasses with over-lapping scales and iron helmets with vast neck-pieces and carry long lances which make them resemble the fighting Samurai in the paintings of the Land of the Rising Sun (Plates LVII, LVIII); Turkish and Mongol soldiers of the thirteenth century, like the Japanese in the twelfth, wore the equipment they had borrowed from the T'ang horsemen of the tenth century, and religiously preserved these obso-lete forms—just as bygone fashions of the Court are followed for an indefinite time in the provinces—which had served their turn in the Celestial Empire and were looked upon as antiquated lumber.

These fashions of the Far East could not fail to develop in Iran; they were already well modified in 1310, as we can see from the illumin-ations in the Persian History of the Mongols, by Rashid ad-Din (Plates LXII, LXV); the equipment of the Mongol army in the reign of Öljaitu scarcely resembles any more that of the horsemen of Chingiz: the cuirass of overlapping scales had disappeared after the time of Abagha, for we still find it in the paintings of the History of the Conqueror of the World which were copied in 1438, obviously from the original manuscript which dated from 1260 (Plate XCIV); the pictures in the Arab translation of the History of the Mongols, represent the first manner, the ancient fashions of the beginning of the thirteenth cen-tury, those of the Persian original the fashions of 1310, eighty years later. In the fifteenth century, the Timurids, who came direct from Central Asia and whose princes had always shown themselves faith-ful followers of the Mongol tradition, far more so than the Mongol sovereigns of Persia, re-imported these fashions into Iran, and the cuirass with overlapping scales reappeared in 1436, in the paintings of the Apocalypse of Muhammad, executed at Herat, which was then the capital of the dominions of the family of Tamerlane (Plates LXXX–LXXXVII); but under the rule of these princes these fashions underwent the same rapid evolutions as in Persia in the reign of the Mongols; it was completed in 1480 with Sultan Hosain Mirza, and the Turks

61

who served in the armies of the Safavid kings had completely forgotten these fashions when Shah Isma'il came to the throne of Iran.

China, at this period, was very far from Persia ; the political ties which had bound Iran to the Celestial Empire from the thirteenth to the fifteenth century, under the reign of the Mongols and in the Timurid period, had definitely ceased to exist, and under the rule of Shah Abbas, at the beginning of the seventeenth century, the Emperor Shên Tsung at Peking would never have thought of claiming the suzerainty over the Kingdom of Persia as Ch'êng Tsu had done from Shah Rukh at the beginning of the fifteenth. But commercial and artistic relations between the Safavid Kingdom and China lasted and became so close that, in the end of the sixteenth and at the beginning of the seventeenth century, Ispahan was seized with an access of Chinomania such as had never been known at Tabriz or at Sultaniyya under the Mongols, or at Herat among the descendants of Timur ; the Court ladies appeared at masked balls dressed as Chinese women who had forgotten to set the pins in their black hair; the Persian artists, out of snobbery, amused themselves by imitating the technique of Chinese paintings of the eleventh and twelfth centuries and by copying drawings executed by artists on the banks of the Yellow River and the Yang-tse Kiang.

This fashion, between 1570 and 1610, in the hands of Agha Riza and of Wali Jan gave birth to incomparable masterpieces whose manner disappeared immediately after these artists, when this craze had ended ; the first symptoms appear in the early years of the fifteenth century, in the works of artists living at Herat, during the reigns of Tamerlane's first descendants, but it was only at the end of the sixteenth and the beginning of the seventeenth century that this fashion became the rage and was run to death in Iran, that the technique of drawing without colour, or almost without colour, is sharply opposed to the pictorial style. This technique, which pleased the Chinese of the Middle Ages, was contrary to Persian taste and could not continue to exist in their kingdom ; twice, in the tenth century and in the fifteenth, the norms of the art of the Celestial Empire had entered Iranian territory, and their existence there had been still more ephemeral ; in the year 943, Chinese artists, who had come to Bokhara with an Imperial Embassy and had illuminated with their pictures, pale in tints and delicate in gradations, the masterpiece which Rudagi wrote in Persian verse, his translation of the Fables of Bidpai ; and about 1437, when a Persian artist at Samarkand illuminated the splendid drawings of a Treatise on Astronomy, executed

62

for the Prince of Transoxiana; this style, illustrated by Agha Riza, Sadik and Wali Jan, died out in Iran in the sixteenth century, as it had done in the fifteenth and in the tenth, and left no traces behind it; we should look in vain for a fugitive trace of it beyond the Great River and in the provinces of Persia.

In 943, at Bokhara, at a time when, under the sceptre of Musulman princes, no artistic formula could flourish and Chinese methods seemed miraculous, the subjects of the Samanid Amir gave to painting the name Kar-i-Chini, 'Chinese work.'

This description, this name with the Homeric epithet of 'Chinese,' has lasted through a thousand years in reference to the painting of later ages, while the paintings of manuscripts illuminated in Iran were being decorated by Persians in a style uninfluenced by that of the Celestial Empire, which is essentially opposed to that of the Chinese artists; it has found remarkable confirmation, but unreal and fallacious, in the Far Eastern appearance of the types and figures which animate Persian paintings in the reign of the Turkish princes and the Mongol sovereigns, and even during the rage for the exotic in the reign of Shah Abbas the Great; this error may be excused in Persian authors who never saw a Chinese painting and would have found it difficult to say where China was, who repeat an epithet without understanding; it is unpardonable in the criticism of European theorists; from this point of view the Western scholars, the Orientalists, are far better equipped than the Iranians, although examples of the ancient technique of the Celestial Empire are very rare. The divergences which separate the Chinese manner from the style and methods of Persia in the twelfth and until the beginning of the fourteenth century, are absolute, radical and irreconcilable. Chinese technique consists of a drawing scarcely coloured, or a cameo on a dark background; Persian technique has a style rich in its colouring, clear and brilliant in its tints; the drawing is the essential fundamental part of the Chinese manner; it does not count with the artists of Mesopotamia and not much with Persian painters.

These differences are essential, they become more marked as we go down the ages; the Persian palette grows brilliant after about 1300, or even a little earlier, and the gold background appears in Iranian technique at the same time as the profusion of gold in the ornaments; this brilliant style reaches its height at the end of the fifteenth and the beginning of the sixteenth century. Chinese painting also brightens in the first years of the fourteenth century, it loses its monochrome character which had remained its absolute and formal characteristic up to about 1300, and this under the constant

63

influence of Persian pictures of the Mongol period which were transported into the studios of the Celestial Empire where they were copied; but even then Chinese painting still preserves that sombre atmosphere, that dark tonality bequeathed to it by the technique of the Middle Ages. The painters of China have handed this on to the artists in Japan who painted the great pictures on silk adorning the temples of the islands of the Rising Sun; we should look in vain among the pictures executed on the banks of the Hoang-ho for the appearance of one of those gold backgrounds which are the glory and the lustre of the paintings of the School of Bihzad from 1480 to 1550.

ALTHOUGH it covers the immense spaces which lie between the frontiers of Persia and the Celestial Empire, Central Asia has played but the smallest part in the artistic destinies of Iran, far smaller even than that played by China; never, at any period in the history of the world, neither in ancient times, nor in the Middle Ages, nor in modern days, has any independent, autonomous formula, whether artistic, literary, religious or political, existed in the steppes which stretch from the frontiers of the Celestial Empire to the Oxus and the Ural, from the Himalaya mountains to the shores of the Arctic Sea, among the hordes who inhabited its immensities, the Altaic clans and the Aryan tribes : whether they were Turks, Tunghuz, or Indo-Europeans, these tribes were composed of inferior ethnic elements, incapable of rising to the stage of civilization attained by China and India, and who were obliged to turn to the surrounding empires for everything that went beyond the most material needs of rudimentary life. The Turks and the Tunghuz led a savage life in these deserts, with their magicians who took the place of priests, of soothsayers, of doctors, very much like the clans of the Neolithic period and the Lapps ; the Aryans, the Italo-Celts, the Germanic peoples were living intermixed with the Altaics, who inspired them with a deep sense of terror ; they looked on them as a race of magicians ; they inhabited the towns while the Altaics roamed the steppes far and wide, carrying their conical felt tents on immense wagons, driving their herds before them. In the end their example civilized these nomads to some small degree; they built towns, not to live in them, but in order to be like their neighbours of the Celestial Empire ; cities were for them a superfluous luxury, they never understood their use and were uneasy when they were in them ; even the Celts and the Germans in Europe had no love for cities ; the great majority of the Turks continued to camp at the foot of their walls and to wander in the desert. Chinese historians tell us that, in 916, the Khan of the Khitan took as his intimate adviser an Ambassador, Han Yen-hui, who had been sent him by the sovereign of China and whose intelligence had been pointed out to him by his wife. This Chinese taught the Khitan, who were entirely ignorant of

5

such things, how to build houses and to live in them as separate families, instead of living in unclean promiscuity in their tents on the steppe; he taught them how to group their houses so as to make cities; to cultivate the earth and live on its harvests; that is to say, he took them out of the savage and barbarous life which was still, more or less, that of all the Altaics. It was not till a hundred years later, in 1007, that the Khitan built themselves a capital on the sources of the River Liao, in imitation of the Celestial monarchy; Chingiz Khan and his Mongols had no metropolis, but wandered in the steppes; it was his son, Ogotai who, in 1235, built walls round the site of Karakorum on the banks of the Orkhon, among the ruins of the camp of the Turkish Prince Bilgä Khan, who had ruled over these countries in the eighth century. And this Mongol capital was of a mean enough type, for the Chinese authors tell us in their chronicles, that its perimeter was no more than five li (about three kilometres), which means that there were not even a thousand metres in its greatest width; and this is confirmed by the assertion of the Cordelier, William of Ruysbroeck, who has written in his account of his travels that Karakorum was no larger than the borough of St. Denis at the gates of Paris, built round the Gothic basilica where the ancestors of St. Louis slept. The princes of the Mongols when they had conquered Persia, the Turks of Tamerlane when they had quitted the deserts of Central Asia to come and reign in Iran, did not inhabit the Persian towns, which would have been far too small to hold the crowd of their followers and their guards; like true descendants of those nomads who, in ancient times, prowled by the side of the Great Wall, they pitched their tents in the country under the ramparts of their cities and lived in this way surrounded by their wandering subjects, abandoning the enclosed towns to the Persians, artisans and traders.

The Aryans, who lived, scattered, in the midst of the Altaics, formed the intelligent element of Central Asia; their intellectual development was never comparable to that of the Hellenes, but Greek civilization, the miracle of Hellenism, is a mysterious and inexplicable exception. Both in Asia and in Europe all clans of Aryans were wholly inferior to the Greeks and the Hindus; in Europe they lived exclusively on what they borrowed from Hellenism; Rome stole from Athens without a gleam of originality, in all provinces of life, in art, in philosophy, in science, in literature, so that Lucan is perhaps more Roman than Virgil. The Celts copied Rome,[1] the Germans, Rome, and the Latin civilizations derived from it, except with regard to Common Law.

[1] It was not Aristotle but Aristocles, an obscure rhetorician of the second century,

66

MUSULMAN PAINTING

Central Asia from the year 120 B.C. to A.D. 750 was under the sway of the Chinese Empire; the influence of the Celestial Empire had been operative there long before this time and lasted till well after the eighth century A.D.; it was all-powerful from the thirteenth to the sixteenth centuries. The religious beliefs of these peoples were as rudimentary as their civilization; the Altaics had borrowed from China the popular cult of the Celestial Empire, composed of magic and sorcery; the Aryan clans had borrowed from Persia an elementary Zoroastrianism; these peoples were influenced in turn by all the religions which succeeded each other in Asia, by Buddhism, by Manichaeism, by Nestorianism, and finally by Islam, which slowly filtered into Central Asia and in the end prevailed over the other religions; these beliefs, as adapted to the populations of these countries, existed among them in a very limited form, as is shown by the books which have been found.

It was otherwise with Buddhism, which flourished in these regions : it is indisputable that it met with special favour among these Barbarians, as if it corresponded better with the mysteries of their idiosyncrasies and satisfied their mentality better than Mazdaism or Christianity; as if they rediscovered within it something which seemed to them the echo of some far-off tradition, born among their clans under the inclement skies of Central Asia, a blurred memory of thoughts and concepts which had existed in the imagination of their ancestors. The complexities of Hindu Buddhism, the improbabilities, the exaggerations, the impossibilities in which it abounds and which seem to defy common sense, were, in the Middle Ages, incorporated into the heroic legend of the Mongols to form a singular sort of epic, full of strange marvels, which recalls the wild character of the Brahmanic Chanson de Geste, the Ramayana, and the Mahabharata; its nature is well known in the West, since Schmidt, in 1839, translated into German one of its most characteristic episodes, the extraordinary history, even more extraordinary than Pulci's Morgante Maggiore, of Boghdo Geser Khan, one of the very rare Mongolian books that a learned interpretation has offered to our time in a European idiom.

Buddhism in India stirred up hostile feelings against the privileged classes; its reforms, like those of Protestantism and of the Jansenism

who said that the Greeks had borrowed their philosophy from the Barbarians; that philosophy had been born before Greek times among the Persian Magi, the Babylonians, the Gymnosophists of India, among the Semnothees or Druids of the Celts and the Gauls, and that the Greeks had learnt it from them. Aristotle never wrote a treatise on magic; he would never have uttered such a heresy as to say that the Magi of Persia were the predecessors of the Egyptian sages, as Aristocles has done.

that followed Protestantism, preached equality and tended to Republicanism; its ideas were absolutely foreign to the Hindu spirit of the sixth century B.C.; Brahmanism was repelled by them, for they menaced its existence; it despised them as an invention of the Barbarians, and waged on them a deadly war. It is possible that Sakyamuni, 'the ascetic of the Saka race,' belonged to the clans of Western Turks who, at that date, were camping in Central Asia to the north of Hindustan, and to whom the Achaemenidae kings, who included them among their subjects, gave the name of Saka. The Turks in every period aspired to leave the aridity of their steppes in order to command nations who lived in a less harsh climate, whose sole ideal and only way of life were not massacre and pillage, who would allow themselves to be conquered by the Turkish warriors and would abandon the profession of arms to them. These Turks, on the west of China, lived in the poorest conditions; they knew nothing of social conventions; they set the highest value on a horse, a bow, and liberty; so much so that, for centuries, in their clans as among the Germanic people, almost nothing distinguished the chief from the soldier; even in modern times the Padishah of Stamboul, the Shadow of God on earth, astounded the Western people by his simplicity; on receiving the information from a red-turbaned odalisque, he was obliged to leave his harem in order to go personally to fight outbreaks of fire which had taken place in his capital; obviously the impersonal and powerless deities of Buddhism are conceived far more according to the spirit of Turkish warriors, like the Altaic genii, than according to the Theodicy of Aryan nations, worshippers of creating and powerful gods.

The kings of the Saka who, in the second century B.C., destroyed the Greek Empire of Bactriana and created the Indo-Scythian State, embraced the Buddhist faith with enthusiasm, and it was among the Turks of Central Asia that it found the securest refuge that it ever knew in those days when it was forced to give way before the persecutions of the Vishnuites. It was the Huns, who were Turks and related to the Sakas, who, at the beginning of the fourth century of the Christian era, gave an official position to Buddhism in China and created Chinese Buddhism in the kingdom they had founded in the North, beyond the Yellow River, a kingdom whose legal existence the historians of the Celestial Empire rightly refuse to recognize. After the year 65, when the religion of Sakyamuni entered the land of Han by the highways of Central Asia, Buddhism made no progress among the Chinese people, who abhorred it as an invention of the foreign Barbarians; its doctrines were preached solely by Hindu priests or by the bonzes of Central Asia, for whom

the Chinese felt complete contempt. It happened, about the year 333, that the King of the Huns magnificently entertained one of these Hindu bonzes, Buddhajanga, to whom he was under obligations; the honours paid to him, the deference shown him by the sovereign, made a great impression on the Chinese who lived in the kingdom of the Huns; they began to believe, at any rate some of them, the least educated ones, in the virtues of his doctrine, so much so that the Hindu priests were able to train Chinese bonzes who made converts among the people, a thing which had never yet happened. In the thirteenth and fourteenth centuries the Mongols, who were also foreigners despised and hated by the Chinese, tried to bring about a revival of Buddhism; the attempt was a failure; Buddhist preaching was not more successful, and made no fresh converts in these times; they were broken by the hostility of a people whose spirit was Taoist, while the scholars had, with reason, always clung to the Confucian doctrine.

XVI

ALL the books of the Buddhist Sanskrit Canon were brought up into the steppes of Central Asia from the distant frontier of Persia, on the more western borders of the Chinese Empire ; but this expansion of Buddhism did not answer to the needs of its inhabitants and was in no sense their work ; only a few learned men allowed themselves the expensive luxury of studying its legends, literature and philosophy, its *abhidharma*, an intricate task for their intellects ; the Buddhism in current use as an every-day religion among the Turks and the Tunghuz never attained a development superior to that of Iranism, Manichaeism or Nestorianism, which had been introduced among them, or to that of Islam in the eighteenth century.

These religious forms came to Central Asia from Persia, and after a certain period they met with persecution in Iran, so much so that their followers were forced to take refuge in the plains of the Tarim ; but however violent the proscriptions were, they in no way prevented the spread of Manichaeism through the Roman Empire or made it impossible for Zoroastrians or Nestorians to live under the Musulman yoke.

Buddhism, on the other hand, with all its literature, took refuge in Central Asia as the only asylum open to it and had no hope of return, all other roads being closed to it by the persecution of the Vishnuites ; the Buddhist religion entered China in A.D. 65, but it met with such alternations of favour and disfavour that the faithful lost all feeling of security ; moreover, after the seventh century, it was ruthlessly expelled from Iran, where it had spread itself at the same time as in the plains of Central Asia.

The Hindus and the Chinese made a few disciples in these countries among the Altaics and the Aryans, who translated part of the Buddhist scriptures into their languages ; but this was exceptional, and there is no complete translation of the whole Canon into Turk or into the Indo-European dialects of Central Asia ; this would have been far beyond the needs of these peoples. It is quite certain that there existed in these countries only one living body of rule, that which consisted in the Chinese version of the works of the Buddhist

Canon : that tradition was Sino-Indian ; these translations were commissioned by the Chinese who had them made within the Chinese Empire by Hindu scholars, natives of the real India, men from Gandhara, the land of the Sakas, from the ancient Greek Empire of Bactriana, from the Indo-Greek kingdoms, from Persia, by scholars who had been born in the Aryan cities of Central Asia and who had studied the Chinese tradition, after the beginning of the fourth century by a small number of Chinese scholars. The Chinese showed no very great inclination for this work, which demanded a perfect knowledge of one of the most complex idioms in the world, with conjugations which must have seemed an impenetrable jungle to a people with whom the verb is invariable ; they were far outnumbered by the Aryans of the 'Western lands' of Central Asia, who gave themselves with fervour to the apostolate ; for example, at the end of the fourth and beginning of the fifth century such a man as the celebrated Kumarajiva, the son of a Hindu bonze, Kumarayana, who had married the daughter of the King of Khotan after having been the minister of an Indian Rajah. It is certain that the best of these Aryan translators profited by the instruction they had from their teachers and that they knew Chinese and Sanskrit well, a most difficult thing : they were good executants but could not create ; they translated the thought of the Master but added nothing to the commentaries with which the piety of his disciples had surrounded it, any more than Cicero added anything to the thought of Plato ; they stopped at the letter of the teaching ; we often wonder if they understood the spirit. These Hindus, these Chinese and their pupils were always incapable of impressing their personality on their work ; we find this inferiority again among the Western Turks who came to rule over Persia, the Balkans and Hindustan ; we must also count as Turkish writers the Aryans of Central Asia, who lost their language and their nationality when they became Moslems.

The Mongol version of the Tibetan translation of the Buddhist books, made between the thirteenth and the fifteenth centuries in the convents and lamasseries, is far from proving that the peoples of Central Asia in the Middle Ages ever felt the need of understanding Buddhist thought in its integrity ; this Mongol translation is an artificial thing, made by the orders of the chiefs of the house of Chingiz Khan, when they had attained to the sovereignty of the Chinese Empire, with very different powers from those of the Kings of the Turks and of the little Aryan towns of Central Asia ; no one, among the Mongols, read these translations.

We must also note that, at a not very distant period, cross-

breeding took place in the steppe between the Altaic tribes and those clans of blue-eyed, red-haired men, the Indo-Europeans of Kutcha and the Ili, the Celts, the Germanic peoples, the Slavs, tribes of whom lived in the steppe closely intermingled with the Turkish and Tunghuz clans; the legends of the Turks in the sixth century—among whom Mokan Khan, who in 553 established the power of his people over the whole of Northern Asia, was a ruddy man with blue eyes,—the legends of the Kirghiz, whom the Chinese, a hundred years later, represent as fair, blue-eyed warriors; the fables told by the Mongols about the origin of the family of Chingiz Khan, all bear witness to the importance of these cross strains which modified the basic type of the Altaic (described so well by Jornandès when he speaks of Attila and his Huns with their black eyes and hair shining like jet), to such an extent that the Conqueror thought it a strange phenomenon when his grandson, Khubilai, the future Emperor of China, came into the world with the characteristics of the race of the Huns in a family every one of which was fair.

The likeness and agreement shown in the traditional legends of these tribes of very different origins, the little we know of the history of these hordes of the Far East, confused memories scattered among the chronicles of the Celestial Empire and of Iran, all show that the Altaic tribes passed their time in a merciless struggle for supremacy in the barren steppes which extend between China and Persia, that they were exterminated in the course of ages, one after the other, and that the survivors intermarried with the Indo-Europeans, who were less exhausted by war and knew better how to ward off its disastrous consequences. We recognize the importance of the insistence with which the chronicles of the Celestial Empire speak of these ruddy, blue-eyed men, when we reflect that the Chinese Protocol in the nineteenth century calls the Dutch the red-haired foreigners; it is the same expression as that used by the historians of the ancient dynasties, at the very end of Antiquity, in the fifth and sixth centuries and in the Formulary of the Rites of the Imperial House of the Tai T'sing; we must conclude from this evidence that these Turks and Kirghiz were the sons of Indo-Europeans, just as the red-haired men of Java and Holland, from the seventeenth to the nineteenth century, are Europeans.

These facts appear most plainly in the Turkish tradition formulated in the beginning of the sixth century; it tells how their race, an offshoot from the Huns, perished utterly, with the exception of one child who was reared by a she-wolf; the wolf hid him in her lair and had ten sons by him, each of which was the ancestor of one of the

72

MUSULMAN PAINTING

Turkish clans; this tradition recalls that of the beginnings of Rome, and must be understood in the same fashion; the ancestor of the Turks was given shelter by a foreign woman, called the She-Wolf from the violence of her passions, just as Romulus and Remus were reared by an Etruscan woman who bore this insulting name. According to another version of the legend, the son of the She-Wolf, who possessed miraculous powers, married the daughters of the Winter God and the Summer God, and one of these sons founded the clan of Turks whose skill in metal-work is celebrated by the Chinese, who had the most precise information with regard to these tribes. It is customary among primitive people to regard as miraculous and superhuman everything that they borrow from foreign races more gifted and more intelligent than themselves, and it is enough to say that the She-Wolf, who was powerful enough to protect the son of the Huns from the attacks of his enemies, like the daughters of the Summer and of the Winter God, were women of a race other than the Turks.

The tribes of the Kirghiz in the same way tell us, in explanation of their name 'the Forty,' that they are the descendants of the loves of a red dog and the daughter of the King of this nation and her waiting-women, the only survivors from the massacre of their people; interpreted in the same way as the Turkish story, this means that the Kirghiz women, after the almost complete destruction of the men of their clan, married Indo-Europeans who, like all Primitives and like themselves, bore the names of animals. The Mongols told the story in their tents, about 1200, that the extermination of their race took place in the seventh century B.C., and that all their tribes were born from a single couple whose descendants, like the Turks, were skilled in the working of iron; the legend of the Mongol woman who was the ancestress of the family of Chingiz Khan repeats the same tribal memories as those of the Turks and the Kirghiz, but with one profound and essential modification, imported into the Altaic tradition from the history of the Virgin Mary and the miraculous birth of Christ, learnt by the Mongols from the Nestorian priests who brought them the Christian religion.

This Aryan strain in the Turks and the Tunghuz explains why the men of this race, who had in their veins that mixture of Aryan and Altaic blood, have been able, on several occasions, to take their place in Western civilization without encountering impossible obstacles, while the greater number of them remained in the stage of barbarism. So, in the fourteenth century in Egypt, at the Court of the Mamluk Sultans of Cairo, a Manchu General, Khitan by origin, could write an excellent and remarkable History of Islamism, in a style of great refine-

ment. Here is the secret of the passionate interest that the Princes descended from Tamerlane in Persia in the fifteenth century, in Hindustan in the sixteenth and seventeenth, felt in literature and scholars, in artists and the arts; these appeals of a distant ancestry explain Shah Rukh, Ulugh Beg, Babur, Akbar, Shah Jahan; and thus it is that those Sultans of Constantinople who stand out above the mediocrity of the Imperial line of the Osmanlis, were always the sons of Christian, Greek, Armenian, Slav women: far from it being the Turks, as has been fantastically claimed, who even before Islam roused the inert mass of Persia, it is the Indo-Europeans of Central Asia who struck from the Altaic clans those flashes of intellect of which, in themselves, they would have been incapable.

XVII

THE clans in Central Asia never possessed a single form of art
born of their own thought; they copied, they imitated, or
let us rather say that, in response to their demands, every
possible or imaginable form created among their neighbours in China,
India and Persia was imported among them, for their use; one
looks in vain among their monuments for the most superficial trace
of any idea that has not been borrowed, and all those which have
been found prove, in the most decisive manner, that all through the
ages, to the most remote times, the Central Asian provinces were
open to the influence of China, which always formed the staple
element in Central Asian culture and civilization. To Chinese
succeeded Hindu influence, that of a Hellenism transformed and
systematized in a spirit which is already the spirit of Byzantium,
whence were introduced the formulas of classic art; and lastly, the
influence of Musulman Persia. Never at any period of their existence
have the peoples who lived in Central Asia, or who came out of it,
the Saljuks in Iran, the Osmanlis at Constantinople, the Great Moguls
at Delhi, done anything but copy their surroundings. The invention
of a ' Scythian ' art, of a ' Sarmatian " and ' Greco-Sarmatian ' art,
supposed to have influenced the art of Ancient China, or been subject
to its influence, is a myth based on objects without style, formless and
of most dubious authenticity, whose origin even no one can tell; a
myth which takes no account of the facts of history or of the history
of art. In the time of Charlemagne, the King of the Avars—who were
Scythians in the sense in which both the Greek historians and modern
writers employ this term—when encamped in Hungary, flaunted him-
self in the middle of a field upon a golden throne which he had stolen
from somewhere on the frontiers of the Greek Empire, unless, indeed
he had had it sent him as a present from the Emperor of Constanti-
nople, from whom he was continually demanding beds of solid gold,
with that love of the yellow metal which characterizes savages; these
Barbarians had the mentality of the negro kings of the coast of Africa,
who wear an Admiral's hat on their head but forget to put on his
trousers.

MUSULMAN PAINTING

At all periods, throughout Antiquity and the Middle Ages, the clans that lived in Central Asia between the borders of Persia and of China, whether they were Altaic or Aryan, borrowed their artistic formulas from the Celestial Empire; from early times to the sixth centuries the introduction into the Takla Makan region, by the South-western roads, of the formularies of Indo-Greek art acquainted them with what seemed a luxury of over-refinement; they did not understand its importance, it exceeded their needs. Indo-European tribes lived mingled with the Turkish or Tunghuz tribes through all Central Asia; Darius, in the fifth century B.C., in his inscriptions, names the Teutons and the Goths among the men of the Far East who regarded themselves as his subjects in the same way as the Scythians; it is thus that the Germanic tribes brought to Europe a singular type of decoration which is only found in Germanic monuments, in the illuminations of Anglo-Saxon manuscripts and on the tomb of King Theodoric at Ravenna. This system of interlacing lines and of decorated circles is peculiar to the art of the South of England and the North-East of France, and is never found in illustrated books among the Germanic people of the Rhine, who were too devoid of inspiration to do anything but copy Byzantine and Roman illuminations without attempting to make any additions of their own. The Anglo-Saxons and the Normans were less circumscribed, and they framed their copies of Greek or Latin paintings in a singular kind of ornamentation which is found in no other civilization and which the Norsemen had brought from the coasts of Jutland and of Scandinavia. It consists of a system of interlacing lines, skilfully entangled, of richly ornamented circles, in very bright colours, and it is certain that it is not derived from the vine foliage motive in Christian art, which developed into quite different forms; the Gospels which were illuminated in the Middle Ages at Canterbury and at Fécamp abound in this decoration; these beautiful books were taken by Christian knights, at the time of the Crusades, into Egypt, where, in the twelfth and thirteenth centuries, their decoration was copied by the Copts, in a debased and bastard form which is derived from the infinitely richer formula of Anglo-Saxon art and which could in no case be the source of it.

This curious decoration preserves the tradition of a Chinese technique found in abundance on the bronze vases which have been discovered in the Western provinces of the Empire and which Chinese archæologists ascribe to the reigns of the Shang and the Yin (1766–1122 B.C.), the Chou (1122–256 B.C.), and the Han (first and second centuries B.C.). These vases were used in the ritual ceremonies of the sacrifices; they are decorated with stylistic drawings of fabulous

animals which confront each other as they do in Sassanian Persian art (third to sixth century A.D.), surrounded by interlacings, spirals and entangled circles : this ornamentation offers so many resemblances to that of the Anglo-Saxon books that it is hard to admit that they are independent of each other, especially as both are completely isolated in the history of the world, and we may note as confirming this fact that, in the decoration of the Lindisfarne Gospels, there is a copy of a motive which is essentially Chinese, that of the circle of the male and female principles. In the decoration of Anglo-Norman books of the Middle Ages we rediscover, on either side of the English Channel, all the mysterious fauna of the Bestiaries of the Celestial Empire which decorated the Imperial robes ; the dragon, the emblem of sovereign power, which figured, twelve times repeated, on the standard of the Chou dynasty, which was embroidered in gold on the parasol of the Son of Heaven, ruler on the earth and the four seas ; the phœnix, that presages felicity and decorated the silken robes of the Empresses.

XVIII

BEFORE Islam, Buddhism had been sovereign in Iran, and its Eastern provinces as far as the desert and the Kohrud mountains were but a continuation of Central Asia ; the Avesta called down curses on them as the home of impiety ; epic legend in the tenth century preserves the very definite record that, in the middle of the second century B.C., the prince of the Nimruz who attempted to check the invasion of the Saka Turks, the Paladin Rustam, was an infidel who did not accept Mazdaism. Indeed, Persian civilization, the Mazdean religion, the Zoroastrian faith, was confined to the extreme West of Iran, to a very narrow zone beside the mountains of Kurdistan. Hindu civilization spread over the Persian land far to the west of the Oxus ; Ghazna, Kabul, Kandahar were Buddhist just as Bactria, Samarkand, Bokhara were ; it is more than obvious that the Indo-Greek sculpture in the north of Hindustan, the Buddhist sculpture in the Sapta Sindhava, in Gandhara, in Iran, in Kapisa, in Bactria, was created by the chisel of Hellenic artists ; that the painting, which is the projecture on a plan of the bas-relief, was born and clothed in graceful forms by their brush ; the frescoes of Bamian with their lissom figures recall the elegance of the dancers painted in the first century on the walls of the Pompeian villas. The execution of these remarkable works may be dated before the middle of the seventh century, for the Moslems certainly put an end to the evolution of artistic forms which, to them, were the worst form of sacrilege ; we should look in vain for the least trace of this grandiose technique in the works of Persian painting ; its norms, its methods are even further removed from the essential principles of the style of the Iranian Primitives. The drawing, the forms, sumptuous, full and supple, the rich and brilliant range of colouring, all these are in absolute opposition to the combination of qualities exhibited by the Persian artists at Ghazna, in the twelfth century, when they illuminated the version of the Fables of Bidpai after Mesopotamian models into which, as we have already seen, they introduced contemporary Hindu themes, essentially different from the Hellenic-Hindu art of Bactriana and of Gandhara. This technique was a foreign style in the provinces of

78

Eastern Persia : it disappeared with the artists who had introduced it when it became impossible for them to remain in this country ; they retired to the lands of Central Asia, beyond Kashgar, at the foot of the Celestial mountains, against which the invasion of the Musulman horsemen had been broken.

The technique and style of the Bamian frescoes are related to those of the mural decorations which were found in Chinese Turkestan, at Khotcho, close to Turfan and at Tun-huang. These represent a more modern evolution under a more complex form of Buddhist art ; their essential differences are due to the fact, easily explained by their geographical position, that the paintings at Bamian are made by artists working in the Greek tradition and copying, in Eastern Iran, classical models, while the paintings of Khotcho and of Tun-huang on the frontier of China are the work of Chinese artists following a Hindu pattern derived from the copy of classical models. The date of these frescoes in Eastern Turkestan is uncertain ; the theory according to which Khotcho was destroyed by the Kirghiz about 840, and consequently everything found there must be earlier than this date, has no foundation in fact. Chinese history tells us, on the contrary, that the Kirghiz at this time destroyed the Empire of the Uighurs on the Orkhon and that the King of the Uighurs took refuge with his subjects seven hundred miles to the south-west to Khotcho, which became the capital of the Kingdom of the Uighurs. Khotcho carried on a peaceful existence under this government, unmarked by any great vicissitudes. It soon ceased to be the administrative centre of the Uighur monarchy, about 1036, when the invasion of the Hsi-hsia forced the King of the Uighurs to transfer his capital further to the north ; Khotcho dropped to the position of a provincial town, which vegetated until the middle of the thirteenth century and after the definite destruction of the Uighur Kingdom by the Mongols was divided between China and the Kingdom of Chagatai ; it was in this state during the Ming and Manchu periods, losing all its importance, which was absorbed by its neighbour, Turfan. All this does not preclude the fact that, for centuries, Buddhists, Manichaeans and Moslems elbowed one another in the streets and made copies in their houses of the books of their sects ; therefore in the fourteenth century, a Manichaean from those distant countries copied a painting from a Persian book dating from about the year 1280, which had been mislaid on the frontiers of the Celestial Empire.

In these conditions it is difficult to admit that all the paintings and, in a general way, all the objects found in this remote city, are earlier than the date at which the King of the Uighurs took refuge

in this town with his government; there seem to be better grounds for a contrary deduction; in any case the Buddhists, from the date at which Khotcho became the capital of the Uighur state, from 840 to 1036, and at later dates, certainly did not cease to set up their religious monuments in their town. It is a curious fact that the Ambassador of the King of Persia who passed this town and Turfan in 1420 has left a record of the existence there of Buddhists, and describes the mural decoration of the convent of Bezeklik which was found and copied at the beginning of the twentieth century by the Prussian Archæological Mission.

The date at which the mural decorations of the grottoes of the Vihara of Tun-huang were painted is also uncertain : it may be that this Buddhist city had been walled up in 1036, when the Tibetan frontier of the Hsi-hsia kingdom was pushed northward in the East of Central Asia, and the King Li-yuan-hao took possession of Sha-chou and all the neighbouring country ; but this circumstance, which moreover is not established, gives us no indication either of the period at which the frescoes were executed nor of their chronology. However, this fact has not the importance we might be tempted to attribute to it, at any rate for the history of Persian painting : if it is impossible to date the paintings discovered in Central Asia because we do not know any Chinese document of indisputable date with which to compare them, the divergences which separate their methods and their technique from the style of the Primitives of Musulman art are of such a character, both as regards the frescoes of Bamian and the paintings of Eastern Turkestan, that it is clear that, from the point of view of drawing, perspective and colour, there is no relation between the productions of Mesopotamian, that is of Musulman art, from the end of the tenth to the beginning of the fourteenth century, and the Buddhist paintings. I have given the reasons for this elsewhere [1] and it is useless to repeat them here ; I will content myself with saying that Buddhist painting constitutes a type of art more learned and far more powerful than the technique of the Musulman Primitives ; in point of richness and flexibility the two arts are not to be compared. Moreover, the illuminations of the Arab books illustrated in Mesopotamia about 990, may be earlier than certain of the frescoes of Central Asia (though we cannot say definitely which), or at least may belong to periods very near each other ; some very fine paintings on silk found at Tun-huang bearing the dates 910, 971, 983 are exactly in the style of mural frescoes, reproducing a

[1] *Les Peintures des Manuscrits orientaux de la Bibliothèque nationale*, 1914–20, pages 197 et ssq.

traditional technique, examples of which it is very difficult to range in chronological order. Hindu, Chinese or Sino-Hindu styles never had any influence on the Musulman painting of the Caliphate (tenth to thirteenth centuries).

XIX

IF we were tempted to admit certain relations between Musulman paintings and works native to the Far East, it would be necessary for us to descend as far as the end of the fifteenth and the beginning of the sixteenth centuries; but there is only a seeming likeness, an unreal connection, due to the fact that Persian drawing grew more refined in the fifteenth century; a closer analysis shows us that, at these dates, it is still essentially different from drawing in Chinese art and in the Buddhist style of Eastern Turkestan; it remains less precise, less clear-cut. Composition in Iranian drawing is less important than colour. Besides, the range of colouring in Persian works in the fifteenth and sixteenth centuries is very different from that of Far-Eastern works; it is richer and more varied than the colouring of painters of the Ming period (fifteenth and sixteenth centuries), which only apportions colour to the figures and to certain parts of their pictures; it has infinitely more sparkle than the colouring of the Buddhist frescoes of Central Asia, most of which are yellow and red, in sombre tones, while the dominant note of Persian painting between 1470 and 1550 is a scale of vivid colour with brilliant blues and greens. There is a likeness again to ancient Japanese painting and to the modern woodcuts of the Land of the Rising Sun, but this is merely a deceptive illusion; Japanese painting is a reproduction of forms born in China, borrowed from the technique of Classical art and from the Buddhist style; the woodcut, in the hands of the best Japanese print-designers is only the simplification of the technique of the picture, with drawing reduced to a minimum, to a conventional scheme.

If we find in Japan, as in China and in Central Asia, forms scientifically studied, elegant drawing, over-nice attitudes which tend to be affected and which recall the precious manner of the Persian School of Herat, it is because it is inevitable that there should be likenesses and parallels between accomplished techniques which, through analogous processes, tend to a like result. We must, however, except certain works of art created at Ispahan, quite at the end of the sixteenth century, by the delicate brush of extremely skilful artists, Sadik, Wali Jan and others whose names are unknown, all disciples of Agha

82

Riza who tried passionately but vainly to outrival Bihzad. These artists exhausted their ingenuity in copying and recopying Chinese drawings on silk of the Celestial Empire which were current in Persia at this time, under the rule of the King Shah Abbas I, a period noted for its passion for works of art from the Middle Kingdom and its craze for everything that came from the countries of the Far East; these artists copied in Ispahan the clean incisiveness of Chinese drawing, but they were far less happy when they wished to imitate the painting of the Celestial Empire, and did not often attempt it. It is quite exceptional to find Persian paintings that are copies of Chinese pictures or conceived in a Chinese technique; the copy of a monochrome drawing demanded only great craftsmanship, which was not beyond the powers of the masters of Ispahan. It is evident that the technique of the Middle Kingdom appeared merely fantastic to men who were used to the bold and vivid tints of Mongol and Timurid paintings; they did not understand it and made no attempts in a genre which did not correspond to their mentality. The charm of this style did, however, tempt an artist who illuminated a copy of the Book of the Kings about the year 1540, the first picture in which is conceived in a pale and discreet technique which is certainly an imitation of that of China.

It is impossible to see how contact could have been established between paintings made in Eastern Turkestan in the eighth or ninth century, pictures executed towards the thirteenth or fourteenth century in the islands of the Rising Sun, and the illuminations of the Persian books of Herat at the end of the fifteenth century; indeed the technique of Chinese drawing influenced Persian style in the reign of Shah Abbas, between 1580 and 1620, for about the lifetime of a generation of artists who copied in Ispahan some of those monochrome drawings which the Chinese execute to perfection, in the treatment of which they show such incomparable mastery. But it must not be thought that this technique had any influence on the quality of the Persian illustrations of Ispahan under the reign of Shah Abbas, for their drawing, with rare exceptions, is bad and slovenly, inferior to that of paintings of 1480–1540, inferior to those of the Mongol period (1260–1310), which were rather summary but accurate, often more accurate than the drawing of the pictures of 1480–1540, under an influence tending to decadence.

The Chinese painters who worked in this fine manner in the towns of Central Asia were driven away by the progress of Islam in these countries, and by the decadence to which this led them, just as Hindu artists had been forced to abandon Eastern Iran before

the Arab Conquest. It was in the first third of the fourteenth century that the King Dharmashri abjured Buddhism, but the followers of Sakyamuni continued to live in Turkestan long after this date— the Ambassador of the King of Persia records their existence at Turfan about 1420, and in 1865 the Moslems of the Altai massacred the Chinese Buddhists of Yarkand and Khotan. They made no pupils, no disciples in Iran or in Central Asia ; there was never any Buddhist art, there was no art at all in the provinces of Turkestan ; artistic formulas were imported from age to age, by Hindu, Chinese or Musulman artists ; they lived while these artists lived and died when they died, or disappeared when the artists returned to their native lands.

We cannot therefore speak of the influence of the art of Central Asia on the methods of Persian painting, since this art consists of nothing but the importation of foreign formulas by foreigners. So it was that Chinese craftsmen came to Karabalghasun about the year 730 to build sumptuous temples to the memory of dead Princes, in the capital of the King of the Turks ; his subjects were incapable of such works. The Chinese architects came, but remained as short a time as possible in this country, whose sovereign was constantly at war with their Emperor ; they made no disciples ; towards the year 1240 Ogotai, the son of Chingiz who lived in those quarters, carried off from Persia and the cities of Transoxiana all the artists, all the craftsmen whom he could find, and they were sent into Mongolia, the ancient domain of the Turks, to work for the Master of the World. This precaution would have been unnecessary if there had existed anywhere between China and the Oxus, any independent or autonomous formulas that the Mongols could have used : not only did none exist, but they could never have existed, since Tamerlane, at the end of the fourteenth century, had the same work to do again. He sent to Samarkand all the art workers he could find in the towns of Persia, Mesopotamia and Syria which he had conquered by force of arms, for example the architect of Ispahan who built in his capital the mausoleum where the princes of his dynasty sleep, or the craftsmen of Damascus who built the royal palace of Samarkand.

Shah Rukh, his son and successor, carried on this old tradition ; it was probably Greek artists from Syria who carved the delicate sculpture of the mausoleums of Kazirgah, near Herat, covered with a network of intertwined flowers, the delicacy of whose forms is combined with a depth of cutting unusual in the technique of the Musulman artists, the wrought columns which the inhabitants of the land declare fell from Heaven, a pretty way of expressing the opinion that no

one in that country had ever been capable of executing such a marvel; in the same sense as when Arab authors always attribute to demons the construction of the marvellous buildings set up through the immensity of the Empire first by the Romans, then by the Byzantines, to mark the overwhelming superiority of Classical technique over the imperfect workmanship of their architects, or as when the Cambodians say that Angkor Thom and Angkor Wat are the work of angels, from which we understand that it was Hindu builders who brought these majestic forms from the Eastern shores of the Peninsula.

In this way there came into existence in Islam the legends of Solomon and of Jamshid King of Persia, who compelled angels and genii to build the gorgeous palaces that sheltered their majesty— the majestic ruins of the immense stone foundations on which Herod's Temple was built by Roman architects, that the Moslems wished to regard as the ruins of the Holy House built by Solomon in honour of his God, and the springing columns of the Apadana of Darius at Persepolis, the work of Greek artists, created this marvellous legend, confirming the inferiority of Oriental craftsmen and proving their knowledge that it was so.

A reading of the Persian chronicles in which the history of the end of the Timurids is told, shows that all the great artists, painters and calligraphists who lived at this period at Herat, on the frontiers of Central Asia, were Persians, who had come to seek their fortune at the Court of the Master of Iran; the Persian historians never speak of the architects and sculptors, who were unknown to them; they speak of painters, calligraphists, illuminators, because these artists practised arts and crafts in direct connection with the art of the book to which they contributed; they are equally silent about foreigners, whom they wished to ignore; but it is certain that the monuments of Herat were the work of Persian architects who repeated formulas well known in Western Iran in the time of the Mongols, and that there were Greeks among them, as is sufficiently shown by the name *erghat*, Greek ἐργάτης, which the Eastern Turks gave to art workers. This tradition is continued among the Safavids in the sixteenth and seventeenth centuries, as is shown by the Western influence that we notice in the paintings in illuminated Persian books of this period, and proved by the fact that a painter named Geraldi, in the service of the King Shah Abbas, decorated the palace of Kazirgah with drawings in gold on a background of azure.

Thus there is no question of the influence of Central Asian art on the formulas and the technique of the Persian Primitives, this art being an imaginary thing; there were artists in those far-off countries

because they came there from India, China, Persia, but there was no art in the Turkish and Mongol steppes, for all the artistic formulas we find there are artificial importations and do not correspond to any real needs, they do not last or live there ; their style is sporadic and essentially transitory, like the technique of the Chinese paintings which, towards the middle of the tenth century, illuminated the Fables of Bidpai at Bokhara, the type of Chinese paintings which were copied by a Persian at Samarkand, about 1437, for the Prince Ulugh Beg, the style of the School of Bihzad which the artists of Herat revived at Bokhara for fifty or sixty years in the beginning of the sixteenth century.

XX

PAINTINGS executed in the Mongol world before the end of the thirteenth century are very rare; the invasion of Chingiz at the beginning of this century, the raid which brought Hulagu before Baghdad, had shaken the world to its foundations; these cataclysms, and especially the fall of the Caliphate, had put an end to the evolution of Islam, which from this moment lost all political orientation or aim and started on its decadence; the effects were even more cruelly felt in the fourteenth century when the exhausted dynasty of the Mongols was submerged in its turn, leaving to its heirs a mere blank for sole legacy. The men who lived in these troubled times had other cares than literary and artistic preoccupations; this explains the restricted number of paintings which can be dated from the beginning of the Mongol period; those we know allow us to say definitely that, about 1290, the style of Persian illuminators consisted in the imitation of Mesopotamian technique and the methods of the studios of Arabian Iraq; this is proved by the methods of painting in the illuminations of a curious copy of the celebrated Treatise on Astrology written in Arabic by Abu Ma'shar al-Balkhi, two of which are reproduced in Plates **XXXII, XXXIII**; the drawing, style and technique are manifestly derived by a schematic simplification, from the methods of the Schools of Baghdad, Kufa and the towns of Syria, and were carried to their highest point a few years earlier in the capital of the Caliph on the banks of the Tigris, in the Arab manuscript of the Assemblies of Hariri whose very curious illustrations are reproduced in Plates **XXIV–XXXI.**

One of the oldest books of the Mongol period, illuminated in the days before the princes descended from Hulagu had become converted to Islamism with Mahmud Ghazan, contains a copy of a History of Chingiz and his Descendants, which was written by 'Ala ad-Din 'Ata Malik al-Juwaÿni, who finished it in the year 1260; this manuscript is dated 8 December, 1290. I have given elsewhere the reasons which lead me to think this book was copied at Tabriz, from the original of the Chronicle of Juwaÿni, for the library of a person celebrated in the political and literary history of Iran, the minister

Rashid ad-Din. Rashid ad-Din had a copy made of the manuscript of the history of Juwaÿni in the same format and dimensions as those of the original, which had been dedicated by the author in 1260 to the Mongol Prince of Iran, and a painter in his pay reproduced the picture on two pages, which was at the beginning of the book. Unfortunately, this composition, one of the most ancient specimens of Persian painting, has been deliberately disfigured by a fanatic Musulman, who effaced the heads of the figures, and even that of the horse of the Mongol sovereign. What remains of this picture shows that, forty years after the Conquest, its characteristics are those of Mesopotamian painting modified by a passing influence, by the norms of Chinese technique; certain parts of the drawing are sharper than Mesopotamian drawing, and the noticeable lowering of the tints of the palette betrays a Chinese influence, as if a Persian artist had ingeniously set himself to imitate the style and manner of the silken pictures painted in the Celestial Empire. But at this date, in the year 1260, in which the original of the Chronicle of Juwaÿni was offered to Prince Hulagu by its author, painting, in the Chinese provinces, consisted of a line-drawing just heightened on its edges with some pale tints scarcely indicated, or to a sort of cameo, a drawing in monochrome, or reduced to very few colours, even fewer than the tints of this composition, in extremely dark tones, essential and fundamental characteristics which were inherited, long centuries after, by the art of Japan; this diminution of colour is found again in the paintings of Rashid's history, about 1310 (Plate XLVIII), in a lower proportion, and it only indicates a flitting fashion which was not destined to last in Persia.

These norms of Persian painting, in the lands of Iran, subject first to the authority of the resident officers whom the Mongol sovereign sent from Karakorum in the West, and then to the sceptre of the princes of his family, are essentially different from the characteristics of paintings executed at the expense and to the orders of Rashid ad-Din in his publishing house, at Tabriz, which, between 1304 and 1318, the date when this establishment was destroyed in a rising, decorate a series of splendid manuscripts, illuminated for the minister, and for the Mongol princes of Persia (Plates XLIV–XLVI, LIX–LXV).

The range of colouring in these pictures is infinitely richer and has a totally different tonality, as different from that of the painting which decorates the manuscript of the chronicle of Juwaÿni, as from that of the artists who, at the beginning of the thirteenth century, were working in the states of the Abbasid Caliph. I am not speaking here of the type and accoutrements of the persons who figure in the

pictures of the Chronicle of Rashid ad-Din, which cannot be found in the illustrations of the 'Assemblies' of Hariri and of the Fables of Bidpai made when the Mongols were still far from Baghdad, when no one in Islam could foresee the fall of the House of Abbas; these heterogeneous elements consist in the portrayal of Tartar soldiers or of details of equipment and furniture which the Tunghuz had brought with them from the steppes where they lived in the neighbourhood of the Celestial Empire; they are superimposed on a setting which is, in technique, the Mesopotamian setting, exactly like that of the Persian paintings of the Fables of Bidpai reproduced in Plate XL, but the colouring, the palette, the gradation of shades have changed under an influence which has enriched them. We must recognize in this tendency the imitation, or rather the influence, of Western paintings, both French and Italian, which the missionaries sent by the Pope, and the Ambassadors of the Kings of France and England, brought to the Mongol States; Christianity hoped to win them as allies against the Moslems and have their help in recovering the Holy Land. This explains how a painter who, in Tabriz, at the beginning of the four-teenth century, was decorating the Arabic version of the Chronicle of Rashid ad-Din, imitated French paintings of the second half of the thirteenth century illuminating a book sent to the master of Iran. The painting of the Mongol period is thus definitely constituted at the beginning of the fourteenth century, in the lands of North-western Persia, through a modification of the technique and the methods of the Schools of Mesopotamia, under the influence of the European manner of the Italian Primitives who illustrated the Bibles and Gospels which the soldiers of Christ brought to Iran to kindle the faith of the Tartar Princes or to convert them; from the painting of the Mongol period in the type and manner fixed by the artists of Tabriz about 1310, is derived, through a series of successive stages, the whole evolution of Persian painting up to the day when its destiny was accomplished and it sank to mediocrity and decay.

Although Mesopotamian technique was inspired by the methods of the Late Empire, we almost never find in the pictures which illuminate Musulman books from the middle of the twelfth century to about halfway through the fourteenth, a background of gold analogous to that which lights up the illuminations of Greek manuscripts and which sheds its radiance over Greek mosaics; and this is the proof that Musulman art did not draw directly from the teaching of the schools and studios of Byzantium, that it only knew the Classic methods through the interposition of the Syrians, who had weakened the splendour of the Western style by replacing the glory of the gold

background in frescoes and in the paintings derived from them, by a yellow background, a miserable imitation, or by suppressing it altogether for reasons of strict economy, gold only being preserved in ornaments in the exact proportion in which it appears in Musulman illuminations.

The gold background makes its timid and awkward appearance in Persian technique from 1310 till 1340, at the end of the power of the Mongol dynasty, in the Western Provinces; at that date in Iran it constitutes an innovation, whose origin cannot be explained by the development, the independent and autonomous evolution of the style which grew out of the methods of the Mesopotamian Schools. It can only be explained as being an imitation of the backgrounds of gold which shine with so bright a splendour in the paintings of Western books of the thirteenth century, the works of the Italian Primitives, panels painted in the studios of Florence by masters of the Quattrocento, transported to the East at the very time when the mausoleum of the Sultan Öljaitu at Sultaniyya, in the first half of the fourteenth century, is copying on a reduced scale the gorgeous technique of San Vitale at Ravenna, which is a form born from a combination of elements native to Rome.

This technique of the gold ground remained for long a shy and tentative phenomenon in Iran, while it was a favourite method in the West which clung to the age-long tradition of the gold background in frescoes and mosaic; we feel that it did not correspond to a need of the artists, who made use of it without knowing its origins or understanding its purpose. It took nearly a century for it to spread in Iran; it acquired all its lustre, and only reached its perfection in 1436, a decade or so before the middle of the fifteenth century, in the schools of Khurasan, in East Persia, at Herat, and in the brilliant workshops which prospered with such vitality under their disciples up to the middle of the sixteenth century in the countries of Transoxiana, at Bokhara where the Uzbek princes were reigning. It was a favourite device of Bihzad at Herat and of his pupils, who brought it to absolute perfection in a form which recalls the mastery of the Florentines; they carried it with them to Tabriz, to the Court of the Safavid Prince, Shah Isma'il, King of Persia, and it attained to great splendour in the schools of Western Persia at the hands of Bihzad's pupils and their disciples at Tabriz and at Kazwin; here too it disappeared about the middle of the sixteenth century or was only used by artists very sporadically, when they were copying old pictures.

This technique, in spite of the skill of the masters who devoted themselves to it, answered so little to a natural need of Iranian art

90

that the artists of Transoxiana, at Bokhara, soon made it merely a convenient and expeditious way of squandering gold and used it without any discernment. Persian illuminators, from the middle of the fourteenth century to the first years of the sixteenth, had, in imitation of Western artists and of Italian painters, reserved the background of gold to represent the radiance of the sky under the glow of the setting sun or the first caress of dawn; their disciples, in Transoxiana, towards the middle of the sixteenth century, no longer had before them the Western paintings which had inspired the method of their masters, but only the Persian cartoons; they looked on it as an empty bit of decoration, and so far did they miss its meaning as to let the gold background spread over the ground and to paint the sky blue. This heresy preceded only by a few years the total disappearance of this sumptuous manner; we still find a few examples in the schools of Persia and in Osmanli studios, at the end of the sixteenth and beginning of the seventeenth century, by skilful artists who copy obsolete style; but we should look in vain for any trace of it in the desolate and savage lands of Transoxiana, where no artistic formula ever had a longer life than from fifty to sixty years.

XXI

IN spite of the modifications it underwent during the reign of the Mongol dynasty, notwithstanding the evolution which its style and methods had passed through since about the year 1300, in spite of the influences brought to bear on it, which, indeed, had not affected all the craftsmen, Persian painting, towards the end of the fourteenth century, still exhibited the essential characteristics of Mesopotamian technique, with a brighter range of colouring than that of the artists of Bassora or of Baghdad ; the illuminations of a treatise on the wonders of the world, illuminated in the year 1388, for the Prince Ahmad, son of Uways, sovereign of Irak and of the Azarbaijan (Plates LXVIII–LXXI), offer an excellent example of the stability of Persian technique at the very end of the fourteenth century, in the dawn of the triumph of the House of Tamerlane, in a Royal manuscript of the most sumptuous type.

It is under the reigns of the Princes of the House of Tamerlane, from the last years of the fourteenth century which saw the collapse of the Mongol dynasty, to the beginning of the sixteenth century, that Persian painting reached the climax of its perfection. The Timurid schools carried on the manner and the style of the studios of Tabriz, about 1320, in a more exquisite form and a more sumptuous technique which was, in fact, the method of the workshops of Herat, in Khurasan, in Eastern Iran. The Princes who were descended from Tamerlane went to reign in this distant town, the most remote place in all Persia, on the confines of Central Asia, the frontiers of that land of Chaghatai, the Moghulistan of Persian geographers, where their dynasty had taken its birth, and where their great ancestor, who was to defeat Bayazid the Thunderbolt, had attained to sovereignty; they fled from Persia, which was incomprehensible to them, and wholly unsympathetic, especially the southern provinces, Shiraz and Ispahan, whose torrid climate crushed them, while they found pleasure in the Oriental countries whose harsh skies reminded them of the severe climate of their native land.

It was at Herat, for nearly a century the capital of the Timurid monarchy, till overthrown by the Uzbeks of Transoxiana, only to return

92

in a short while with all Khurasan to the crown of Persia ; it was to these confines of the Iranian world that the Persian artists carried the methods and the norms they had inherited from their predecessors of the Mongol period ; they did not differ appreciably under the reign of Tamerlane (end of the fourteenth century) from the technique of the studios of Tabriz or Baghdad, which were inspired by the Mongol style, or rather which carried it on, in a spirit and under the influence of an evolution whose character and stage of development are typified by the illustrations of the Book of Marvels, copied in 1388 for Ahmad ibn Uways.

The characteristics of the art of the Timurid era, in a first period which extends from the beginning of the fifteenth century, or even from the last years of the fourteenth, up to about 1450, continue to be identical with the norms of the Mongol studios ; the paintings which go back to this period and are almost exactly coeval with the reign of Shah Rukh Bahadur, the son of the Conqueror, are archaistic rather than archaic, richer in their tones, more delicately gradated than the palette of the artists of Tabriz about 1310, and of their successors up to about 1380. The influence of the Italian Primitives may be recognized immediately in the radiance and the gorgeousness of the colouring which, in one of the most beautiful books ever illuminated in the reign of Shah Rukh Bahadur, the Apocalypse of Muhammad, in 1436, in Herat (Plate LXXXIII), recalls the splendour and brilliance of the panels of Fra Angelico ; if the range of colouring of the Khurasan artists was enriched by a new splendour, the type of the drawing remained identical with that of the paintings of the School of Tabriz at the beginning of the fourteenth century ; the personages who figure in the pictures of the Apocalypse of Muhammad, in a fine Book of the Kings illuminated about 1430 (Plates LXXIII–LXXIX) remain the same, wear the identical clothes, take the same postures, use the same gestures and movements as the kings, the warriors, and the ladies who animate the pictures of the History of the Mongols written by Rashid ad-Din, which was illuminated at Tabriz about 1310 (Plates LIX–LXV). This technique was made easier for artists by the circumstance that, from every point of view, the world of the Timurids remained a Mongol world, that they considered themselves the heirs of their cousins the Chingizids, and that up to the middle of the fifteenth century, the Mongol conquests, in spite of a short eclipse under Öljaitu, Abu Sa'id Bahadur Khan, and their unworthy successors, continued to be under Timurid rule. But it is enough to compare the paintings created at Herat by the brush of the artists of Shah Rukh and of Mirza Abu Sa'id Körgen with those of the Mongol period to understand that these works reproduce

like forms, and copy, down to the smallest detail, the paintings of the workshops of Tabriz, in a weakened form; this imitation, this counter-drawing in everything that concerns the art of war, is continued in Persia and in Hindustan, up to half-way through the seventeenth century, when the fashions of the Timurids and their predecessors the Mongols had long been disused and forgotten.

The School of Herat flourished in the capital of the Empire and represented the official form of art at the Court of those powerful monarchs who had gone to reign on the frontiers of the Far East; its norms and its technique perpetuated a powerful, realistic, highly-coloured manner, admirably suited to painting in the grand style, to historical pictures; but this style was not able to express the shades of delicate sentiment, the pleasures of love, the fêtes which were held under the rose garlands, or simply the hours when the prince, casting down the burden of affairs and leaving his crown on a table in the throne room, would take his way into the park of his palace, to sit at the foot of an oak-tree with an elegant lady, to listen to music. The Herat style excelled in the portrayal of battles, in the rendering of hand-to-hand conflicts of cavalry, of the siege of towns, of assaults, of all the things which the Persians of the province of Persia, of Fars, Shiraz, Ispahan, find most horrible and disturbing to their quietude. The province of Persia made for itself an art corresponding to the pacific tendencies of its inhabitants, a much more refined art than that of Herat; it was created by drawing from the same source, but with a different intention. Herat had made the palette of Tabriz more complicated and heightened the brilliance of its tones; the painters of Shiraz did their utmost to lower those tints by melting them into a harmonious scale; they banished the reds that denoted violence, the vivid greens, the black that inspires sadness, while the Timurids used them to excess and obtained such splendid effects; in painting pictures to illustrate the tales in books they were obliged to use the colours which are life-giving, but they knew how to impart to them a sweetness and suavity which we should look for in vain at Herat through all the first period of the Timurid Schools; these, however, took a brilliant revenge in their decoration, in which they never used more than two shades of sky blue on a background of two tones of gold.

Works originating at Shiraz, or in Western Persia generally, during Timurid times are rare; Shiraz and Ispahan during this period were provincial towns under the rule of a prince who was subject to the sovereign of Khurasan; in this troubled period of the fifteenth century, in the midst of the constant wars which were devastating Iran,

MUSULMAN PAINTING

following years in which horror reached such a pitch that, for a whole century, no one had the courage to take a pen and tell the tale, it was only possible for princes to enjoy the luxury of having books illuminated for their library. Princes can always find money for their pleasure, even when their prodigalities have emptied the treasury, but princes are few in number, and their rarity explains the small number of paintings executed in the South-west of Persia; there are, however, enough for it not to be impossible or even difficult for us to obtain an exact idea of this clear and limpid technique which substituted rhythm and elegance, a calm and harmonious tonality, for the harshness of expression in the Mongol style of Tabriz in the fourteenth century. It was born at Shiraz in the hours when Hafiz, in subtle and ideal symbols, sang that divine love which leads to supreme beatitude in Nirvana, where the creature finds extinction and loses the capacity for suffering in the Unity of the Creator.

These two techniques subsisted in complete antithesis when destiny ordained that they should be fused into a single formula which combined the power of Herat with the grace of Shiraz; the painters of Khurasan under the reigns of Shah Rukh Bahadur and of Mirza Abu Sa'id Körgen lived on the norms they had brought to Eastern Iran and developed them there for half a century; they repeated the same things in the same formulas, copied over and over the clichés of the Mongol Schools till their invention failed and became exhausted. There came a moment at the end of the sovereignty of Mirza Abu Sa'id when they had used up all their means and saw themselves condemned to impotence, unless they wished to repeat the same themes indefinitely and work on the same old motives to all eternity; they looked round for new elements which would permit them to renew their methods and to refresh their imagination: Khurasan, Eastern Iran, had been from the earliest times a forbidding and wild country, almost as inhospitable to art and artists as the Chaghatai, whence their masters had come. It was only with difficulty that, in the centuries before Islam, the Hindu missionaries who had climbed up there from the Land of the Seven Rivers, had introduced the themes of Indo-Greek art which clothed the strange forms born from the restless spirit of the Vishnuites and the followers of Sakyamuni, in the serene majesty of Attic style. The Hindus had colonized these far-off countries as far as Bactria on the Turkish side, and Marakanda on the side of the Celestial Empire, but the natives had remained completely indifferent to the artistic forms flourishing in Gandhara, in Kapisa, in Bactriana, in Sogdiana; no sooner had Islam driven out the Buddhists, than the Iranians of Khurasan only remember that

95

those men, who tried to bring them civilization, worshipped the Devil and were cursed.

The painters of Herat turned to the West, whence they had come fifty years before, whence they had brought the splendour of the methods of the Schools of Tabriz; Tabriz had been abandoned for Sultaniyya, through a caprice of Öljaitu and was, at this time, a mere provincial town, without political importance, since the day when the mob had risen in insurrection and burnt the publishing house of Rashid ad-Din, without artistic importance either. It regained importance to some degree when the Turkomans had destroyed the power of the Timurids in Western Persia, and when these Barbarians had become sufficiently powerful to possess a Court where the artists of Herat, painters, calligraphists and poets, resorted when they had ceased to please the Prince of Khurasan or when they ceased to please themselves in the capital of this monarch. But the style of Tabriz, at that date, did not differ appreciably from that of Shiraz; the two techniques offered two scarcely different aspects of the style of the schools which, at the end of the thirteenth and the beginning of the fourteenth century, had flourished in this capital of the Mongols, which was only to recover its importance, whether political or artistic, for a few years at the beginning of the sixteenth century, when the fall of the Timurids made the Safavid princes in their capital of Tabriz the masters of Iran.

Baghdad had no formulas of its own and repeated those of Shiraz; it was to Shiraz that artists turned for fresh inspiration from the traditional sources, and up to the neighbourhood of 1485 the blue and gold colour scheme of South-west Persia in all its harmony, illuminates the luxurious manuscripts of Khurasan, while its elegant and supple style softens the severity of the forms of the earlier Timurid era.

Bihzad inaugurated the second period of the Timurid studios; he created its norms and its style; he invented nothing and it is probable that he was not the first to conceive the notion of fusing the methods of Herat and the style of Shiraz; such fusions come about of themselves by the force of nature and as an inevitable necessity; it is as if they were the work of a race rather than an individual, though the credit of it goes, no one knows why, to some remarkable personality who never dreamt of it and who would probably have been greatly astonished at being credited with so fine an invention. It seems most likely that Bihzad was an incomparable virtuoso, gifted with exceptional talent and marvellously skilful; he codified the norms of the new school and, if we are to believe the witness of a critic who

96

lived at the Court of the Timurid Emperors, the part he played was limited to this, for the formulas that became his, which he brought to perfection and in which his pupils gloried, had already an integral existence at the time of the sovereignty of Tamerlane, and it was their perfection which constituted the technique of Shiraz in the fifteenth century.

The works of the School of Bihzad are the glory of the reign of the Sultan Hosain Mirza, with whom, in the very early years of the sixteenth century, the Timurid monarchy disappeared, though an offshoot from it, Babur Mirza, was to found an empire that lasted till 1865. Bihzad as painter, Sultan Ali as calligraphist, were the two leaders of Persian art at the Court of this Turkish prince, who was a master of style, who wrote charming verse, and was an excellent general; but all his political qualities, all his practical gifts, could not save him from ruin. This descendant of Tamerlane who, like Chingiz, had come to Iran only to plunder it, experienced the strange destiny of presiding at once over the decline of his family, and the literary, artistic and political decadence of Persia; his genuine and solid qualities deserved a better fate.

The Mongols, descendants of Chingiz through Chuchi, who lived in the steppes of Siberia and in the plains of South Russia, had seen with vexation the princes of the House of Tamerlane take possession of all that Iranian country which had been the object of their covetous thoughts and which they had tried to conquer in the two latter centuries; the weakening of the Timurid monarchy, which had been forced to cede the Western provinces of Persia, first to the Turkomans and then to the Safavids, the anarchical rivalries among the princes descended from Tamerlane, allowed them to take the offensive against an empire which, at the beginning of the fifteenth century, stretched from the frontiers of China to the shores of the Ægean Sea. In 1505, the Khan of the Uzbeks, Muhammad Shaibani, entered Khurasan; in 1507 he defeated the army of the Timurid princes; they realized that their part was played out in Iran and that the days of their sovereignty were at an end; Badi az-Zaman Mirza, son of Sultan Hosain Mirza, fled to Tabriz and took refuge with his brother-in-law, Shah Isma'il I, King of Persia, while Babur Mirza evacuated Transoxiana to descend on Kabul (1501) whence he passed into the north of India and conquered it. Badi az-Zaman took with him the official artists of his Court, who carried out in Herat the splendours of the Bihzadian methods; Bihzad, the head of the School, remained in Herat till Shah Isma'il conquered Khurasan and took him to Tabriz, where he offered him a welcome worthy of his talents and, in 1522, appointed him

7

President of the Academy of Painting, a position which, after the king's death, procured for him the honour of giving lessons to his son, Shah Tahmasp, and of teaching him the secrets of illuminating manuscripts, up to his death, which occurred in 1533 or 1534.

Others, less fortunate, stayed at Herat, which had lost its rank as capital, but still remained an important town, and continued to work for the amateurs who had remained in Khurasan; others followed or were made to follow the victorious Uzbeks, beyond the Oxus, and went to exercise their talents at Bokhara, where these barbarians reigned and there kept alive the excellence and majesty of the formulas codified by Bihzad, up to a date rather beyond the middle of the sixteenth century. Painters grounded in the study of this sumptuous manner had followed the fortunes of Babur Mirza, and the skill of their pupils, in the second half of the sixteenth century, under Humayun and Akbar, created the magnificence of the Indo-Persian studios of Delhi. The Bihzadian technique created masterpieces beyond the Oxus, in the capital of the Uzbek princes, who hardly appreciated its splendour; the paintings executed at Bokhara to illuminate the books of their libraries (Plates CX–CXVIII) are the most exquisite and delicate which ever came from the brush of Persian artists; it is a remarkable fact that the style of the Schools of Herat should reach its zenith after the fall of the Empire of Khurasan, where it sprang up; at Bokhara about 1520, at Herat in 1526, when this fortified city was made part of the domains of the King of Persia (Plates CXXI–CXXV), at Tabriz, about 1540, as may be seen in the splendid paintings of two books illuminated for Shah Tahmasp, the son of Shah Isma'il, a Book of the Kings and a collection of the Poems of Nizami (Plates CXXVI, CXXVII). The schools of painting underwent a rapid decadence in Transoxiana, as is shown by the illustrations of books which were copied by the best calligraphists of Iran, for the Kings of that country; the technique rapidly deteriorated in the hands of the successors of the artists, who had exiled themselves to Bokhara at the beginning of the sixteenth century; the tradition dies abruptly a little after 1567, never to be revived in these barbarous countries which have always been, always will be, refractory to all civilization.

XXII

THE traditional methods of the Herat studios had a happier fate at the Persian Court, first at Tabriz, then at Kazwin, under the sceptre of princes of the Safavid dynasty ; in Western Persia the ground was more favourable and propitious for artistic evolution than at Bokhara, or even at Herat ; Persia, at all times from the tenth century, had enjoyed a marvellous literary efflorescence. Doubtless the poets in 1500 were not the equals of Anwari, Firdawsi, Khaqani, but it is no less true that Persian letters were still to produce masterpieces, and the excellence of the Iranian formulas showed itself in all domains of technique. The methods of the Bihzadian studios found at Tabriz and Kazwin a sumptuous technique, very delicate, very decorative, which amply sufficed for Persian needs and which sprang from the manner of Shiraz, or rather which was, purely and simply, the style of South-west Iran, derived from the technique of Tabriz at the beginning of the fourteenth century. Its forms were rich, supple and elegant, but it was a different richness, a different suppleness, a different elegance from that of the norms of Bihzad ; a picture decorating a little manuscript illuminated in 1543, in which we find medical prescriptions, impudently attributed to Aristotle (Plate CXXIX), gives an excellent idea of the delicacy of this sumptuous manner which was in the spirit of Iran in the sixteenth century and was to become, at the beginning of the seventeenth century, in a decadent and altogether too luxuriant line form, the favourite fashion of the reign of Shah Abbas I.

The fusion of the style of Western Persia and the methods of Herat created a new genre, which owed its grace and its delicacy to the formulas of Shiraz, its grandeur and power to the Bihzadian influence. The formulas of Shiraz lacked largeness, the artists who employed them were miniaturists who tended to forget the technique of the fresco ; we can see that Bihzad and his disciples at Herat had always the memory of mural decoration behind the illumination and that they preserved on the pages of their books the broad and masterly design of the paintings which spread over the wide spaces of the walls of royal palaces ; elsewhere Bihzad had been a fresco painter, as we can see from illustrations in a book which was copied for Akbar in the

beginning of his reign, for these pictures reproduce mural decorations executed by Bihzad at Herat. Examples of this gorgeous manner are not very rare; they all belong to the first part of the reign of Shah Tahmasp, and reproductions will be found in Plates CXXI–CXXVII, CXXXIV, CXXXV, of a few of these beautiful paintings, with their warm suffusion of colour evoking the memory of the glowing style of the works of Tintoretto.

Its perfection was confined to the magnificence of the royal books; only kings and sultans could afford themselves the enormous luxury of a fully illuminated Book of the Kings, a whole Nizami of such splendour. The princes of Herat were crazy in their passion for art, they gratified it at the expense of the treasury; the Sultans of Bokhara were absolutely indifferent to matters of art, but they encouraged artists in order to ape the Timurids and to make themselves pass for great monarchs. From his accession Shah Tahmasp showed great taste for painting; he wished to learn how to paint, and was given lessons by Bihzad; he worked so seriously that he would shut himself up for several hours a day with the Master and his disciples, to paint in their company; such an occupation pleased him infinitely more than presiding over the Council or examining into contentious questions of finance or politics; he was quite young and his ministers left him free to follow his infatuation for a certain time, perhaps they profited by it; the day came when the king realized that he could not continue to live as a dilettante and that sovereignty carries with it serious obligations for him who wears the crown. The Palace painting room declined when Shah Tahmasp frequented it no more, and the Bihzadian school found itself dragged down the slope of decadence.

The painters became craftsmen and ceased to be artists; they exaggerated the methods of Bihzad, or rather the exaggeration of his methods by his first pupils; they simplified his design; they reduced his palette, diminished the amplitude of the composition; with Agha Riza in the second half of the sixteenth century, with Riza-i 'Abbassi, with Haidar Quli at the beginning of the seventeenth, they degenerated into a mannerism, masterly in its way, which brought about the hopeless decadence of painting from about 1580; the extreme rapidity with which the artists of this period worked in order to satisfy the passion and the craving of too numerous amateurs, hastened the end of the School after having been the cause of its beginning.

Up to the end of the Timurid period, at the beginning of the sixteenth century and even up to about the reign of Shah Tahmasp, the cult of the gorgeously illuminated book had been the exclusive appanage of the princes of Iran and of one or two important people

sufficiently wealthy to be able to recompense adequately the artists' talent; it is rare at these times for the illuminated manuscripts which have survived in their integrity with their first and last pages intact, not to carry some record, some ex-libris, seals or marks of property which allow us to go back to the source whence they were stolen.

The situation changed about 1550, under Shah Tahmasp, when one finds in Persia a considerable number of ornamented manuscripts whose decoration was quickly executed, of paintings conceived in a hasty and summary technique, whose mediocre and bastard forms only distantly remind us of the masterpieces which were painted in past centuries for the masters of Iran or for their ministers. These manuscripts bear no dedication, no ex-libris; they are illuminated copies, executed in the workshops of good booksellers, who had a regular clientèle of collectors of moderate means; they were not rich enough to order luxurious books from a calligrapher of recognized merit or from painters who had made their name; the smallness of their means obliged them to content themselves with copies executed by ordinary craftsmen and by artisans of the second rank, whose work had all the faults of commercial reproductions, giving only an approximate idea of the splendour of decoration in the royal books; this sufficed for the middle-class Persians, who were without literary appreciation or taste in art, and only wished to possess books out of snobbery.

The decadence of painting was complete in Persia at the end of the reign of Shah Abbas II; literature decayed at the same time. The Safavid dynasty had begun with welcome reforms; it had made the Kingdom of Persia strong to resist the Turks who had been masters of Persia since the tenth century, and it had given Iran back to the Iranians. It ended more tragically than all the dynasties that had preceded it, and fell through the shameful incapacity of its sovereigns; its fate was a hundred times more miserable than that of the Saljuks, the Kings of Khwarazm, the Mongols, the Timurids: the Saljuk princes and the last King of Khwarazm died sword in hand; the last of the Timurids attempted to fight against the Uzbeks; the 'Sophy' allowed the Afghans to insult him and fell back under Turkish domination with Nadir Shah. Politics, literature, art, science were all brought down to the level of the mentality of the Kings of Persia, and after the end of the seventeenth century count for nothing in the intellectual history of mankind. We still find quite sporadically, at the end of the Safavids, under the Kajars, in the nineteenth century, certain finely-executed paintings which bear witness to the cleverness of their authors and to the mastery of their craft, but they form an

101

insignificant exception. They do not belong to a type, far less to a school; they are only connected with the ancient technique by the fact that they illustrate the same scenes as were chosen for illumination in 1300, 1400, 1500; the artists had not, for a long time, had enough imagination to make modifications in the iconographic canon, but they broke with tradition when they took their inspiration from European methods and imported them into their technique, more and more down to the present day.

Decoration lived longer because it clung to tradition; the Persians excelled in this genre while they had always shown themselves as painters, very inferior to the artists of Hindustan; this weakness of the painters in Iran compared with the brilliance of the decoration is enough in itself to show that painting was not, in Iran, a national art, born of the soil, but a foreign importation, whose tradition did not respond to any very imperious need. Ornamentation lasted on till nearly 1880 in a brilliant though much less plastic form than that of the decoration of the fourteenth and fifteenth centuries; it, in its turn, disappeared, and we should look in vain for any trace of it now, since it has outlived the technique of painting which was always, in Iran, a very limited activity reserved for the decoration of the halls of royal palaces, for the illumination of epics and of the scenes of love from lyric poetry. It owed nothing to religious tradition, which ignored and was hostile to it; Art of all kinds in Persia was always secular in spirit; the true Moslem has always looked upon it as a superfluity, since forms created by the hand of man can only give a false and erroneous idea of the perfection of the Unique Being.

May 1926.

TERMINAL NOTE

FROM the evolutionary point of view, in religion, science, philosophy and art, Islam is a post-Byzantine form; Byzantium is a post-Roman form; Rome a Hellenic form tending to decadence. If we except China, who knew how to frame her independent life on the concepts which she had created, civilization so far as it is concerned with ideas and form, does nothing but offer new embodiments for Hellenic conceptions. Classical Greek art, so-called Hellenistic art, Roman art both of the Republic and of the Early and Late Empire, so-called Byzantine art, the art of the Merovingian and Carolingian periods, in France, England and Italy, Romanesque followed by Gothic art, Syrian art from the fourth to the tenth century, these are not autonomous independent entities, up to a certain point opposed to and contradictory of each other, as some scholars are pleased wrongly to imagine, while they set themselves the vain task of determining the differences in their characteristics and of studying their influence on each other, the part which each owes to the entity which immediately precedes it in history. Roman art is the parent of Romanesque, from which is born the ogival formula; French buildings of the fifteenth and sixteenth centuries are composed by the juxtaposition of elements derived from the Roman technique, and their method, like that of the cathedrals, is essentially classical; this art vanished from France before the invasion of Italian formulas, because it had been developed to its extreme limit and could no longer find renewal in sources which had long been dried up, nor refresh its formulas by a return to its originals which had disappeared, to give place to totally different norms which had been born from them. But Italian technique could never perfectly satisfy French taste, and it dreamed of combining the two styles sprung from Roman art, the Romanesque and the Gothic, in a syncretism which, when its evolution was complete, left no other combination possible and obliged the West to return to Rome and copy the antique. The paintings in the Latin books establish two facts particularly interesting for the history of the evolution of art in our West, namely (1) that French technique in the twelfth and thirteenth centuries is a scarcely disguised copy of the Carolingian

103

style of the ninth century, which derives from the formulas of the Roman Empire from the sixth to the eighth century, and (2) that the norms of the craftsmen of the fourteenth century derive, by a series of successive modifications, from the methods prevailing in the work-shops of the thirteenth century.

Only one art has ever existed, and that is Classic Art; it was born mysteriously at the foot of the Acropolis, after a long evolution among the Achaeans who preceded the Ionians in the fourteenth century B.C., in Asia Minor, and among the Ionians, whose works, in strong relief and with plastic form, are found in the land of the Hittites mixed with the flatness of Chaldean sculpture. It spread over the whole civilized world, civilized and colonized successively by the radiant Hellenic genius, by the Macedonian conquest, by Roman arms, by the expansion of Christianity. This art includes varied and numerous aspects, according to the stages of its evolution, according to the countries in which it flourished, according as it inspires the chisel of Pheidias or that of the sculptors who worked after the time of Alexander, according to whether it took life in Athens, Antioch, Bactria, or Rome, or guides the brush of the monks of Milan, Canterbury, or Fécamp. Outside this classic art which has given its graceful clothing to the reveries of the Hindus, outside its evolution, throughout the centuries, no plastic form exists either in sculpture or drawing or architecture, other than the clumsy conceptions of savages and uncivilized beings. Roman architecture, like Syrian and Bactrian architecture under the Seleucids and after them, is a formula of Greek technique, a provincial, nay, a colonial style which had no currency in European Greece, in Attica. And this explains the striking resemblance, apparently illogical, which exists between the monuments of Indo-Greek art and Roman monuments, by contrast with the Hellenic technique; the Greeks were architects, the Romans engineers; it was Greeks who raised the Corinthian colonnades in the temples of the Eternal City, but Romans who built the Coliseum and the Pont du Gard; which did not prevent the Greeks from achieving the great and the colossal when they chose, as in the Doric temples of Magna Graecia, in the south of Italy, which were colonial forms, while the Parthenon was a national, metropolitan form. The Greeks of the fourth century B.C., as we can see in the tholos of Lysicrates and of Epidaurus which repeated the formulas of earlier and more ancient monuments of the fifth and sixth centuries, and in the round temples of the Treasury of Sicyon (580) and of Delphi (end of the fifth century), understood, in spite of all static difficulties, how to build a dome by marble vaulting upon the colonnade of the single-aisled temple.

MUSULMAN PAINTING

This technique from the strictly practical craftsman's point of view implies and presupposes the knowledge of semicircular vaulting on upright supports; the Romans adopted, out of economy, a simplified but greatly inferior formula, and substituted for it the rubble work dome; the technique of the cupola of the Pantheon exhibits the culmination of the style of the dome, the evolution of which required centuries before it could reach this perfection, all the lapse of time that separates the Pantheon from the Mycenean domes raised on columns (twelfth to tenth century B.C.), which Homer mentions—from those pre-Hellenic cupolas which served as models for the brick domes of Assyria in the time of Sargon (end of the eighth century B.C.), just as the stone construction of the Achaeans, and of the Ionians their successors, on the coasts of Asia Minor, is the origin of the stone technique in the Assyrian Empire and in Persia, at the time of Cyrus and of Darius. The conception of the dome in Rome is not Etruscan; it is not Oriental, it is Hellenic; the vault of the Pantheon contains the solution of the problem of covering a square hall by the intersection at right angles of vaulted arches; it contains the principle of the groined vault of one of the halls of the Baths of Diocletian in the third century, which was copied, exact in all its dimensions, at the beginning of the fourth century by the architect of the Basilica of Constantine, and the groined vault of this celebrated monument, exact in all its dimensions, was copied at Constantinople by the architect of Sta. Sophia and crowned by a dome. It is the Pantheon, lifted on the vaults of the Basilica of Constantine, which is the parent of the Basilica of St. Peter.

The roofing of a square hall by arches intersecting at right angles and resting on piers situated at the ends of the two diameters leads on, through the juxtaposition of a group of such halls, to the roofing of a rectangular hall, no longer by a continuous semicircular vaulting, as in the Roman style, but by a series of independently-springing vaults, the principle of Gothic architecture: this method is a variant on that which consists of roofing a rectangular gallery by a series of vaults supported on pendentives.

The vault of the Pantheon contains the precedent for the buttress and the ogee. It matters little from the point of view of statics whether the buttress be external or internal, merged in the body of the building, continuous or discontinuous; it is a buttress from the moment when it forms part of a continuous solid, intimately united to the body of the building. The reinforcing brick-courses in the Pantheon whose half-circles are cut off in their upper part by the oculus of the temple, rest on pillars placed at the furthest points of diameter of the monument and merged in the mass of the dome; none the less do they exist

105

as a primordial condition of the equilibrium of the cupola on its drum under the essential form and in the very spirit of the ogee, nine or ten centuries before the date to which the Armenian churches, built about the year 1000, go back. If one covered the ogees of Westminster Abbey with a layer of plaster they would, none the less, exist; from the point of view of statics it matters little if the mouldings are visible and obvious or not; this is only a question of æsthetics.

The Armenian builders, it has been wrongly claimed, invented this technique, though at Ani, about the eleventh century, in a sepulchral chapel with an elongated roof, they have obviously copied the formula of the monument built at Rome, about the year 250, and known by the name of Minerva Medica; the Cathedral of Ani (eleventh century), a Basilica with three naves and a cupola, is an extreme simplification of Sta. Sophia at Constantinople (sixth century). The intersecting of the arches of Sta. Sophia copies the exact dimensions of the Basilica of Constantine (early fourth century), which copies that of one of the halls of the Baths of Diocletian (late third century); the Christian Basilica copies, not the Pagan temple, but the Pagan Basilica, to show that the Faith of Christ is based on justice. San Paolo on the road to Ostia (end of fourth century) with its five naves, is a copy, even in its dimensions, of the Ulpian Basilica in Trajan's Forum (about 110), with the proportions of roughly one-half of width to length of the Pagan Basilicas; these proportions in the Pagan Basilica of Constantine, with its three vaulted naves, have been modified and extended to three-quarters by the disposition of the ground on which it was built; the 65-metre width of the Basilica of Constantine corresponds to the plan of a Pagan Basilica with five naves, 65 metres wide by 130 long, and this was copied, exact in all its dimensions, at the beginning of the fourth century, by the architect of St. John Lateran, the width of which is exactly that of the Basilica of Constantine. In fact, St. John Lateran, the oldest of Christian churches, exactly reproduces the proportions of the Basilica of Constantine, or rather of the Basilica whose plan was modified into that of the Basilica of Constantine. St. John Lateran consisted of five naves of 10, 10, 25, 10 and 10 metres; the central nave of 25 metres being a copy of that in the Ulpian Basilica, which itself was imitated in the Tepidarium of the Baths of Diocletian; the three naves of the Basilica of Constantine are respectively 20, 25 and 20 metres wide, which brings us back to the fact that the architect of this remarkable building combined into one the two lateral naves, 10 metres wide, of the primitive plan, while respecting the integrity of the central nave of 25 metres, which was an ancient tradition; we also find the average

width of 25 metres in the great nave of St. Peter's at Rome, which is 27 metres, 50 at the entrance and 24 metres at the apse.

<div align="center">* *
*</div>

The earliest documents we possess on the Roman Basilicas are to be found in the Liber Pontificalis which dates from the sixth century and after, while Eusebius, at the beginning of the fourth century speaks at length of the Syrian Basilicas, the only ones he knew. Scholars have unreasonably deduced from this that the Syrian Basilicas are earlier than those at Rome, while it is manifest that the authors of the Liber Pontificalis have used documents of the time of Constantine, and that the first Christian Basilica, St. John Lateran, follows the original plan of a Pagan Basilica which had been modified in the Basilica of Constantine. The Roman Basilica, with three or five naves, is an evolution from the Greek Temple with antae, with the superposition of the two orders as in the Parthenon at Athens. The splendid stone Basilicas in Syria, in the Hauran, to the south of Damascus, are the work of Greek architects or of Syrian craftsmen who had learnt in the school of Byzantine artists; Monsieur de Voguë has, in a remarkable book, described these monuments, which date from the fifth and sixth centuries and several of which have the same claim to be the work of Justinian as the brick Basilicas of Ravenna. He sets himself to prove that they are conceived and executed in a technique which is the natural and normal evolution of the Classical Greek method, which passing through to Romanesque found its end in Gothic, that it contains no Oriental element whatever, neither Syrian nor any other. And this doctrine is completely confirmed by the fact that a Christian historian who wrote in Arabic towards the middle of the fourteenth century tells that, in the year 1317, the church of a village near Aleppo was destroyed by a cyclone which tore it from its foundations; he lays stress on the circumstance that it was built according to Roman technique in Heraclian stone, either because the Emperor Heraclius at the beginning of the seventh century had ordered its construction, or, which is more likely, that it is the work of Justinian or one of his predecessors. These were unknown to the Orientals, while Heraclius is celebrated among them from his having turned the flanks of the defences which the Chosroes had piled up in Mesopotamia by passing through Armenia to carry war into the heart of the Persian Empire, rather than hurling himself, as his predecessors had done, against obstacles which might well have annihilated the Roman army.

The semicircular arches of the pure Greco-Roman style were replaced

<div align="center">107</div>

in the Cathedral of Ani by pointed arches, at a date which is very near to the time when they appeared in Western technique (the second half of the eleventh century); the first example of the pointed arch is found at Constantinople, in the Wall of Theodosius, in the fourth century, at a date much before that at which the archæologists claim that it appeared in the East.

The Armenian legend claims that the Cathedral at Echmiazin, the oldest church in Armenia, was built 'towards' the end of the fifth century and 'restored' in the seventh century; it is in the form of a Greek cross crowned with a cupola, and the Armenian architects wish this to be considered as the origin of this formula of building, but in the sixth or seventh century it is a copy in its restricted dimensions of the Holy Apostles at Constantinople which was built by Justinian. The domed cross is made up from the two arms of the transept and the central nave of the Roman Basilica with its three naves, and follows, on a reduced scale, the Basilica of Constantine, substituting a dome to the groined vault ; this formula was in no way influenced at Echmiazin by Persian art, which, with its national style of building in unbaked brick, knew nothing of this type.

Zwartnotz (towards 650), close to Echmiazin, is a reduced copy of San Vitale at Ravenna (about 530), which is the Roman combination of Minerva Medica (towards 250), and of Sta. Costanza (fourth century), and what is much to the point, we know that Narses, who ordered it to be built, had been brought up among the Greeks. The Golden Temple of Antioch in Syria was an octagonal Rotunda crowned by a dome, and, as far as we can judge from the description given by Eusebius in his biography of Constantine, followed the same formula as San Vitale at Ravenna; but the fact that this author insists on the exedrae of this wonderful monument which aroused the admiration of the Moslems, shows that it is an actual copy of Minerva Medica where the style is characterized by the exedrae. Some have wished to see in San Vitale a copy of the Golden Temple of Antioch and to find there the decisive proof of the influence of Syrian art on the technique of the Late Empire in the time of Justinian; but we know that the Golden Temple of Antioch was a building of the time of Constantine, which was set up by the first Christian Emperor in the early days of his reign, at the beginning of the fourth century, and at the same date as the admirable Baptistery of his daughter Sta. Costanza, at the gates of the Eternal City, in the Roman formula of Minerva Medica, which belongs to Paganism; at the same date as the Basilica of Bethlehem, which copies the august forms of the Roman Basilicas; at the same date as the Rotunda of the Holy Sepulchre at Jerusalem, where

108

the Tomb of Christ was covered by a reproduction, in a reduced form, of the gigantic formula of Hadrian's Pantheon.

The high drum of the Armenian churches, like the high drum of the Byzantine churches, copies the drum of the Holy Apostles of Justinian's time which was born from the evolution of the Laconicum of the Baths of Caracalla (early third century), which was the elevation to a second story of Hadrian's Pantheon; domed monuments in the Roman technique having, from the second century onwards, a marked tendency to rise in height which continues through Romanesque, till it reaches an exaggerated point in Gothic style.

All domes, Roman, Byzantine, Oriental, or Chinese, are diminutions, successive degradations for the sake of simplification and economy, of the dome of the Pantheon; the debasement of the formula takes us from the dome of the Pantheon to that of Minerva Medica, to that of Sta. Costanza, to that of the tomb of the Tossia family, to the domes of Ravenna and of the monuments of Byzantium, then to the succinct and elementary domes of Musulman architecture. The domes of Chinese temples about the year 669 copy a Roman formula which is that of the incomparable faceted dome of the Florence Baptistery (late sixth century) which was born at Rome in the Greco-Latin formula of the Pantheon, through the elevation of the drum which we find again in the Laconicum of the Baths of Caracalla and in Minerva Medica at the close of Antiquity.

* *
*

Russian art, the fresco and the painting of icons, reproduces forms which are more Roman than the technique and the style of the most classical works of the current technique of the Late Empire. The fresco which decorates the cupola of the little church of St. George at Staraya Ladoga, in the fortress of Rurik, on the Volkhow, close to St. Petersburg, at the beginning of the twelfth century, is an elegant replica of the circle of the Apostles in the Baptistery of the Arians at Ravenna, about 520. The fact can be noticed very often in the icons which were painted in late times, in the fifteenth and sixteenth centuries; an icon representing the Holy Trinity in the monastery of St. Joseph at Volokolamsk, reproduces types of the second and third century which are quite antique, as if it had been created by the brush of a Florentine artist in the dawn of the Renaissance. These icons, which were painted in the dominions of the Kniaz of the house of Rurik, reproduce the manner and copy the over-nice technique of the mural paintings adorning the walls of the sanctuaries of Mistra, in a form much superior to that which was generally

known in the West through the illustrations in manuscripts and through mosaic; the frescoes of St. Theodore (late thirteenth century), of the Virgin weeping over Christ; the Holy Women at the Sepulchre of the Church of the Brontochion (early fourteenth century), the Holy Women, the Angels bearing the Glory of Christ; the very beautiful mural compositions of the Metropolitan Church of the same date as the Brontochion, Jesus in the synagogue, the Miraculous Healings; the Falling Asleep of the Blessed Virgin at the Peribleptos; the Ascension at the Pantanassa (middle of the fifteenth century); those frescoes of Mistra are conceived under a richer form, in a more supple and more learned manner, than the paintings in much earlier Gospels, with a more bewitching harmony within the framework of a highly skilful composition, which has kept the Roman tradition and recalls that which was to become the glory of the Italian Renaissance.

And these works, the frescoes of Mistra like the icons of the Slavs, show, that by the side of the iconography of books and mosaics which often represent a mediocre technique, there persisted in Byzantium and later on in the Greek convents, down to a much later time, to the fifteenth century and even later, paintings, whose tradition was purely Roman; they copy Roman pictures in which the Byzantine artists made no modification, into which they allowed no motive to enter that was foreign to Antique Roman art, which became characteristic of the art of the Late Empire, and, in consequence, possess a quality much more precious than the illuminations in manuscripts. These productions of Russian art reproduce in the sixteenth and seventeenth centuries a Roman tradition of great antiquity, more than a thousand years old, in times when the art of the Late Empire, if its evolution had not been fettered by the Barbarians, would have arrived at a stage very different of stylization and deformation of the antique Roman model. This circumstance is easily explained: the Russian artists in their sacred icons copied faithfully the ancient themes and motives; religious tradition would not have permitted a change of any sort in these. Russia, in the fifteenth and sixteenth centuries, remained very much what she was at the time of her conversion by Byzantium; she knew no Renaissance and her craftsmen felt no need to modify their technique; they exhibited a far surer taste than the painters of Constantinople when they decided that they could only make changes for the worse; their merit lay in reproducing their models more carefully and more faithfully than the Byzantines; it allowed them to create works which were infinitely superior to the illustrations in Greek Bibles, Gospels, and Martyrologies. That these

110

MUSULMAN PAINTING

Russian icons of the thirteenth and fourteenth centuries, like the Rumanian icons of a much later date, are directly copied from Greek pictures, or from copies of Greek paintings, is a fact sufficiently established by this circumstance, that the names of the Holy Personages whose features they represent are recorded in Greek.

The Roman technique may also be recognized in the Basilicas of Russia, where the medallions between the pillars of the principal nave contain the portraits of female Saints wearing the national head-dress of the Kakoshnik, which corresponds to the portraits of the Popes on the walls of the Basilicas in the Eternal City, at San Paolo on the road to Ostia, towards 400.

The early Christians borrowed their music from the Romans; the Romans had it, like all their artistic formulas, from the Greeks. The Antiphonary of St. Gregory (sixth century) which settles the method of Gregorian Plain-song, is the re-handling of a collection of liturgical chants made, towards the end of the fourth century, by St. Ambrose, at Milan; the collection of St. Ambrose is composed of adaptations of hymns of classical music to the needs of the Church.

Thus there exist in the anthems of the Antiphonary of St. Gregory (sixth century), themes and motives which, through the channel of Roman music, go back to Hellenic modes, to strains chanted by the Choruses of the Greek Tragedies, strains to which Pindar's Odes were sung. The similarities and analogies which unite the music of the Orthodox Church to that of the Roman Church show that we must look for their common origin in Greek music; it is certain that there never was a point of contact between Kieff, Moscow, and Rome; the Orthodox take all their formulas from Byzantium, and they say this themselves, recognizing an obvious fact. If there are affinities with Roman norms, it is because both go back to a common source from which they are derived; they were transmitted to Kieff by the medium of the Late Empire, which in all its domains continued the Classical tradition under its Roman form, and this had borrowed all its elements from Hellenism. It is thus that modes which have been absorbed by the music of different nations, each borrowing from the music of the Late Empire—for instance, Hungarian music, where one finds all sorts of things—go back to Greek music mixed with Oriental elements, music such as Mozart's Turkish March, played with the harpsichord, where we can hear the citherns and the bells of the Chinese hat; some recall the lamentation of Iphigenia; the Volga Boat Song, which has become the national song of Russia, is a Miserere of the Greek Church; and among the Arabs, the musical system of al-Farabi is an adaptation of Byzantine music.

111

MUSULMAN PAINTING

The ceramics of Northern Persia at Zanjan in the ninth or tenth century show a weakened survival of the classical manner. Antiquity possessed a ceramic yellow and green in colour and decorated in high relief with a technique translated from sculpture; pottery thus decorated is found throughout the whole of the Mediterranean world, from the Syrian provinces as far as Pompeii; its Greek origin can hardly be doubted; it is indeed in Hellenic art that the finest examples are found, remarkable specimens with sides wreathed with a rich ornament of vine leaves. The ceramics of Zanjan are also yellow and green, identical in their tonalities with those of the classical World; but, out of economy and in order to simplify the processes of the work, the relief has been suppressed; the plastic ornament has been replaced by a flat design, in which the shadows cast by the relief are translated into tints of black, and this simplification of the technique is enough to show that this style is derived from that of the pottery in high relief of Classical Antiquity; ceramics of a deep blue colour were the creation of ancient Egypt; she transmitted the secret to Iran, who transmitted it in turn to China.

* *
*

The theory of the influence of the East on Western art is a fancy born from the combination of several errors, the essence of which is wilfully to attribute to Oriental monuments dates much earlier than those to which they really belong.

The influence of the technique of Oriental architecture on the Roman style is a hypothesis upheld by assigning to about the year 480, or even to the end of the seventh century B.C., the Persian palace of Firuzabad, in Southern Persia, a building notoriously Sassanian, of the last phase of Antiquity, about the fifth century A.D., and the palace of Sarvistan, a building of about the middle of the fourth century A.D. This theory was invented by Dieulafoy, who made it the crown of his mission to Persia, and declared the two palaces of Sarvistan and Firuzabad to be works belonging to a distant antiquity, far earlier than the Macedonian conquest, Alexander the Great or the Seleucids. At the end of his life Dieulafoy was forced to recognize that Sarvistan is a much more modern building, much later than the beginning of the Christian era, though its date cannot be precisely fixed; but certainly Sarvistan and Firuzabad form two consecutive terms of a series, and if the date of Sarvistan is 350, then the date of Firuzabad is 460.

In fact, Sarvistan and Firuzabad, the brick churches of Ravenna, Sta. Sophia in Constantinople, St. George of Ezra, the Cathedral of Bosra,

112

form a chain, the Western end of which is infinitely superior to the Eastern. The construction of the Persian palaces is greatly inferior to the learned technique of the monuments of Ravenna, although these are inferior to the Roman manner; their brick walls always await the marble covering which clothes the edifices of the Eternal City. The characteristics of Sarvistan and Firuzabad are found again in a much more elaborate form in Italy, their place of origin; the trompe-vaults of the Persian cupolas are a clumsy copy of a technique whose principle is found in the round Temple of Spalato, built in the third century, under Diocletian, an evolution from the Pantheon; its dome is formed by a superposition of small blinded arches, an exaggeration of the method of the Pantheon where the eight arches filled with bricks are the eight archivaults of the octostyle temple surmounted by a dome. Imitations of cupolas on trompe-vaults are indeed found among the Buddhist ruins of Bamian in Afghanistan; but they do not belong to the second century B.C., as is claimed, for, in Hindu architecture, the dome only appears in the very latest period of the evolution of Buddhism, towards the third or fourth century A.D., when it is frankly the copy of Western technique. In the same way, the origin of pendentives which it has been attempted to attribute to the East is found in a monument which was set up in the Roman Campagna at a date soon after the beginning of the Christian era.

This theory has falsified the whole history of art; the doctrine according to which Persian and Armenian architecture spread westward through the world through the medium of the Arabs is a mere fancy, created round a hypothesis, with the intention of attributing to Oriental lands an importance in the development of civilization which is not theirs.

At a given time, in the same country, the arts, sciences and literature arrive at the same stage, and it is past dispute that, under Sassanian rule, literature and science were at the lowest ebb. The Byzantine historian, Agathias, tells us that when Justinian closed the School of Athens and persecuted the philosophers, many of these sages crossed the frontier to seek shelter in the states of the King of Persia, Khusrau Parviz, who enjoyed an exaggerated reputation at Constantinople. It was said that he had been nurtured on Greek philosophy, that the works of Plato and the Stagirite held no secrets for him, that he was the model of the good despot governing his people according to the laws of divine wisdom. The philosophers were disillusioned on their arrival at the Court and after their first interview with the King of Kings; like all peoples who are, or believe themselves to be, in a state of decadence, the Byzantines attributed

8 113

purely imaginary qualities to their neighbours; these sages discovered that the King of Persia barely knew the first elements of learning and that, like his subjects, he was a very barbarian.

Parviz had allowed himself to be duped by a certain Syrian doctor, Uranios, who had learnt up philosophical jargon and handled it with dexterity, utilizing it to pour into the King's ears a flood of wild nonsense which he admired the more the less he understood it, and which he much preferred to the conversation of the Greek philosophers; and this, says Agathias, is the logical order of the world; for it is natural that mediocre minds should seek the society of their peers, who overwhelm them with compliments, rather than that of wiser men whom they irritate. The favour enjoyed by this charlatan offended the Greeks and, in spite of all the efforts of Khusrau Parviz, they returned to their own country, preferring the hostility of their own prince to the tranquillity of the Persian Court. There exists in Latin literature a translation of a little work on philosophy and first causes supposed to have been written by Parviz: we see on reading this that the Persians of the seventh century had not got beyond the rudiments, if we admit that they understood them, a thing one might be permitted to doubt when the worthlessness of Pehlevi books is considered.

The Persia of the Achaemenidae, the Arsacids and the Sassanians (sixth century B.C. to seventh century A.D.) never did more than copy artistic forms which had been born further west; Armenia was not more genuine; before 302 A.D., the date when Christianity was introduced into its districts, the civilization of Armenia, then an inferior province of Iran, was as non-existent as that of Persia itself, and the fact that at the end of the sixth century, the Armenian Church separated itself from the Orthodox communion, and at the same time discarded the heresy of Syria, left it isolated among its mountains. Before 420 A.D. the Armenians could not write; the only books which existed in their country were works in Greek or Syriac, translations of which form the foundations of their literature; the earliest historian of Armenia, when he was seeking information as to the origin of his nation, had to look for it in chronicles written by Hellenes and Syrians; from 230 B.C. to A.D. 240 Armenian coins, like those of the Kings of Persia, the suzerains of the country, bear Greek inscriptions; after this date they copy, in a deplorable manner, the silver pieces of the Sassanian Kings.

If there exist in details obvious likenesses between the Arab monuments and the churches of Southern France, it is because the Musulman edifices were built by Christian architects or by subjects of the Caliphs who copied Western methods, the only ones which existed in their

time, and not the contrary, for whenever the historians of Islam speak of the origin of their monuments, it is in order to mention the part Christians took in building them.

When one civilization has borrowed from another, when there exist in two civilizations forms which present similarities and analogies beyond what can be attributed to chance or to illusion, we must, in order to decide which is the borrower, take less into account the age of the monuments in which these are found and still less the supposed date of buildings which have no known date, than their quality, the perfection with which they have been executed and, above all, the relative value of the intellectuality, the comparative power of the two forms of civilizations. The moral, intellectual and material superiority of one of them inevitably brings off its originality; a powerful civilization will not take from a secondary civilization elements that are defective in form and improve them in order to bring them to the state of technical perfection; the contrary is the rule. If a monument in any one civilization reproduces, in inferior form, a type of monument which is found elsewhere, much later, and in a superior form, this is due to both being copies of a prototype, created by the second of these civilizations, and which in the course of years has disappeared.

* *

*

Other mistakes of the same sort are the attribution to the sixth century of paintings executed in Syria and Armenia at vastly later dates; the ascription of the pictures in the Syriac Gospels of Rabula to the year 586 A.D. when, in reality, they were added to it in the tenth or eleventh century, and are copies from Greek originals, as is shown by a Greek word which the artist has reproduced in Greek letters instead of translating it into Syriac, because he found it difficult to read; the attribution to the first half of the sixth century of the four initial paintings and the four last pictures of the Armenian Gospels of Echmiazin, which were copied in the year A.D. 989, and to which they may have been added at the end of the tenth century, at the date when it was executed, more than four and a half centuries after the time when they are said to have been painted; but it is an obvious fact that the four paintings at the beginning (*sic*) are absolutely contemporary with the execution of the book itself, as can be seen by the parchment they are on and the writing which accompanies them; as to the four pictures at the end (*sic*) of the Gospels, they were added to the manuscript in 989 by the artist, who did not take the trouble to copy his models, the paintings of a Syriac Gospels, but merely inserted these into his own work; these paintings are either Syriac or copies made directly and without altera-

8* 115

tion of any sort, from Syriac originals between 880 and 940; both sets of paintings, those at the beginning as well as those at the end of the book, are copies in a second-rate and careless style of beautiful models analogous to the illustrations to the Homilies of St. Gregory Nazianzus at the end of the ninth century. Thus these Syriac and Armenian pictures in which it has been desired to find prototypes of the seventh and eighth century frescoes in Sta. Maria Antiqua at Rome, are really later, by nearly as much as two hundred and fifty years.

A definite fact in the history of Oriental Art is that all the figures appearing in the pictures of Christian books, whether they are Roman, Greek, Syriac or Armenian, and in Russian or Rumanian icons, are clothed, and armed in the Roman and not in the Greek fashion; personages clothed like Greeks appear only in the paintings of Pagan books, the Homer of the Ambrosiana, the Virgil of the Vatican; and that is enough to show that the canon of Christian iconography was established and elaborated in Rome, at the very beginning of Christian times. The doctrine according to which Syrian paintings served as models to the Byzantine painters arises from an erroneous interpretation of material facts; from the end of the sixth century to the second half of the ninth century, in countries where Greek was spoken, in consequence of the war against images made by the Iconoclasts, and from those last years of the sixth century to the beginning of the ninth century in the West, largely owing to the inferiority of the craftsmen of Merovingian times, there exist hardly any paintings in manuscripts; therefore, during more than two centuries, in Europe, nothing can be found to compare to the so-called Syrian illuminations supposed to go back to the sixth century and to be the origin of Greek pictures and of all Christian art.

But this explanation would be unnecessary, even if these Syrian illustrations belonged to the sixth century, instead of to the tenth, as they really do, and there is no need whatever to invoke the existence of Oriental models in order to explain the Carolingian Renaissance and that of Byzantium, in the ninth and tenth centuries; the tradition of painting was far from being dead in the seventh and eighth centuries, there is proof enough of this in the frescoes of Sta. Maria Antiqua and in the mosaics which adorn the triumphal arches and the walls of the basilicas of the Eternal City; it was perpetuated in Italy in a form far superior to any ever assumed in the East, as is sufficiently shown in certain paintings in Sta. Maria Antiqua, whose exquisite technique recalls the frescoes of Mistra; therefore, in the history of the art of the Late Empire, it is incorrect to contrast the old tradition down to the sixth century with Oriental tradition from the sixth

to the tenth centuries, or the Syrian Schools with Byzantine work-shops. The iconography of the earliest Christian art is said to be divided into two different aspects : the products of Constantinople and Alexandria, and the formulas of Palestine or Syria. Palestinian studios are supposed to have influenced the Constantinopolitan Schools in their departure from the Hellenistic tradition. This theory is obscure : it rests on trivial details, on the choice of scenes to illustrate Bibles and Gospels, on the number, gestures and arrangement of the figures ; but it furnishes no proof of an Eastern influence on Byzan-tium : the methods of the Palestinian studios, exactly like the Con-stantinopolitan workshops, copy, not the so-called Hellenistic forms, but Roman iconography, without a single foreign influence. The Roman model in Jerusalem or Damascus has not been influenced, and a Syrian technique for this was non-existent : before we can speak about a modification of the Roman formulas under the influence of Palestinian norms, we should possess examples of a Palestinian art older than the first century in which those elements should be formed, which exist later on in the pictures of the Syrian Gospels. The influ-ence of Palestinian workshops on the Byzantine schools can be thus reduced to the influence of one aspect of Roman iconography or another aspect of the selfsame Roman tradition, that is to say, an interior evolution of classical art without the slightest Eastern influence ; these divergencies being, moreover, mere stylizations of the Roman model.

AUGUST, 1929.

INDEX

INDEX

INDEX

INDEX

Russians, 58, 109–11
Rustam, the Paladin, 78, XLIV, LIII, LXXIV, LXXV, CLXIX, CLXX

S

Sabaeans, Star-worship of (Sabeism), 3–5
Sabellianus, 5
Sadi, 19, CX, CXVI–CXVIII, CLXXII
Sadik, 63, 82, CXXXVIII, CXXXIX, CXLI
Sadiki Beg, see Sadik
Safavids, 57, 62, 85, 96, 97, 99, 101, CXIX–CLXVIII
Sagittarius, constellation of, XXXIII, LXVIII
St. Ambrose, 111
St. Front, Church of, at Périgueux,
St. George, Church of, at Staraya Ladoga, 109
St. George of Ezra, Church of, 16, 112
St. Gethsemane, Church of, 17
St. John Lateran, Church of, 17, 106, 107
St. Joseph at Volokolamsk, monastery of, 109
St. Mark's at Venice, Cathedral of, 16
St. Peter, Basilica of, 105, 107
St. Sergius, Church of, at Constantinople, 8
St. Theodore, frescoes of, 110
Sakas, 2, 56, 58, 68, 71, 78
Sakyamuni, 52, 68, 69, 84, 95
Salim Khan, Sultan, CLXXIII
Salim, Prince, CLXXXI, CXCII; see also Jahangir
Saljuks, 46, 47, 75, 101
Salm, LXXIII
Samanids, 42, 45, 49, 63
Samarkand, 1, 62, 78, 84, 86
Sàmarra, 18, 20
Samosatenism, 5
Sanaa, CXXXI
Sanaan, Shaikh of, CXII, CXXI
San Lorenzo fuori le muri, 17
San Paolo, Church of, 17, 106, 111
Sanskrit, 70–71
San Vitale at Ravenna, 90, 108
Sta. Costanza, at Rome, 16, 108, 109
Sta. Maria Antiqua, Church of, at Rome, 116
Sapor, 41, 42, 54, LXXVIII
Sapta Sindhava, 78
Sarah, L
Sargon, King of Assyria, 56
Sarvistan, palace of, 112, 113
Sassanians and Sassanian art, 3, 7, 13, 18, 34–5, 41–4, 53–4, 56, 59, 112–14
Saturn, planet, CLXXIV
Sayyid Muzaffar, CLXXVIII
Scandinavia, 76
Schmidt, 67
Scorpion, Zodiacal sign of the, LXVIII
Scythians, 2, 7, 44, 55–6, 75, 76
Seistan, army of, LVII
Seleucids, 2, 14, 20, 104, 112
Sergius, 17
Serpent, constellation, XCI, XCIII
Serpentarius, constellation, XCI
Seven Sleepers of Ephesus, CXXXIII
Seven Wandering Stars, 3
Sha-chou, 80
Shafi-i 'Abbassi, CLXVIII
Shaghad, LIII, CLXX
Shah Jahan, 74, CXCVI
Shah Rukh, 62, 74, 84, 93, 95
Shaibanids, 60, CX–CXVIII

Shaïkhem, illuminator, CXVIII
Shaikhzada Mahmud, CVII–CVIII
Shang dynasty, 76
Shên Tsung, Emperor, 62
Shiraz, 46, 92, 94, 95, 96, 99
Shirin, 42, CXXII, CLXI, CLXII
Shirwan, Prince of, CXXVIII
Shi'ism, 39
Shun-Ti, Mongol Emperor of China, XXXVII
Shuturba, bull, XV
Sicyon, Treasury of, 104
Sinimmar, 16
Sinjar, Sultan, CXIV–CXV
Slavs, 2, 56, 72, 110
Sogdiana, 95
Solomon, Holy House of, 85
Spain, 33, 38, 39, 49
Spalato, Temple of, 113
Ssŭma Ch'ien, 12
Stamboul, 40, 68, CLXXIII
' Stupefied ' planets, XXXIII
Sulaiman Khan, CLXXIII
Sulayman of Badakhshan, Mirza, CLXXIX
Sultan Ali Mashhadi, calligrapher, 97
Sultan Hosain Mirza, 61, 97, XCVI, XCVII
Sultaniyya, 62, 90, 96
Sultan Muhammad, painter, CXXVII
Sun, the, XXXIII, LXXI
Sung period, CXLII
Sunnism, 39
Surdas, CLXXIX
Susa, 1
Syria and Syrian influences, 2, 4, 8, 13, 14, 20–21, 26, 32, 38, 44, 46, 49, 84, 87, 89, 103, 104, 107, 112, 114–17
Syriac, 14, 20, 28, 32, 114–16

T

Tabari, 49, 61
Tabbagh, Georges, Collection of, at Paris, X, CLXVII, CLXIX–CLXX, CLXXXIX–CXC
Table of the Fixed Stars, 62, LXXXVIII–XCIII
Tabriz, 32, 60, 62, 87, 89, 90, 92–7, 99, CXX
Tafghach the marvellous, 58
Tahmasp, Shah, 98, 100–1, CXLIII
Tai-ping, insurrection of the, 5
Tak-i Bustan, 35, 54
Takla Makan, 55
Tamerlane, 66, 84, 97
T'ang dynasty, 19, 59, 61
Tartars, 38, 89
Tasm, clan of, 3
Tauris, see Tabriz
Tayy, clan of, 3
Teutons, 76
Thamud, clan of, 3
Theodoric, King, Tomb of, at Ravenna, 76
Theodosius, the Younger, CXXXIII
Theophanes, 6, 15, 17
Tihama, 4
Timurids, 38, 46, 53, 61, 62, 83, 85, 92–6, 100–1, LXVIII–CIX, XCVI
Timurids, of India, 97–8, CLXXVI–CC
Tossia family, tomb of, 109
Tradition, The Musulman, 10–11, 12–14, 15, 18, 22–3, 43, 48
Transoxiana, 84, 90–1, 97, 98

123

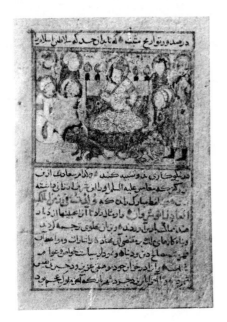

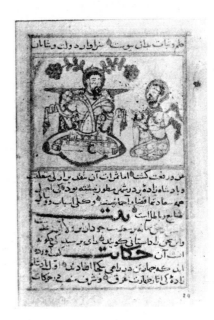

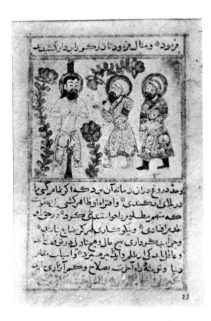

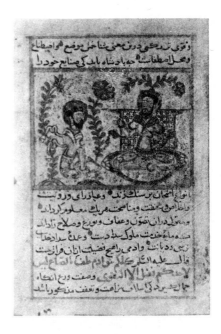

PLATE II

(a) Khusrau Anushirwan, King of Persia, surrounded by his Court, receives the Hindu original of the Fables of Bidpai; two paintings representing (b and d) the Indian King Dabshalim conversing with the Brahman Bidpai; (c) the goldsmith hung on the gibbet. (Fables of Bidpai in Persian. Eastern Persia, probably Ghazna, about 1150. Bib. Nat., Paris.)

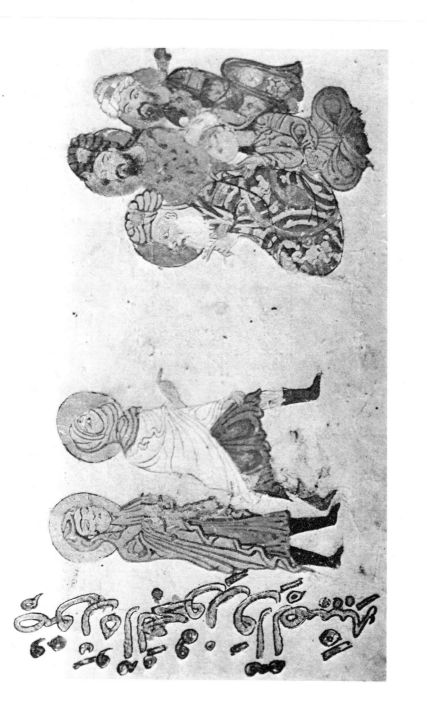

PLATE III

Al-Haris as he goes on pilgrimage to Mecca meets with an old woman who tells him the story of her life. (Makamat of Hariri. Northern Mesopotamia, about 1180. Bib. Nat., Paris.)

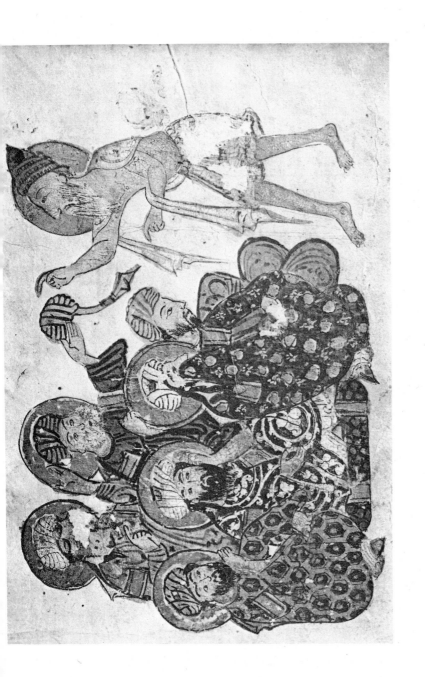

PLATE IV

Al-Haris and his companions meet a half-naked old man who speaks to them in verse. (Makamat of Hariri. Northern Mesopotamia, about 1180. Bib. Nat., Paris.)

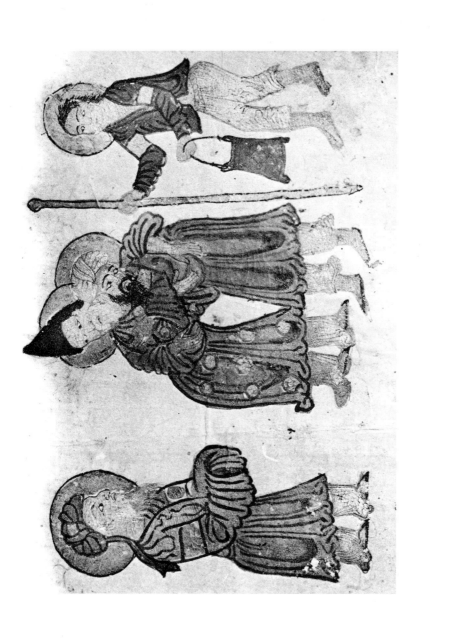

PLATE V

Al-Haris and his friend Abu Zaid, embracing. (Makamat of Hariri. Northern Meso-
potamia, about 1180. Bib. Nat., Paris.)

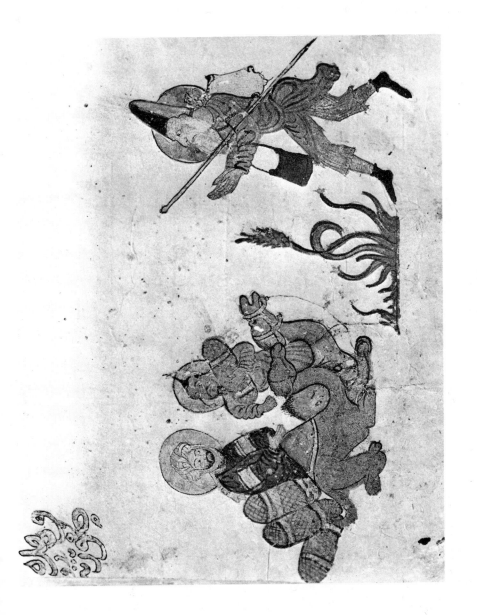

PLATE VI

Abu Zaid and two men preparing to set out on a journey on their camels. (Makamat of Hariri. Northern Mesopotamia, about 1180. Bib. Nat., Paris.)

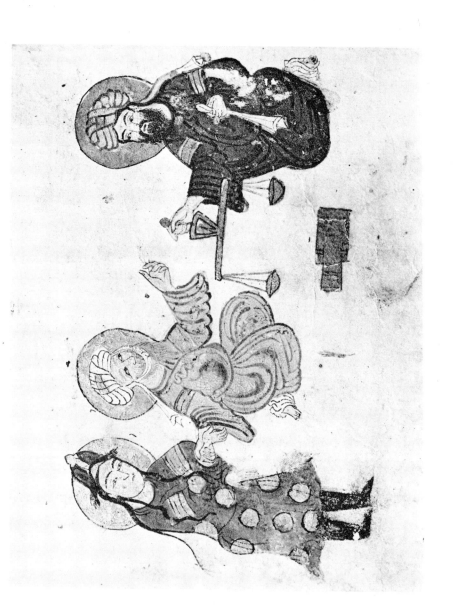

PLATE VII

Al-Haris discussing with a merchant the purchase of a young slave whom he holds by the hand; the slave merchant holds scales in which to weigh the money; see Plate XXVII. (Makamat of Hariri. Northern Mesopotamia, about 1180. Bib. Nat., Paris.)

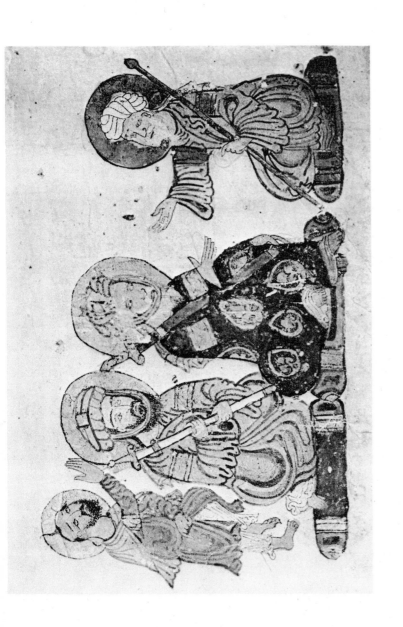

PLATE VIII

Al-Haris in conversation with an Arab who is relating his misadventures with a man of law. (Makamat of Hariri. Northern Mesopotamia, about 1180. Bib. Nat., Paris.)

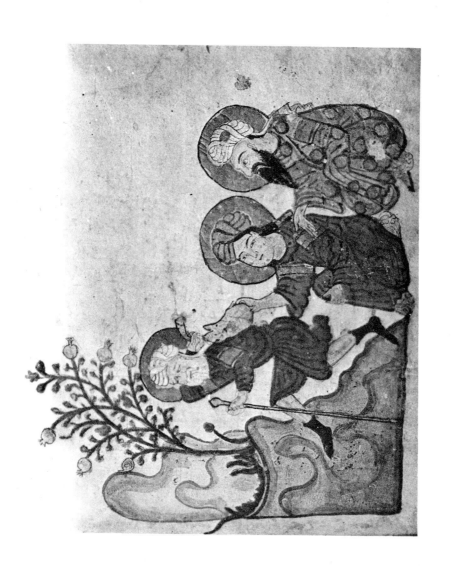

PLATE IX

Two persons trying to stop a third, who is running away. (Makamat of Hariri. Northern Mesopotamia, about 1180. Bib. Nat., Paris.)

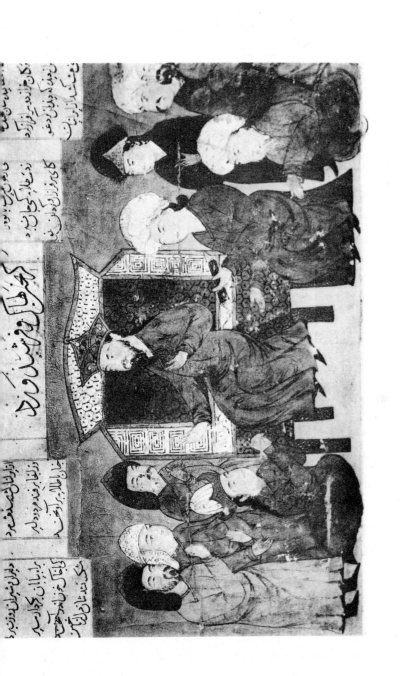

PLATE X

Lahak and Farishward, warriors in the army of Afrasiab, King of Turan, before their sovereign. (Book of the Kings, by Firdawsi. Western Persia or Saljuk Asia Minor, 1206. Georges Tabbagh Collection, Paris.)

PLATE XI

The King of Mazandaran, a Northern province of Persia, mounted on an elephant and surrounded by his warriors. (Book of the Kings, by Firdawsi. Western Persia or Saljuk Asia Minor, 1206. Pozzi Collection, Paris.)

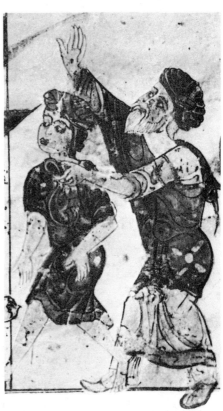

PLATE XII

(*a*) A figure which combines the characteristics of a Buddha and those of a Byzantine Christ ; on the left a figure like a Jewish prophet. (*b* and *c*) Figures copied from Byzantine paintings. (Makamat of Hariri. Baghdad, 1237. Makamat of Hariri, Northern Mesopotamia, 1222. Bib. Nat., Paris.)

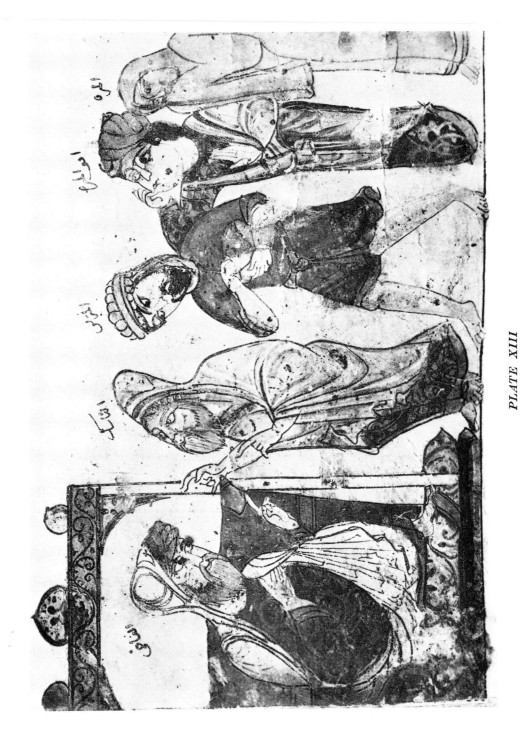

PLATE XIII

Persons accused of crimes and misdemeanours are brought before the judge. (Fables

PLATE XIV

The King of the lions, duped by the King of the hares, falls into a well ; the lion's muzzle has not been coloured and it can be seen that the illuminator used a stencil. (Fables of Bidpai in Arabic. Northern Mesopotamia, about 1220. Bib. Naṭ., Paris.)

PLATE XV

Animals before the crowned leopard, who is conducting the trial of the lion Jawash, charged with killing the bull Shuturba; the jackal Dimna is making a speech to the leopard. (Fables of Bidpai in Arabic. Northern Mesopotamia, about 1220. Bib. Nat., Paris.)

PLATE XVI

The King of the crows and the King of the owls, surrounded by their subjects, prepare to attack each other. (Fables of Bidpai in Arabic. Northern Mesopotamia, about 1220. Bib. Nat., Paris.)

وَأَنْتُمُ الصَّوَابَ وَالْغَلَطَ وَأَنْ جَلِيَّهَ الْحَكَمُ عِنْدِي فَارْتَضُوا بِقَدْرِي وَلَا تَسْتَنْفُوا أَحَدَ

PLATE XVII

A boat on the Euphrates. This boat, like that in Plate **XXV**, is copied from one in an
illustration of a Greek MS. of the Homilies of St. Gregory Nazienzen, dated 880. (Makamat
of Hariri. Northern Mesopotamia, 1222. Bib. Nat., Paris.)

PLATE XVIII

The King of the lions at the mouth of a well, where, the King of the hares assures him,
his enemy is hidden ; the lion and the hare are reflected in the water in which they seem
half-immersed. (Fables of Bidpai in Arabic. Arabian Iraq, about 1230. Bib. Nat.,
Paris.)

PLATE XIX

The King of the crows taking counsel with his subjects after their defeat by the owls.
(Fables of Bidpai in Arabic. Arabian Iraq, about 1230. Bib. Nat., Paris.)

صورۃ ملک الارانب والارانب حوله

PLATE XX

The King of the hares taking counsel with his subjects how to free themselves from their enemies the elephants. (Fables of Bidpai in Arabic. Arabian Iraq, about 1230. Bib. Nat., Paris.)

PLATE XXI

The King of the hares, leading the King of the elephants to a pool, shows him the moon
reflected in the water and pretends it is a goddess. (Fables of Bidpai in Arabic. Arabian

خود الناسك وابنه والحية قلا عضته

PLATE XXII

An ascetic, his son, and the black serpent which bit and killed the youth. (Fables of Bidpai in Arabic. Arabian Iraq, about 1230. Bib. Nat., Paris.)

ضعفة القرد على الديى والسلحفة في الهير

PLATE XXIII

The King of the monkeys, deprived of his power owing to his age, takes refuge in a fig-tree and throws figs to the turtle. (Fables of Bidpai in Arabic. Arabian Iraq, about 1230. Bib. Nat., Paris.)

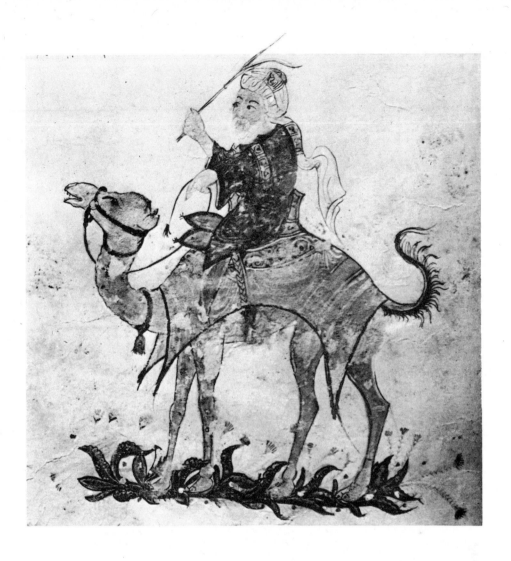

PLATE XXIV

Abu Zaid on his camel. This picture and the seven following ones are the work of an
artist named Yahya, son of Mahmud, son of Yahya and grandson of Kuwwarihā, who
was descended from a family of Aramean Christians. (Makamat of Hariri. Baghdad,
1237. Bib. Nat., Paris.)

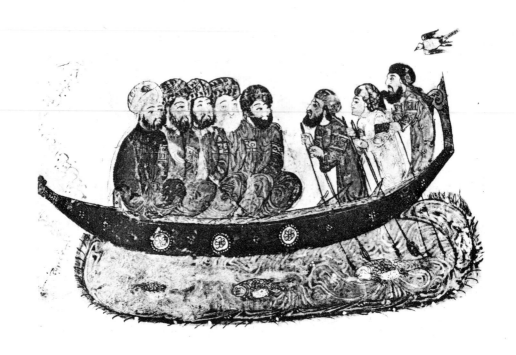

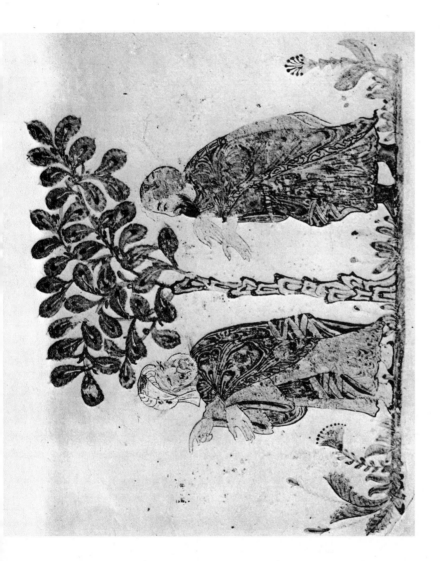

PLATE XXVI

Two Moslems conversing under a tree. (Makamat of Hariri. Baghdad, 1237. Bib. Nat., Paris.)

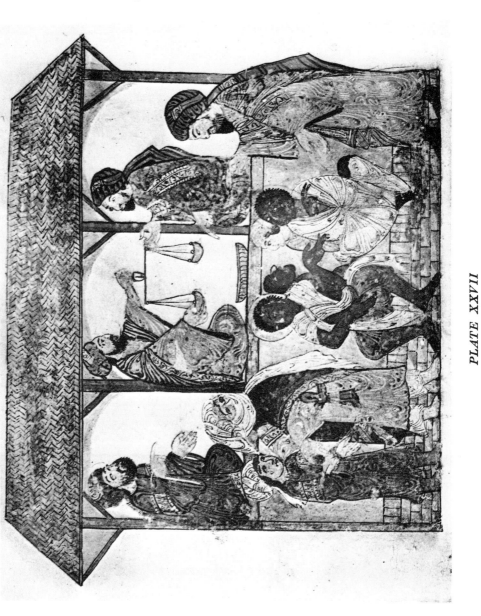

PLATE XXVII

A personage buying a slave, held by a partly-veiled female figure on the left of the composition; see Plate VII. (Makamat of Hariri. Baghdad, 1287. Bib. Nat., Paris.)

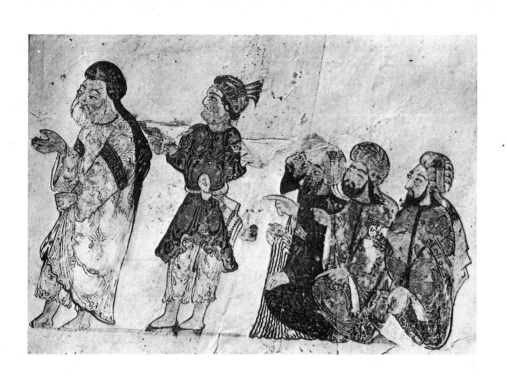

PLATE XXVIII

Al-Haris and several Moslems. (Makamat of Hariri. Baghdad, 1237. Bib. Nat., Paris.)

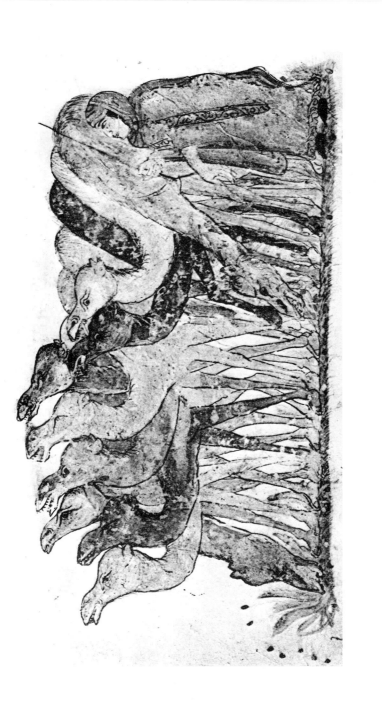

PLATE XXIX

A troup of camels. (Makamat of Hariri. Baghdad, 1237. Bib. Nat., Paris.)

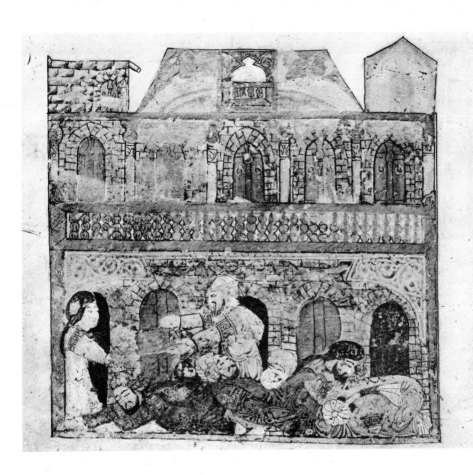

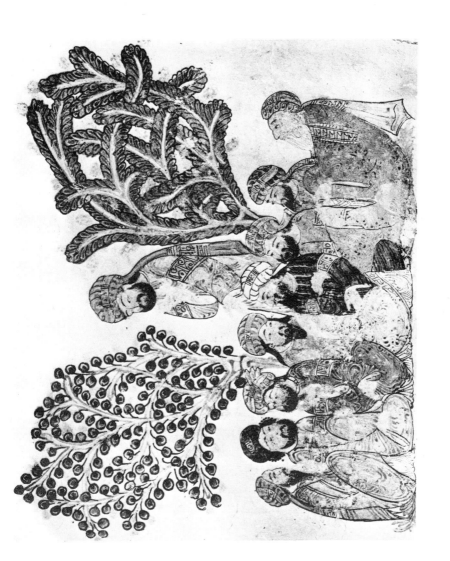

PLATE XXXI

Al-Haris and his companions, talking together before they separate. (Makamat of Hariri, Baghdad 1237, Bib. Nat. Paris.)

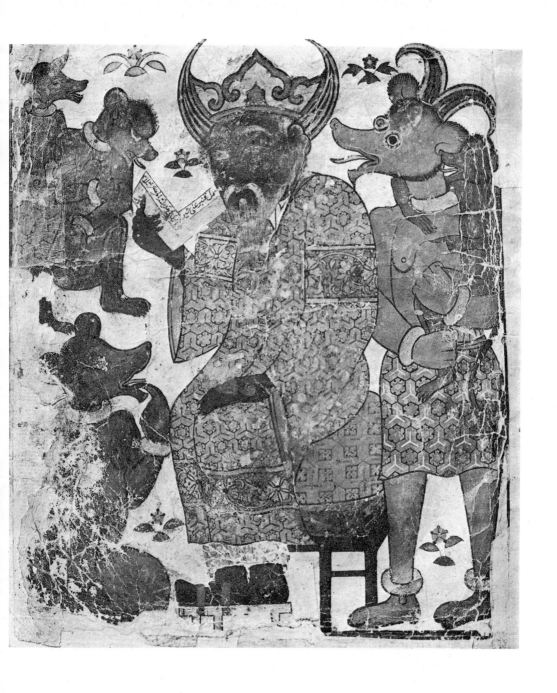

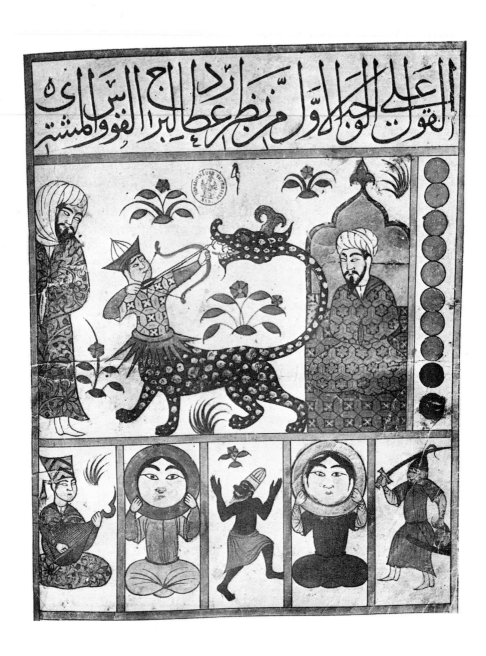

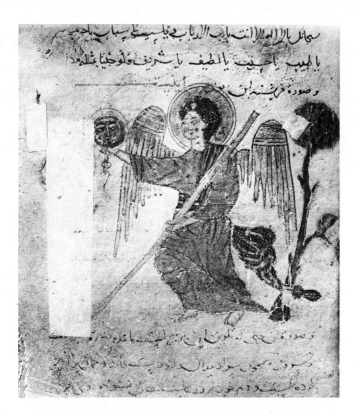

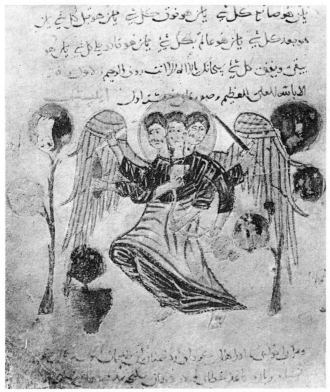

PLATE XXXIV

Two Musulman angels, imitated from the angels in Byzantine mosaics. (Treatise **on**
Magic, by Nasir ad-Din. Caesarea of Cappadocia, 1272. Bib. Nat., Paris.)

PLATE XXXV

Peacocks. (Treatise on Automata, by Jazari. Cairo, 1354. Louvre, Paris.)

PLATE XXXVI

An automaton, worked by water. (Treatise on Automata, by Jazari. Cairo, 1854.
Formerly Martin Collection.)

الجامة فيكون الباقي من الليل احدي عشرة ساعة زمانية والشخص
يسير خلف الشرفات ولا يرى بل ينهم في كل ساعة صوت الا أنه لا عمل
هذه الصور في الليل والنهار على واحد لا يظلم منه شي البتة وعند انقضا
ساعة تخدم النوبة باصوات مزعجة تسمع من بعد وهذه صورتها

PLATE XXXVII

A clock, worked by water ; the hours are marked by the figure in the upper part of the
composition, who occupies each of the twelve battlements on the wall in succession ;
they are sounded by the playing of military music by the seven musicians in the lower
part. The last Chinese Emperor of the Mongol dynasty, Shun-Ti (1333–1368) had
himself made a clock of this type ; Chinese historians speak of it with admiration.
(Treatise on Automata, by Jazari. Cairo, 1354. Formerly Martin Collection.)

PLATE XXXVIII

An automaton worked by water; the statue of a horseman on the top of a domed
building points his spear against the enemies who threaten the capital. An inscription
on the dome tells us that the painting was made for Sultan al-Malik al-Salih Salih al-
Din, who reigned from 1351 to 1354 over the immense Mamluk Empire, Egypt and
Syria. The MS. to which these paintings belong is a copy of one which was presented
to the Ortokid Prince of Hisn Kaifa and Amid, al-Malik al-Salih Nasir ad-Din in 1206.

(Treatise on Automata, by Jazari. Cairo, 1354. Formerly Martin Collection.)

من مَزْرَبِهَا قَضِيب
يَنْفُذُ مِنْ ظَهْرِهَا فِي حَرْفٍ
مُسْتَطِيلٍ وَطَرَفُهُ مَعْطُوفٌ
إِلَى الأَسْفَلِ وَعَلَيْهِ بـ
وَقَمْعٌ مَطْرُوحٌ عَلَى سُقُودٍ
مُعَارِضٍ عَلَيْهِ كَـ وَحَوْضِ
الكِفَّةَ وَالكِفَّةُ وَعَلَيْهَا هـ
وَفِيهِ أُنْبُوبٌ يَنْصَبُّ مِنْهُ
الشَّرَابُ إِلَى القَدَحِ وَعَلَيْهِ قـ
وَخِزَانَةُ الشَّرَابِ وَفِي أَسْفَلِهَا
ثَقْبٌ عَلَيْهِ أُنْبُوبٌ يَقْطُرُ
مِنْهُ الشَّرَابُ إِلَى الكِفَّةِ وَعَلَيْهِ
ـه وَمَصَبُّ الشَّرَابِ فِي
أَعْلَى الخِزَانَةِ وَعَلَيْهِ كـ
فَمِنَ الوَاضِحِ الجَلِيِّ أَنَّهُ مَتَى بَلَّتْ

PLATE XXXIX

An hydraulic automaton; the figure is Egyptian in type. (Treatise on Automata by Jazari. Cairo, 1354. Formerly Martin Collection.)

PLATE XL

(*a*) The cat strangles the partridge and the hare, who, having quarrelled about a terrier, had chosen him to judge between them. (*b*) The son of the King of Yaman is blinded by the parrot whose son he killed. (Fables of Bidpai in Persian. Baghdad, 1280. Bib. Nat., Paris.)

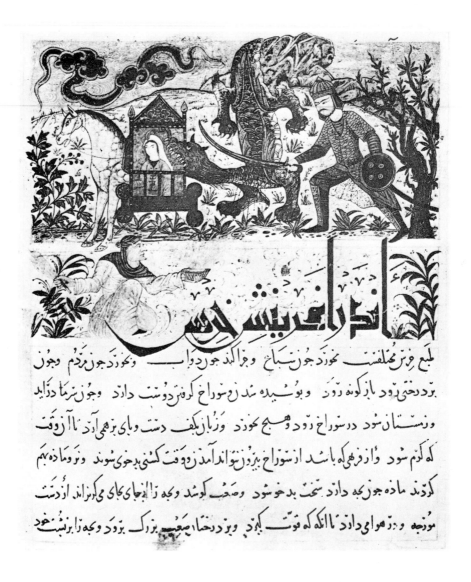

اندر اغريس ...

طبع مرتبت محلقست محوذ چون نباع وجراكذ چورد واب ـــــ وكوذ چون مردم وچون

بردختی بود باز كوه رود وبوشیده شد در سوراخ كرفنز دوست داد وچون بزما دزاید

ونستان سود د سوراخ رود وصبح حوذد وزبان بكف دست وباى برهى آرد ناآروقت

له كذم سود وارفهى كه باسد از سوراخ بزون نوآند آمد زوقت كشنی بحوى سوند ونوماده بهم

كردذ ماده چوزيجه داد سخت بدخوسود وصحب كوسد وجه زا آنجاى جاى مى كرزائد از دست

مونجه و نز هواى داد ناآنكه كه قوت ـــــ كيذر وبز دختا صغيب بزرك بزود وجه زا برنست سود

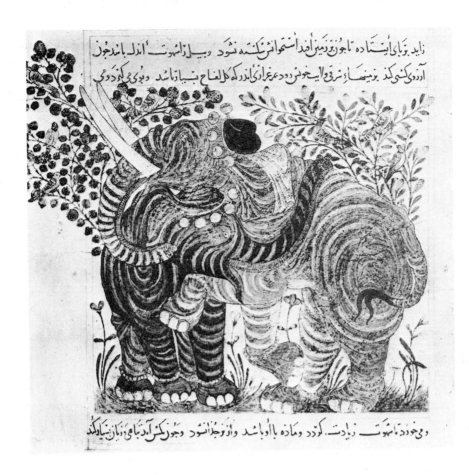

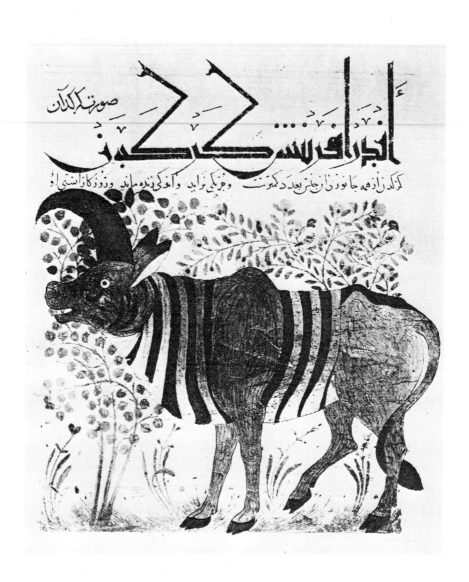

PLATE XLIII

A rhinoceros. (Treatise on Natural History, by Ibn Bakhtishu. Tabriz, 1295. Pierpont Morgan Library, New York.)

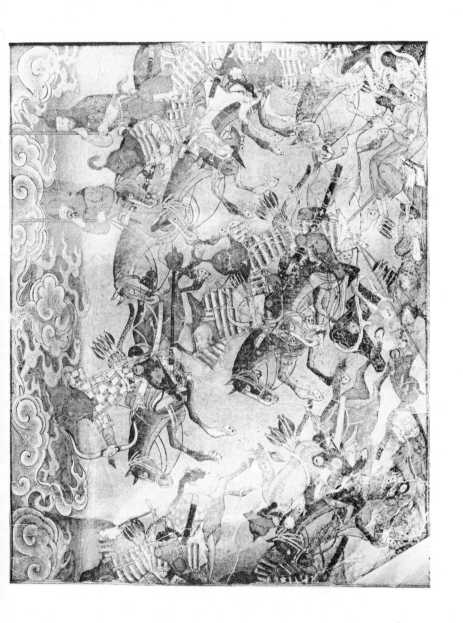

PLATE XLIV

The paladin Faramurz, son of the paladin Rustam, leads the Persian army against the land of Kabul. (Book of the Kings, by Firdawsi. Tabriz, about 1810. Louvre, Paris.)

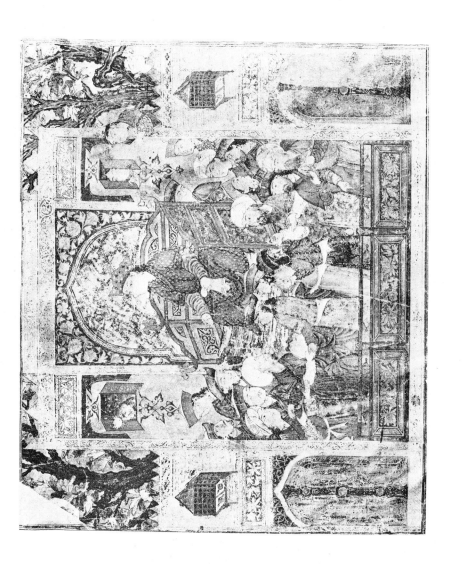

PLATE XLV

Garshasp, King of Persia, seated on his throne surrounded by his Court. (Book of the Kings, by Firdawsi. Tabriz, about 1310. Pozzi Collection, Paris.)

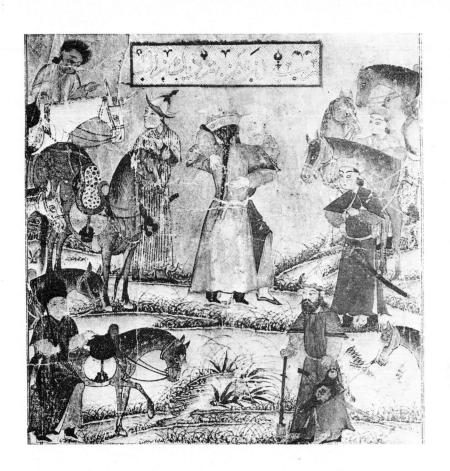

PLATE XLVI

The paladin Bahman imploring Zal, son of Nariman, to save Persia. (Book of the
Kings, by Firdawsi. Tabriz, about 1310. Pozzi Collection, Paris.)

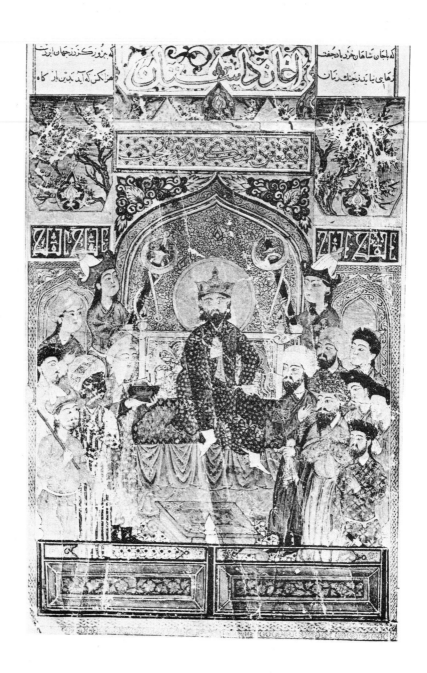

PLATE XLVII

Alexander, King of Persia, seated on his throne surrounded by his Court. The portrait of Alexander is copied from the figure of Christ at Ravenna. (Book of the Kings, by Firdawsi. Tabriz, about 1310. Louvre, Paris.)

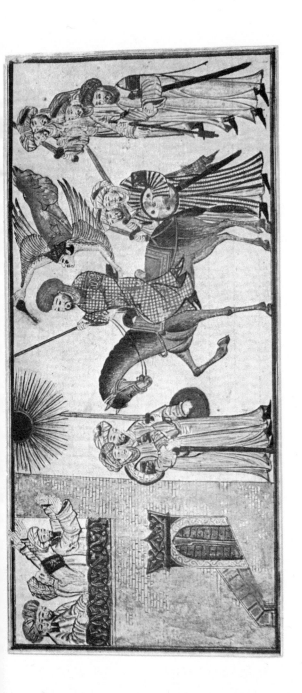

PLATE XLVIII

The Prophet Muhammad besieging the fortress of Banu an-Nadhir; an angel, imitated from the angels in Byzantine paintings, anoints his head. (History of the World, by Rashid ad-Din. Tabriz, 1306–1314. Royal Asiatic Society, London.)

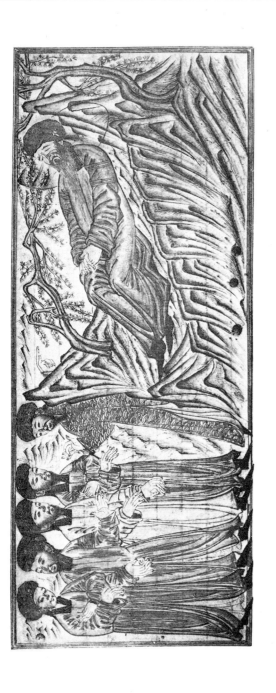

PLATE XLIX

Death of Moses, after giving his instructions to the Israelites. (History of the World, by Rashid ad-Din. Tabriz, 1306–1814. Royal Asiatic Society, London.)

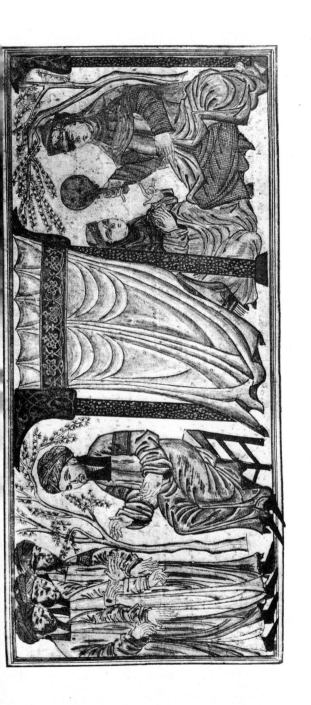

PLATE L

Jacob receiving the angels, one of whom gives him the name of Israel. Rachel is inside the tent at her toilet ; the illuminator of the book has probably represented Abraham visited by the three angels, Sarah appearing behind a curtain. (History of the World, by Rashid ad-Din. Tabriz, 1306–1314. Royal Asiatic Society, London.)

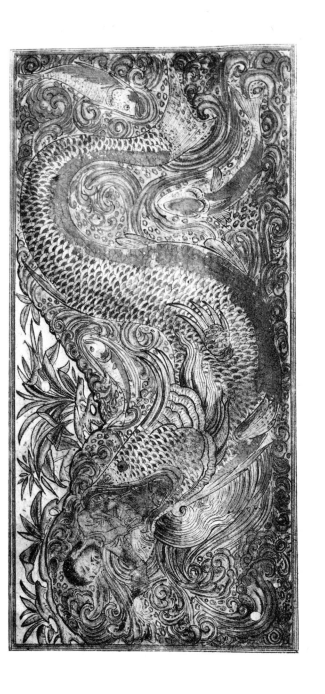

PLATE LI

Jonah swallowed by the whale. The whale is copied from a fish painted by a Chinese artist. (History of the World, by Rashid ad-Din. Tabriz, 1306–1814. Royal Asiatic Society, London.)

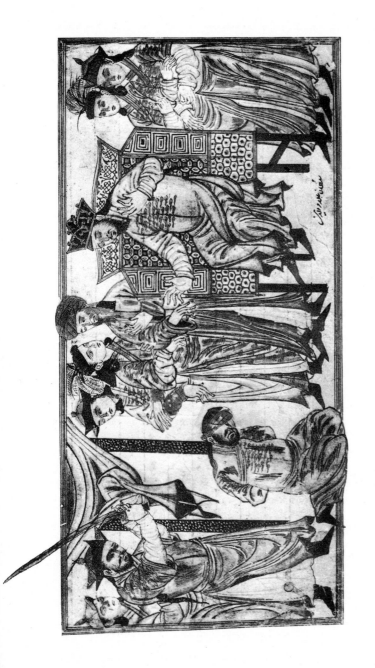

PLATE LII

The Sultan Ala ad-Din Muhammad Shah Khalaji, of Delhi, putting to death his uncle, Jalal ad-Din Firuz Shah Khalaji. (History of the World, by Rashid ad-Din. Tabriz, 1306–1814. Royal Asiatic Society, London.)

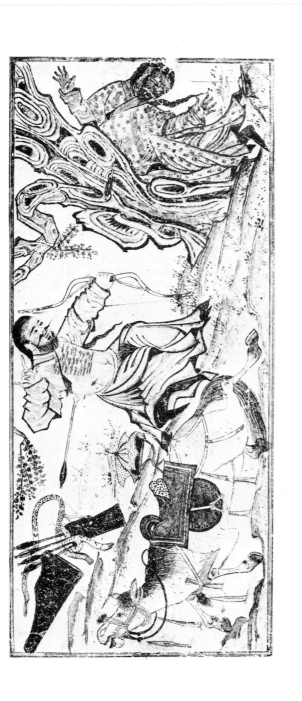

PLATE LIII

Rustam shoots his brother Shaghad with an arrow, from behind a tree. (History of the World, by Rashid ad-Din. Tabriz, 1306–1814. Edin. Univ.)

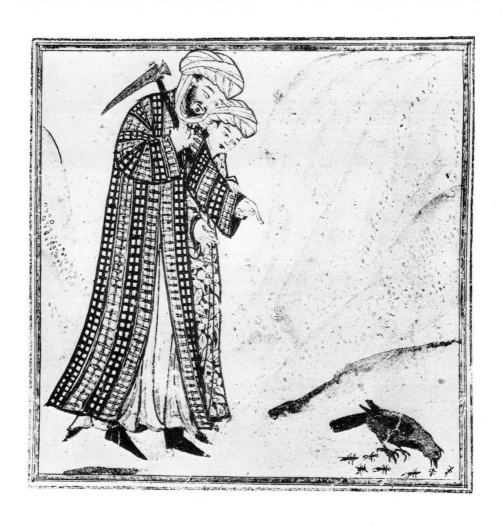

PLATE LIV

Abd al-Muttalib and his son al-Haris seeking where to dig the well Zamzam; notice a crow eating ants. (History of the World, by Rashid ad-Din. Tabriz, 1306–1314. Edin. Univ.)

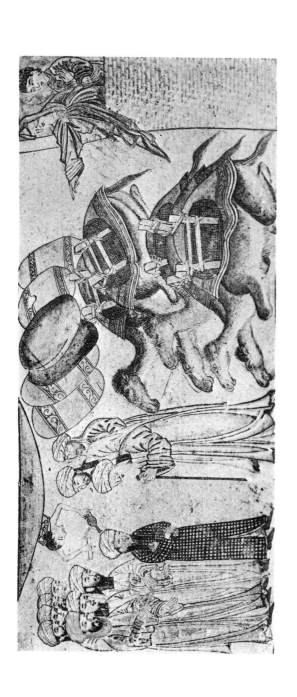

PLATE LV

The child Muhammad is questioned by the Christian monk Bahira, who recognizes in
him signs of his being a Prophet; on the right several figures which are copied from
Byzantine figures; an angel issuing from heaven, as in a mosaic of the Later Empire,
anoints the head of Muhammad. (History of the World, by Rashid ad-Din. Tabriz,
1306–1314. Edin. Univ.)

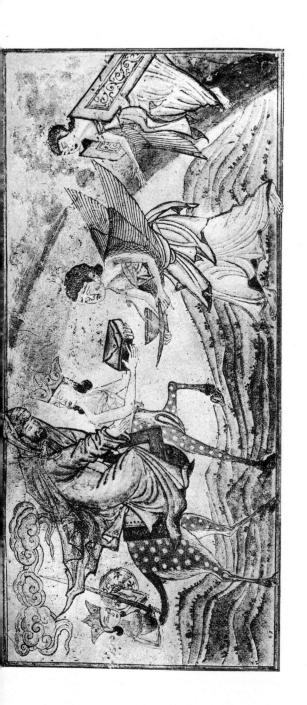

PLATE LVI

The Prophet ascends to heaven on Buraq, accompanied by the archangel Gabriel; an angel offers him a cup of milk. (History of the World, by Rashid ad-Din. Tabriz, 1306–1814. Edin. Univ.)

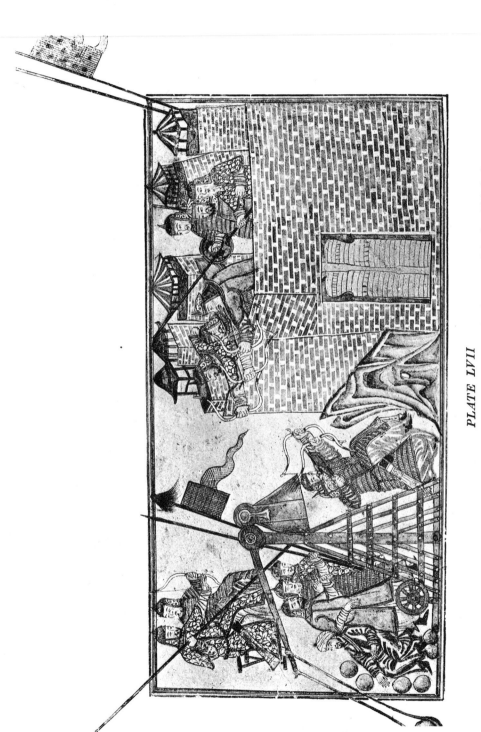

PLATE LVII

The troops of the Sultan Mahmud of Ghazna besiege the fortress of Arak which is de-
fended by the army of Seistan ; on the left of the composition we see the manjanik
which was used to launch round balls against towns ; they were often wrapped in cloths
soaked in mineral oil to start fires. (History of the World, by Rashid ad-Din. Tabriz,
1306–1314. Edin. Univ.)

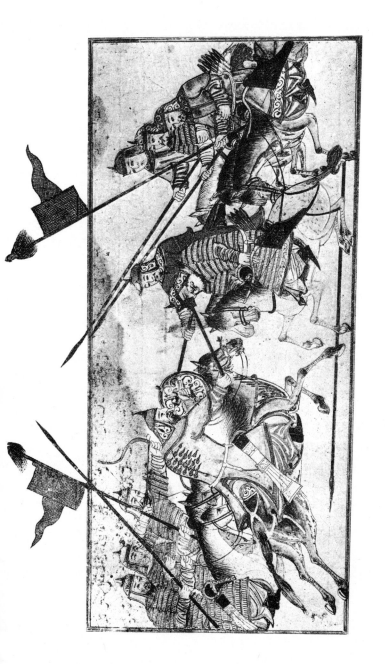

PLATE LVIII

The troops of the Sultan Mahmud of Ghazna engage the armies of the King of India.
(History of the World, by Rashid ad-Din. Tabriz, 1306–1314. Edin. Univ.)

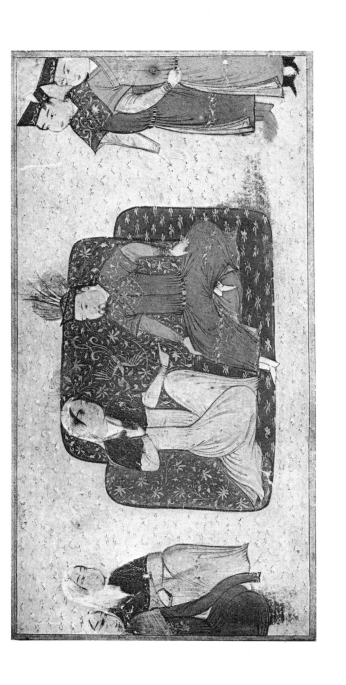

PLATE LIX

Yisukai Bahadur, the father of Chingiz Khan, and his wife Ulun Eke ; in the decoration of the carpet is the Chinese phœnix. (History of the Mongols, by Rashid ad-Din. Tabriz, about 1810. Bib. Nat., Paris.)

PLATE LX

Chingiz Khan proclaims himself Emperor after his victories over the Turkish peoples ; his throne is surmounted by the golden bird, the emblem of sovereignty in China ; on the right the horses' tails which served as standards among the Turks. (History of the Mongols, by Rashid ad-Din. Tabriz, about 1310. Bib. Nat., Paris.)

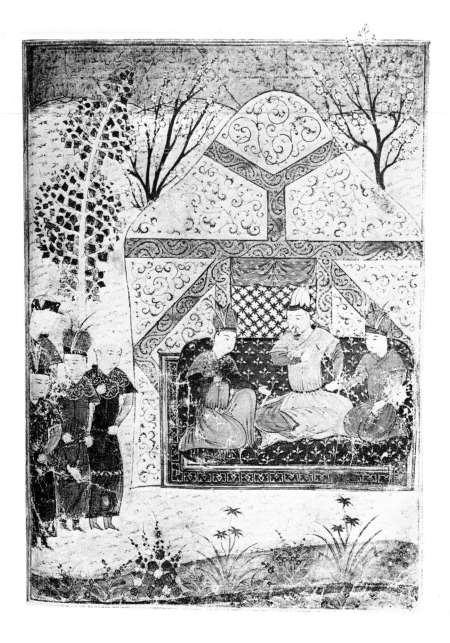

PLATE LXI

Ogotai, son of Chingiz, seated before his tent on a Persian carpet, surrounded by his sons, one of whom wears a Chinese cap and another a turban. (History of the Mongols, by Rashid ad-Din. Tabriz, about 1310. Bib. Nat., Paris.)

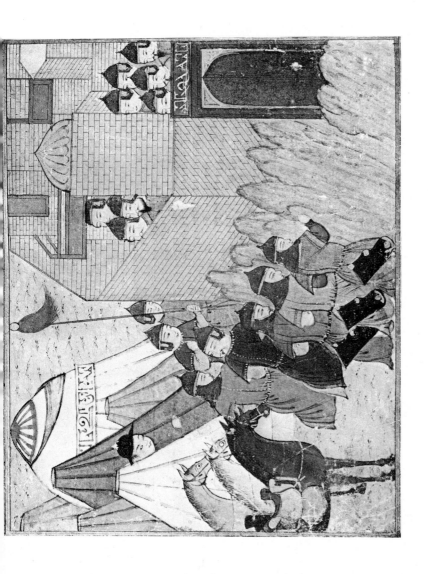

PLATE LXII

The Mongol army under Oroghotu Noyan, having taken Baghdad, comes to besiege Irbil. (History of the Mongols, by Rashid ad-Din. Tabriz, about 1310. Bib. Nat., Paris.)

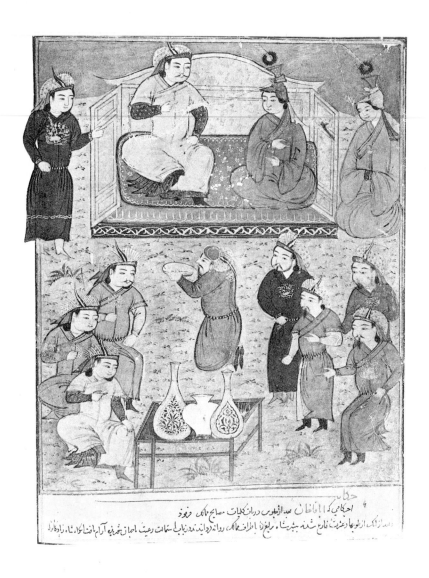

PLATE LXIII

Arghun, Mongol Prince of Persia, seated on his throne with one of his wives; another
is near the throne, in front of which stand five Mongol princes. (History of the Mongols,
by Rashid ad-Din. Tabriz, about 1310. Bib. Nat., Paris.)

PLATE LXIV

Ghazan, prince of Persia, son of Arghun, at the age of eight, hunting onagers ; he is mounted, Cossack-fashion, on a very high saddle with short stirrups. (History of the Mongols, by Rashid ad-Din. Tabriz, about 1810. Bib. Nat., Paris.)

PLATE LXV

Ghazan, after the capture of Nishapur, orders the execution of an officer who had helped
in the pillage of the town and had molested two Persian ladies; the short-handled whip
held by Ghazan is identical with the Cossack nagaika. (History of the Mongols, by
Rashid ad-Din. Tabriz, about 1310. Bib. Nat., Paris.)

PLATE LXVI

(*a*) The lion rending the bull whose horn pierces his belly. (*b*) The cat talking to the rat in the presence of the owl and the hedgehog. (Fables of Bidpai, in Persian. Tabriz, about 1340. Bib. Nat., Paris.)

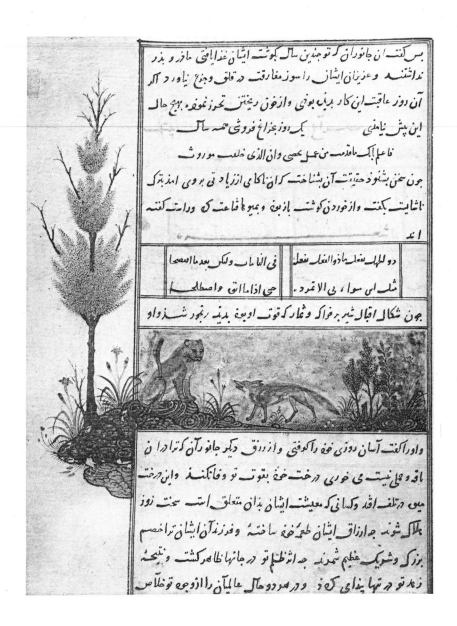

بس کفت ان جانوران که توجدین سال کوشت ایشان غذا باقی مافر و بذر
نداشتند و عزیزان ایشان را سوز مفارقت در قلق و جزع بناورد آگر
آن روز عاقبت ان کار بیان بوئی و از خون ریختن تحرز نموده بدیج حال
این پیش نیامئی یک روز عرائع فروشی همه سال

فاعلم آنک مافدمسن عمل یحیی وان الذی خلف موروث
جون سخن بشنود حقیقت آن بشناخت کراه ناکای ازز یاد تی بروی امذبتک
ناشایست یکنت و از خوردن کوشت بازبن و میوه ها قناعت کنه ورادت کنته
اند

دو للمهرب بعلل ماذ و العقل نفعل	فی الا ماب ولکن بعد ما ابصها
مثل اس سواء ی الا منرد •	حی اذا ما اتق و اصطلمر

جون شکال اقبال شیر بر فراک و عذار که قوت اوبغ بدبه رنجور شد ذو او

و اورا کفت آسان روزی خف را کوفتی و از رزق دیگر جانوران آن کترا دارا ن
نافع و جلی نیست ی خوری درخت خف بقوت تو وفائکنند وان درخت
میوه درتلف افد وکسانی که معیشت ایشان بدان متعلق است سخت نوز
بلاک شوند جدا رزاق ایشان طوعه خف ساخته و فرزندان ایشان نراخصم
بزرک و شریک عظیم شمرد جداثر ظلم تو در جانها ظاهر کشت و نتیجه
زهد تو در تنها بیدای که و در مرد و حال عالیان را از وجوه تو خلاص

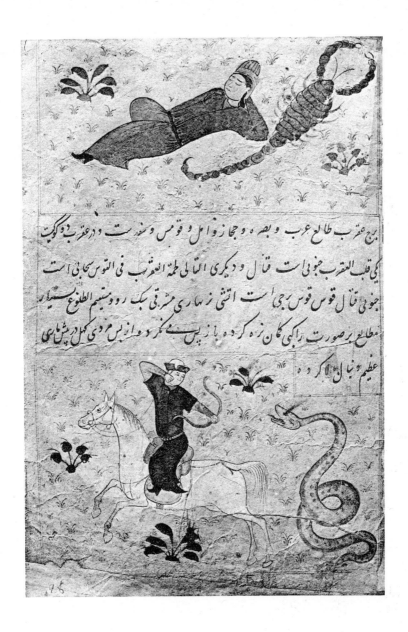

PLATE LXVIII

In the upper part, the zodiacal sign of the Scorpion represented by the figure of a scorpion
beside a sleeping man; below, Sagittarius, represented as a man shooting an arrow;
behind him are a blue man and a serpent; this is a copy of a Hindu composition.
(Kazwini, Marvels of Creation. Tabriz, 1388. Bib. Nat., Paris.)

PLATE LXIX

The archangel Gabriel beneath the Lotus of Infinity; he appears as a young girl dressed in the Imperial yellow silk robes of China, with wings copied from those in mosaics of the Late Empire. (Kazwini, Marvels of Creation. Tabriz, 1888. Bib. Nat., Paris.)

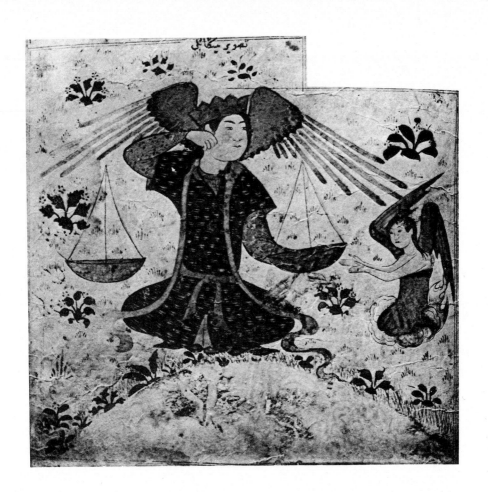

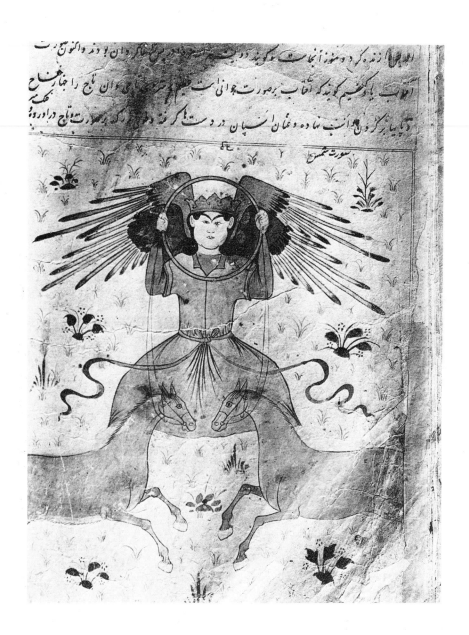

PLATE LXXI

The Sun, wearing a crown, between two steeds and holding the sun's orb round his head;
this figure is a relic of the Greek representation of Phœbus Apollo driving a quadriga.
(Kazwini, Marvels of Creation. Tabriz, 1388. Bib. Nat., Paris.)

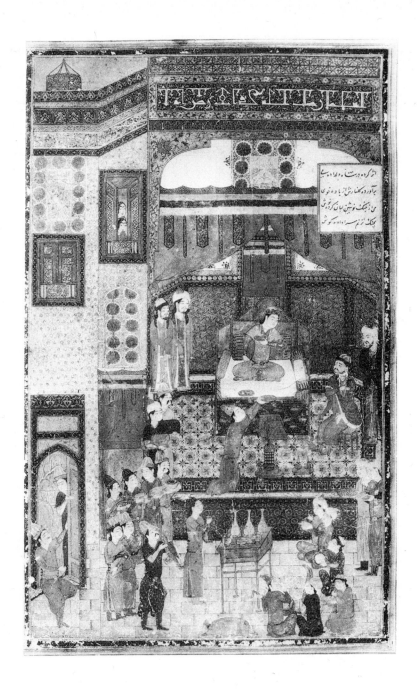

Note: Persian text present in upper-right cartouche and calligraphic band.

PLATE LXXII

Humai, Prince of Persia, is received at the Court of China and falls in love with the Emperor's daughter Humayun, whom he sees at one of the windows of the harem. (The Loves of Humai and Humayun, by Khadju Kirmani. Baghdad, 1396. Brit. Mus., London.)

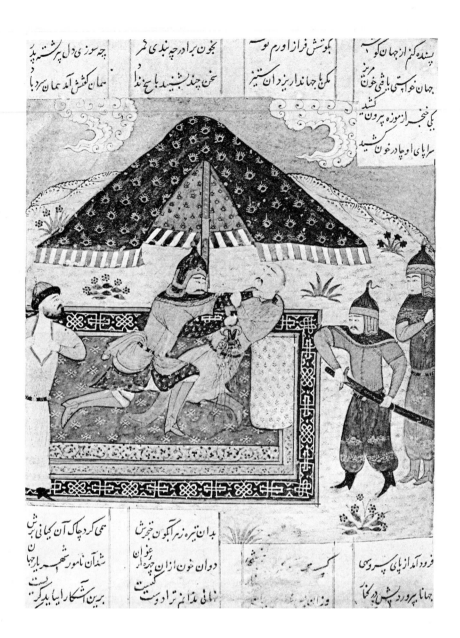

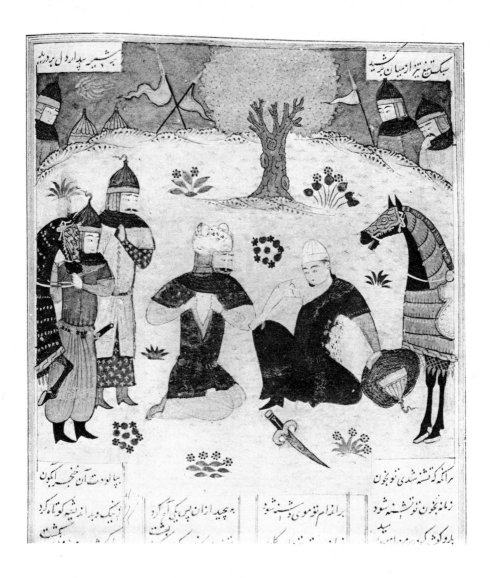

PLATE LXXIV

Rustam recognizes Sohrab, his son by the daughter of the King of the Turks, whom he has just wounded mortally ; the horse wears a cuirass after the Chinese fashion adopted by the Turks, the Mongols and the Japanese early in the Middle Ages. (Book of the Kings, by Firdawsi. Herat, about 1430. Bib. Nat., Paris.)

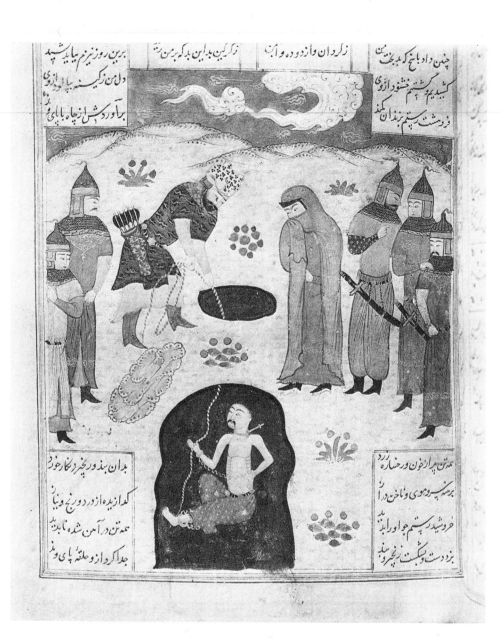

PLATE LXXV

Rustam takes Bizhan from the pit where he has been flung by the orders of Afrasiab, King of the Turks. Manizha, daughter of Afrasiab, who had fed Bizhan with bread, procured by begging, watches the scene. (Book of the Kings, by Firdawsi. Herat, about 1430. Bib. Nat., Paris.)

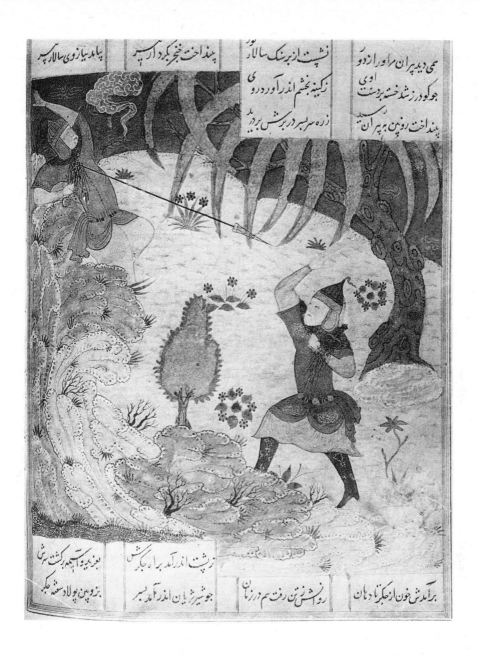

PLATE LXXVI

Fight between the Iranian hero Gudarz and Piran, a knight of Afrasiab's army ; Gudarz,
who stands on some rocks, is wounded by a javelin flung by Piran. (Book of the Kings,
by Firdawsi. Herat, about 1430. Bib. Nat., Paris.)

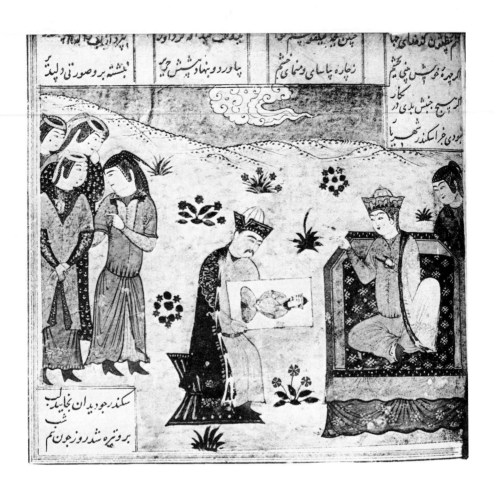

PLATE LXXVII

Kaidafa, Queen of Spain, receives at her Court Alexander, who had come to her country
in disguise; she gives him his portrait which she had had painted secretly in Egypt.
(Book of the Kings, by Firdawsi. Herat, about 1430. Bib. Nat., Paris.)

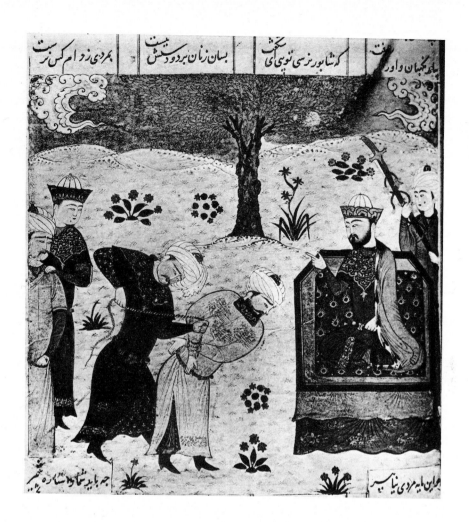

PLATE LXXVIII

Sapor, King of Persia, having come disguised to the Court of the Roman Emperor, is brought before him in chains. (Book of the Kings, by Firdawsi. Herat, about **1430**. Bib. Nat., Paris.)

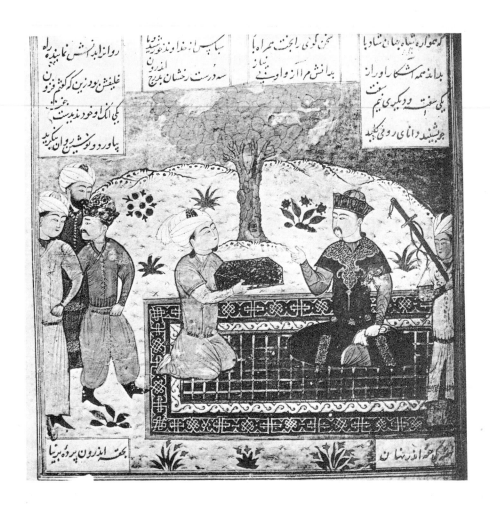

PLATE LXXIX

Khusrau Anushirwan, King of Persia, orders Buzurjmihr to guess what is inside a closed casket. (Book of the Kings, by Firdawsi. Herat, about 1430. Bib. Nat., Paris.)

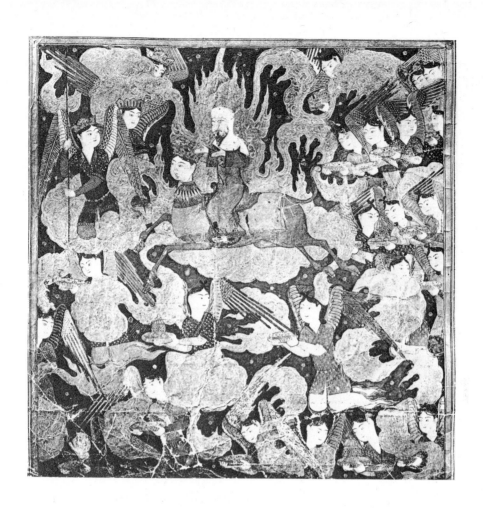

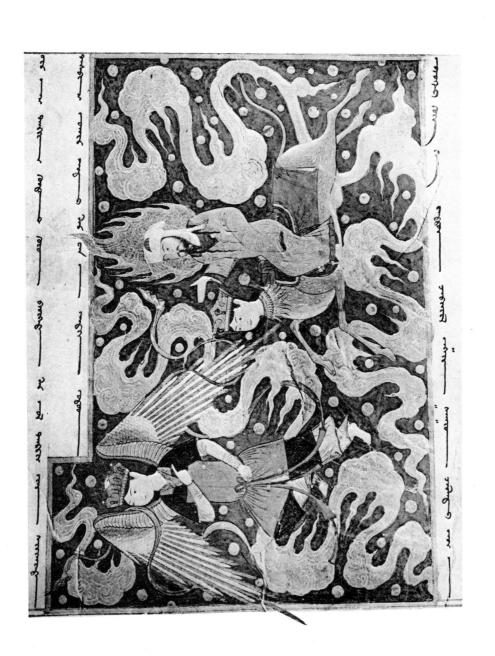

PLATE LXXXI

The Prophet Muhammad arrives on the shores of the White Sea. (Apocalypse of Muhammad. Herat 1436. Bib. Nat., Paris.)

PLATE LXXXII

Moses going to greet Muhammad. (Apocalypse of Muhammad. Herat, 1436.
Bib. Nat., Paris.)

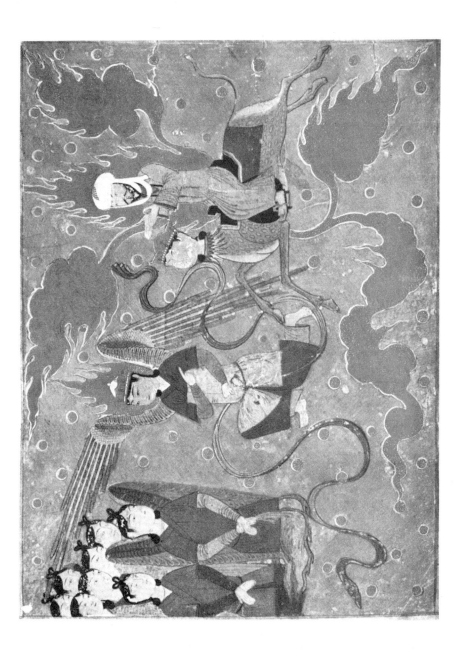

PLATE LXXXIII

Muhammad attains to the Third Heaven. (Apocalypse of Muhammad. Herat, 1436. Bib. Nat., Paris.)

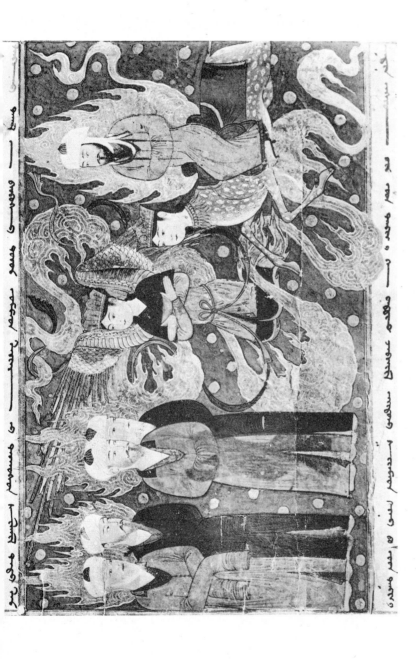

PLATE LXXXIV

The Prophet Muhammad meets the prophets Ismail, Is-hak and Lot; there is an extra figure in this composition. (Apocalypse of Muhammad. Herat, 1436. Bib. Nat., Paris.)

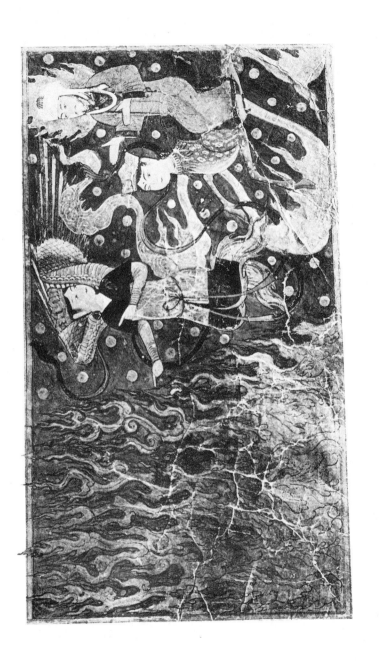

PLATE LXXXV

The Prophet Muhammad perceives the fiery sea which will be cast into Hell on the Resurrection Day. (Apocalypse of Muhammad. Herat, 1436. Bib. Nat., Paris.)

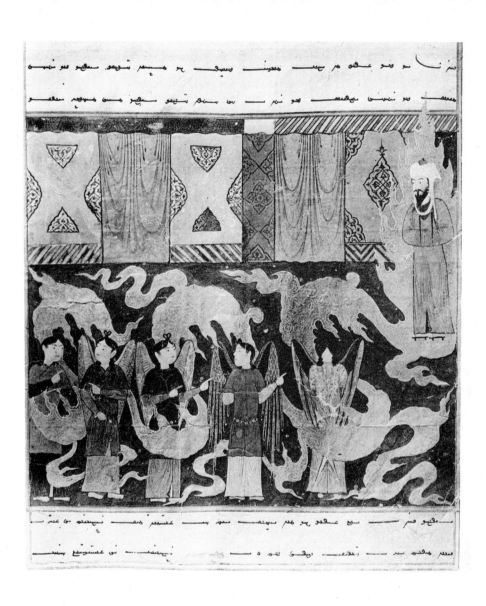

PLATE LXXXVI

The Prophet Muhammad perceives, close to the throne of Allah, seventy thousand tents, each as large as the world, separated from each other by a distance of seventy thousand years, in each of which are fifty thousand angels who adore Allah. (Apocalypse of Muhammad. Herat, 1436. Bib. Nat., Paris.)

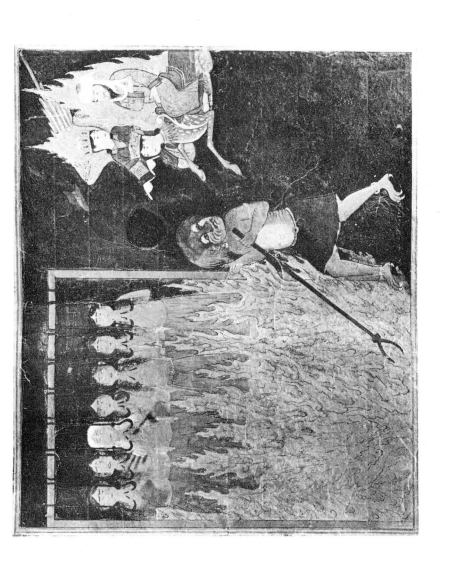

PLATE LXXXVII

Muhammad sees in Hell the women who have introduced bastards into their husbands' families; the devil who feeds the infernal fires is copied from a Buddhist demon of Central Asia. (Apocalypse of Muhammad. Herat, 1436. Bib. Nat., Paris.)

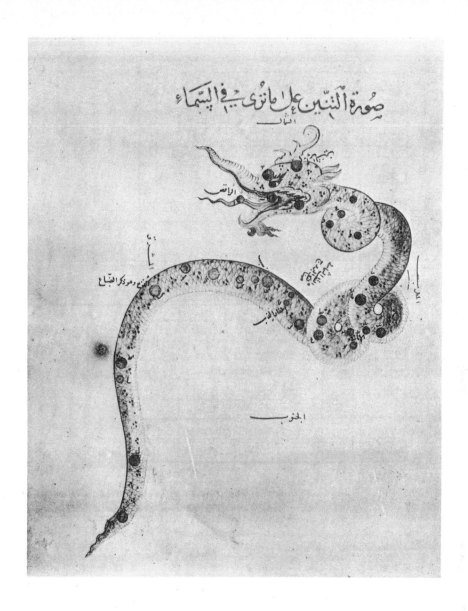

PLATE LXXXVIII

The constellation of the Dragon as seen in the heavens ; this painting copies the Chinese
dragon : the Persian artist has omitted its paws. (Tables of the Fixed Stars, by Abd
ar-Rahman as-Sufi. Samarkand, about 1437. Bib. Nat., Paris.)

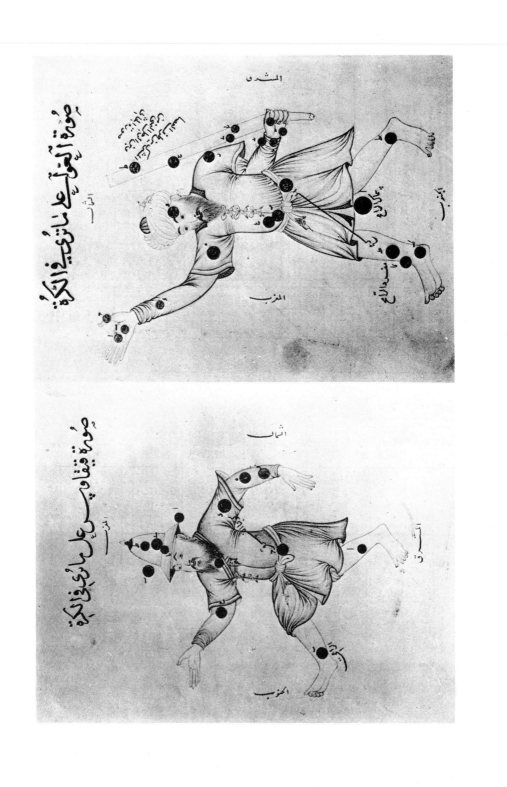

PLATE LXXXIX

The constellations of Cepheus and Boötes as seen on the celestial globes. (Tables of the Fixed Stars by Abd ar-Rahman aṣ-Ṣūfī. Samarkand, about 1437. Bib. Nat. Paris.)

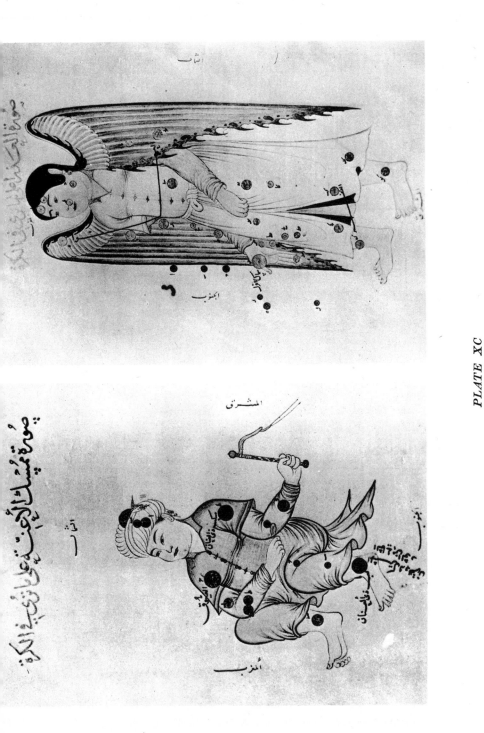

PLATE XC

The constellations of the Charioteer, literally, 'he who holds the reins,' and the Virgin or Spica, as seen on the celestial globes. (Tables of the Fixed Stars, by Abd ar-Rahman as-Sufi. Samarkand, about 1437. Bib. Nat., Paris.)

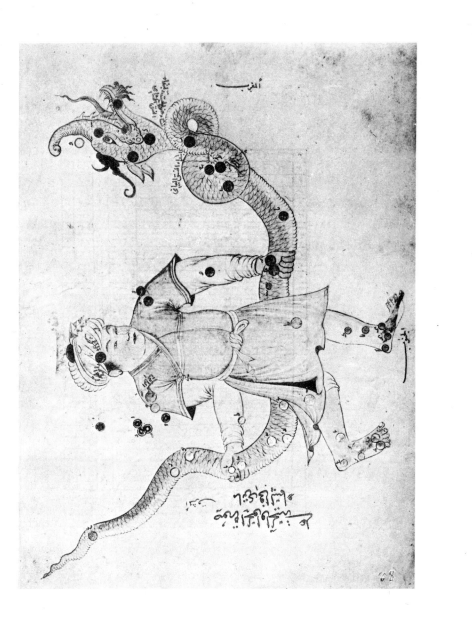

PLATE XCI

The two constellations of Serpentarius and the Serpent, as seen in the sky ; the serpent is a copy of the Chinese Dragon. (Tables of the Fixed Stars, by Abd ar-Rahman as-Sufi. Samarkand, about 1437. Bib. Nat., Paris.)

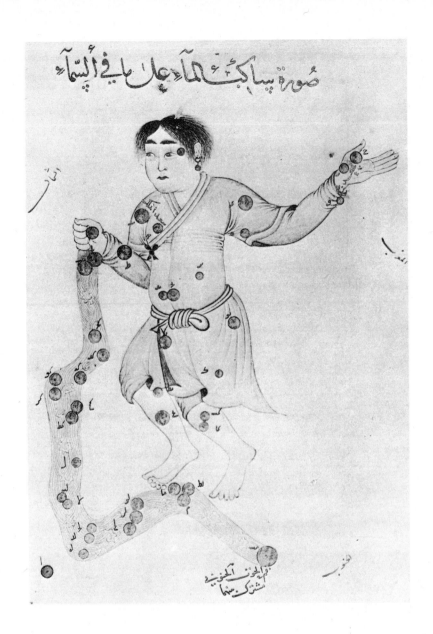

PLATE XCII

The constellation of Hyades or Aquarius, as seen in the heavens. (Tables of the Fixed
Stars, by Abd ar-Rahman as-Sufi. Samarkand, about 1437. Bib. Nat., Paris.)

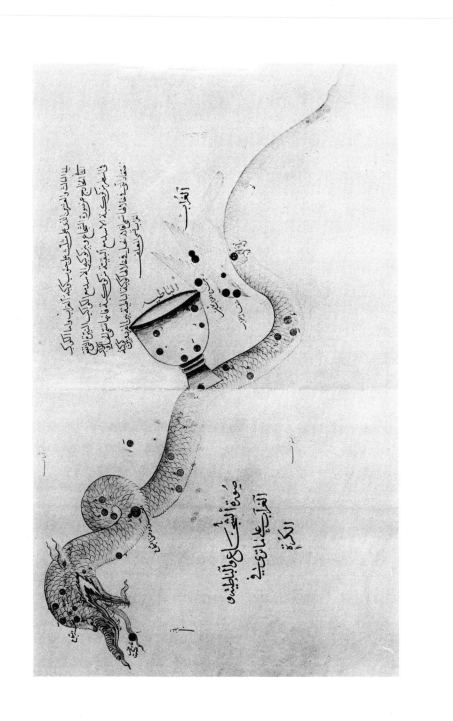

PLATE XCIII

The constellations of the Serpent, the Bowl and the Crow as seen on the celestial globes.
(Tables of the Fixed Stars, by Abd ar-Rahman as-Sufi. Samarkand, about 1437.
Bib. Nat. Paris.)

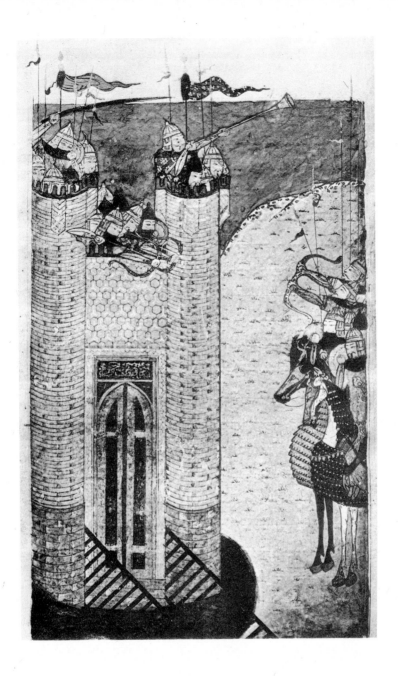

PLATE XCV

Small birds painted by the celebrated Bihzad in panels between the verses in a collection
of poems by Amir Shahi of Firuzkuh. (Diwan of Amir Shahi. Herat, about 1480.
Bib. Nat., Paris.)

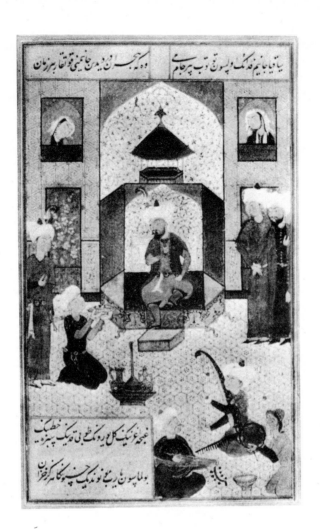

PLATE XCVI

Sultan Hosain Mirza, Timurid King of Khurasan, in a hall of his palace. (Diwan of
the Sultan Hosain Mirza. Herat, 1485. Bib. Nat., Paris.)

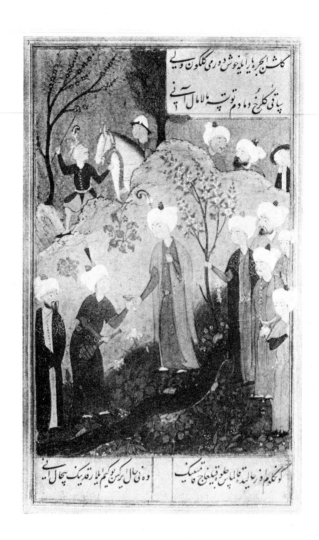

PLATE XCVII

Sultan Hosain Mirza walking in the country near Herat. (Diwan of Sultan Hosain Mirza. Herat, 1485. Bib. Nat., Paris.)

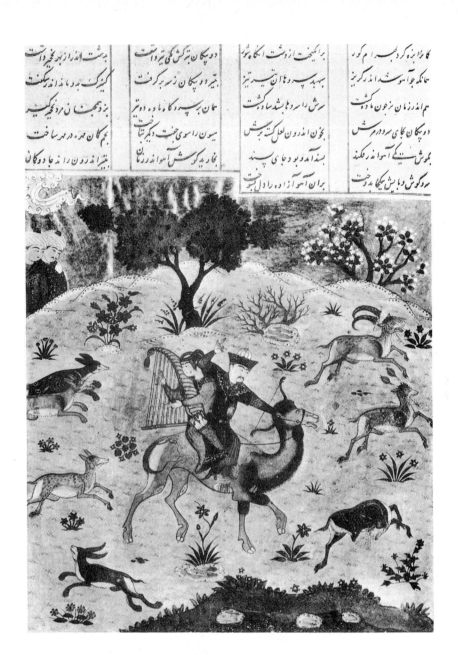

PLATE XCVIII

Bahram Gur, Sassanid King of Persia, hunting with his favourite Azada, who is riding
pillion behind him, playing the harp. (Book of the Kings, by Firdawsi. Herat, 1486.
Brit. Mus., London.)

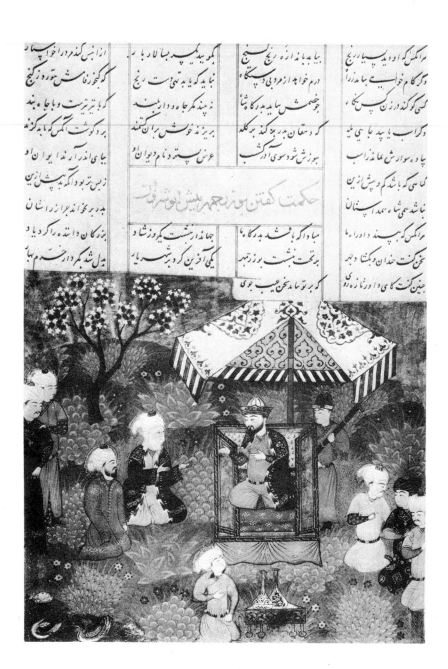

Persian verse text in columns (right-to-left)

PLATE XCIX

Khusrau Anushirwan, Sassanid King of Persia, seated on a Chinese throne, conversing with his minister the wise Buzurjmihr. (Book of the Kings, by Firdawsi. Herat, 1486. Brit. Mus., London.)

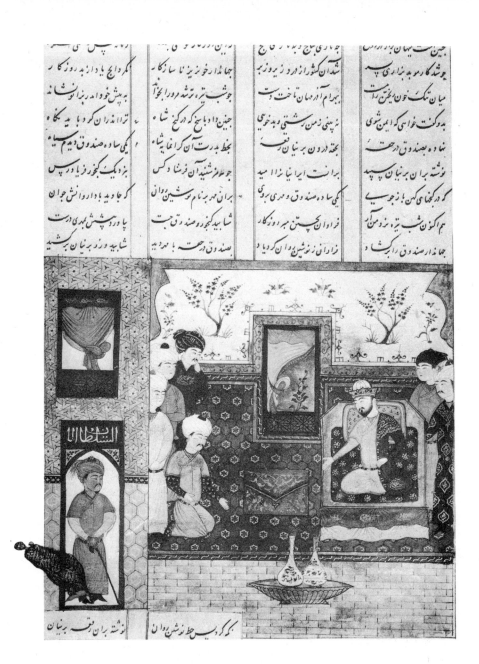

PLATE C

Hormuzd, Sassanid King of Persia, reprimands his son Khusrau Parviz. (Book of the
Kings, by Firdawsi. Herat, 1486. Brit. Mus., London.)

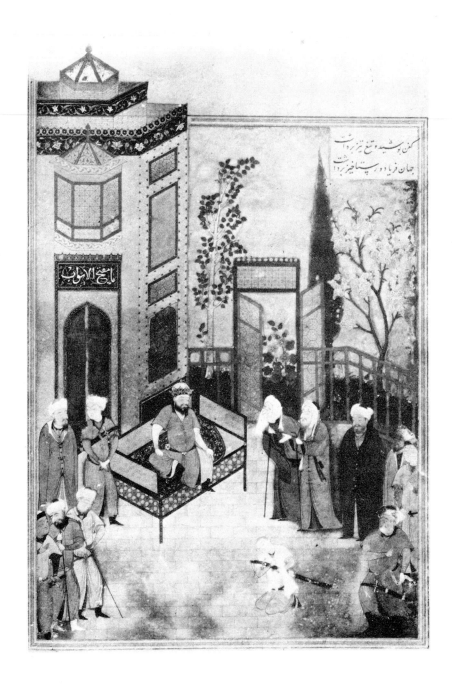

PLATE CI

The ministers of King Hormuzd implore him to have pity on his son Khusrau Parviz
who kneels before the throne ; this and the two following paintings are purely Bihzadian
in style, and this one is attributed to Bihzad. (Poems of Nizami. Herat, 1494. Brit.
Mus., London.)

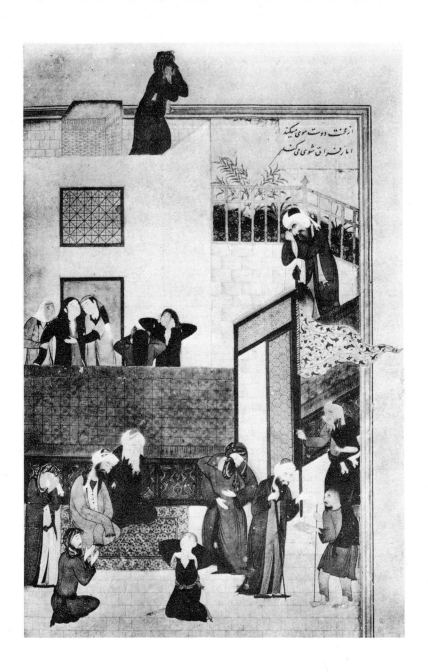

PLATE CII

The wives and friends of Ibn Salam Baghdadi in mourning for his death; this painting
is also attributed to Bihzad. (Poems of Nizami. Herat, 1494. Brit. Mus., London.)

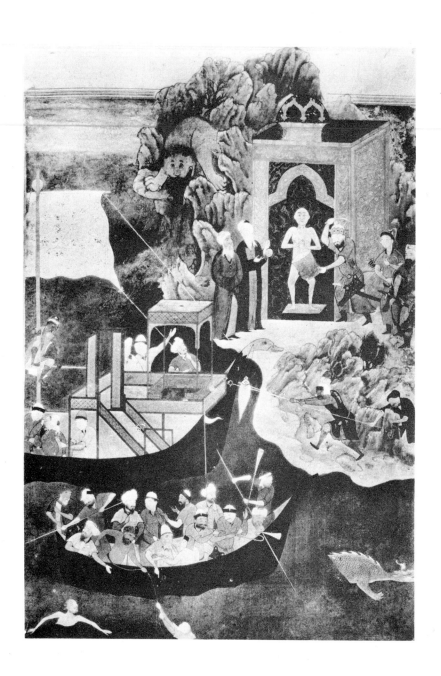

PLATE CIII

Alexander the Great arriving at a temple of idols in India (see Plate CLXVI). (Poems
of Niżami. Herat, 1494. Brit. Mus., London.)

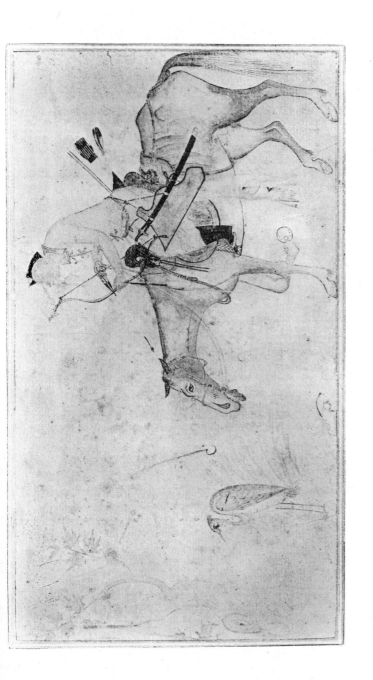

PLATE CIV

A Turkoman horseman preparing to shoot an arrow. (Herat, late fifteenth century. Louvre, Paris.)

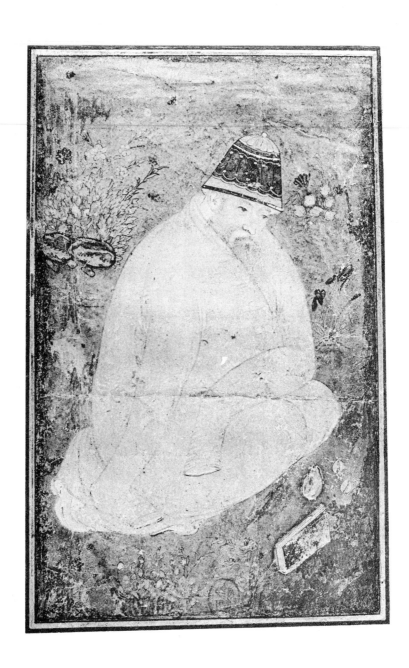

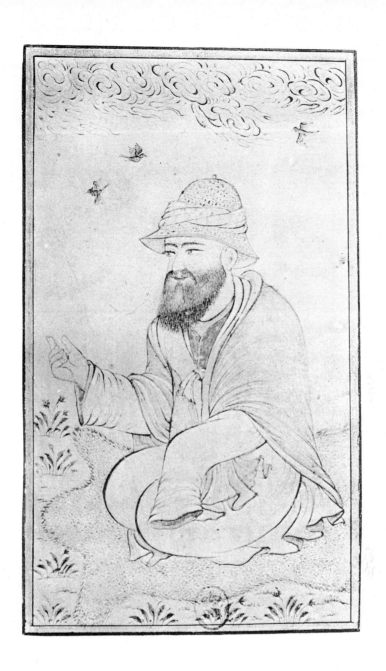

PLATE CVI

Portrait of a Dervish. (Herat, about 1505. Bib. Nat., Paris.)

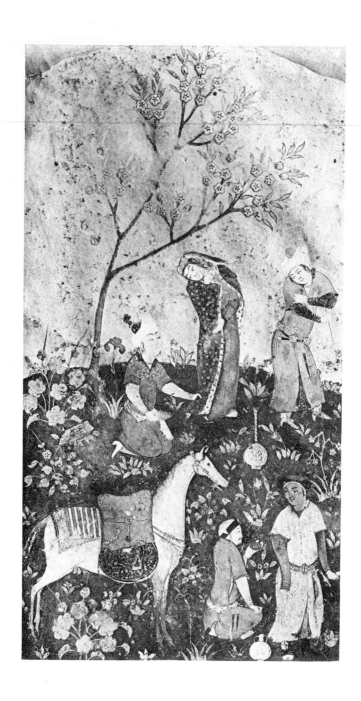

PLATES CVII, CVIII

Picture on two opposite pages representing a Persian prince and his favourite, surrounded by their attendants, amusing themselves in the gardens of their palace; this picture, which is conceived in a much lighter spirit than the paintings illustrating the collections of poetry, is signed by the illuminator Mahmud or Shaikhzada Mahmud, who was a celebrated artist (see Plates CXIV and CXV). (The Gift of the Pious Men, by Jami. Herat, 1499. Bib. Nat., Paris.)

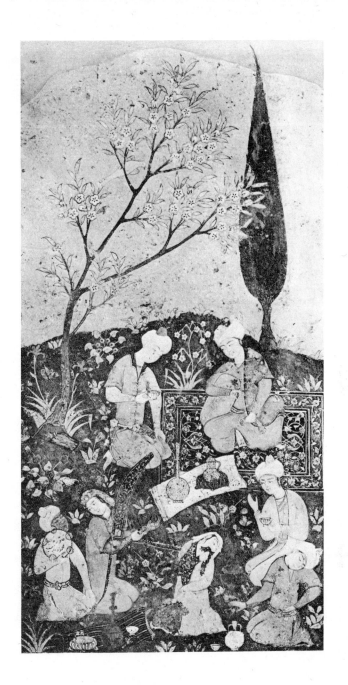

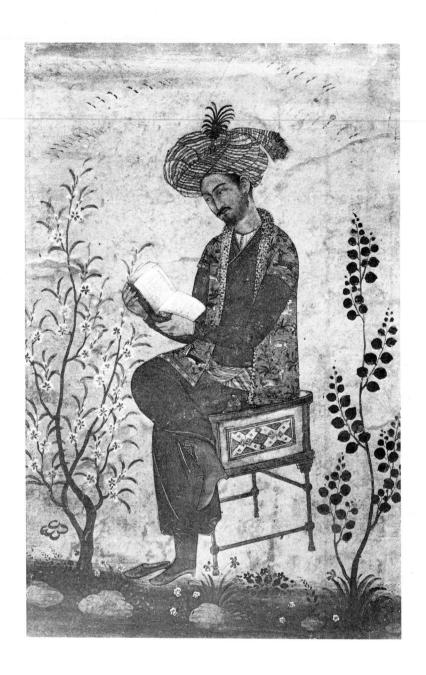

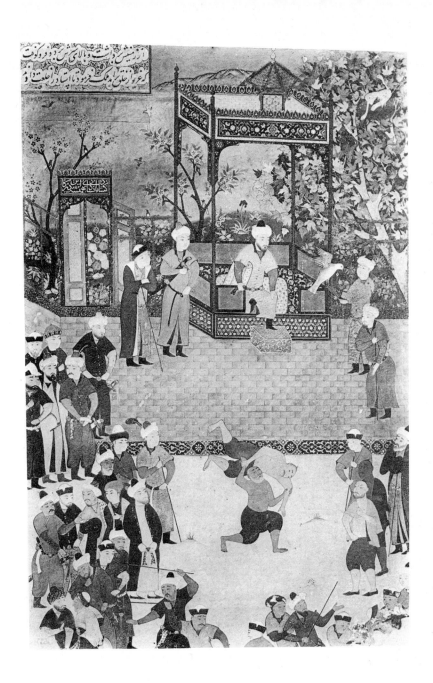

PLATE CX

Two wrestlers, master and pupil, contending before the King on his throne, surrounded by his Court (see Plate CXVIII). (The Rose Garden, by Sadi of Shiraz. Bokhara, 1543. Bib. Nat., Paris.)

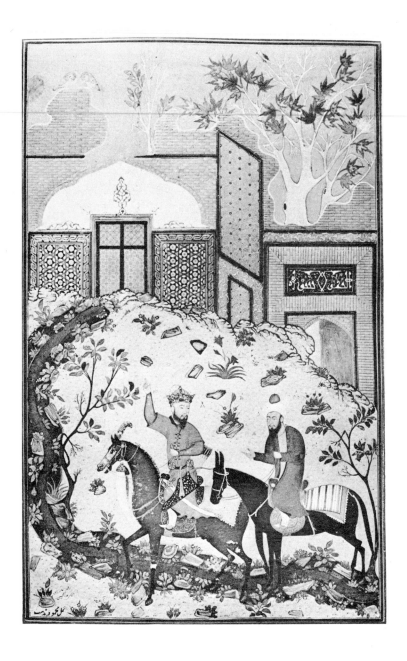

PLATE CXI

Khusrau Anushirwan, Sassanid King of Persia, and his minister, the wise Buzurjmihr, discussing the insecurity of human affairs before a ruined palace ; this painting is the work of a celebrated portrait painter named Muhammad. (Treasury of Secrets, by Nizami. Bokhara, about 1545. Bib. Nat., Paris.)

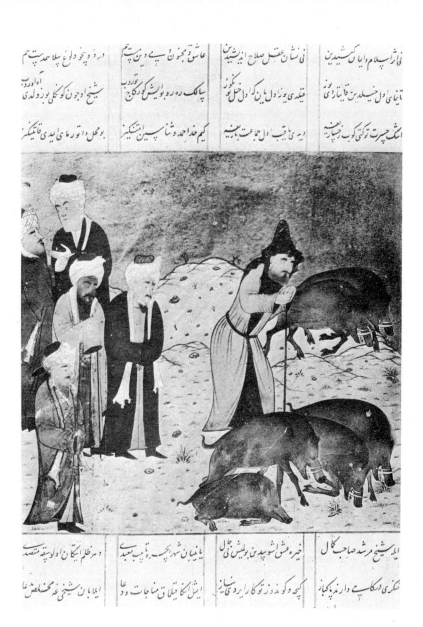

PLATE CXII

The Shaikh of Sanaan (see Plate CXXI), having abjured the Musulman faith, is obliged
to herd pigs, to please the Christian lady with whom he is in love. (Discourses of the
Birds, by Mir Ali Shir Nawai. Bokhara, 1553. Bib. Nat., Paris.)

PLATE CXIII

A King seated on his throne surrounded by his Court. (Discourses of the Birds, by Mir Ali Shir Nawai. Bokhara, 1553. Bib. Nat., Paris.)

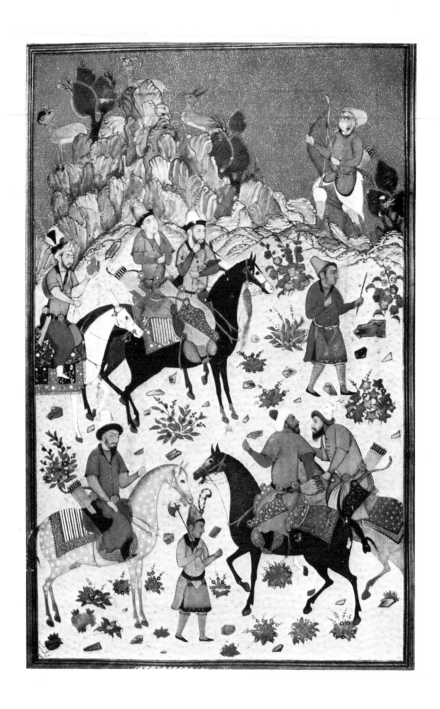

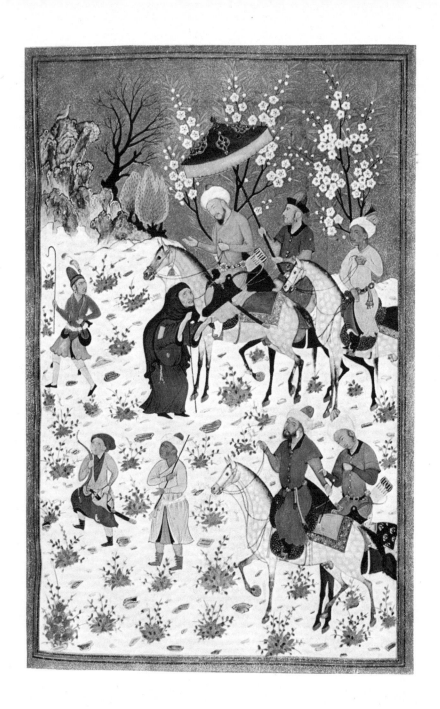

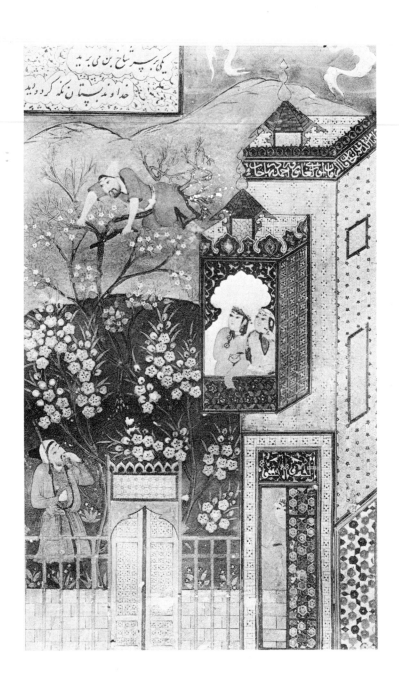

PLATE CXVI

An idiot in a garden saws through the branch of a tree on which he is sitting ; the inscription on the front of the house gives the date, 1555. (The Pleasure Garden, by Sadi of Shiraz. Bokhara, 1555. Bib. Nat., Paris.)

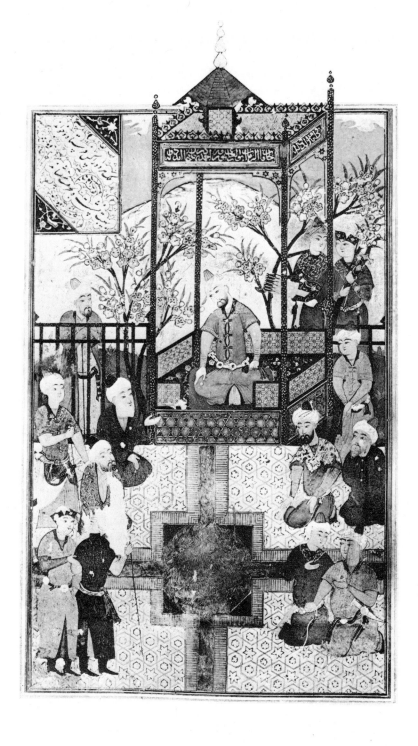

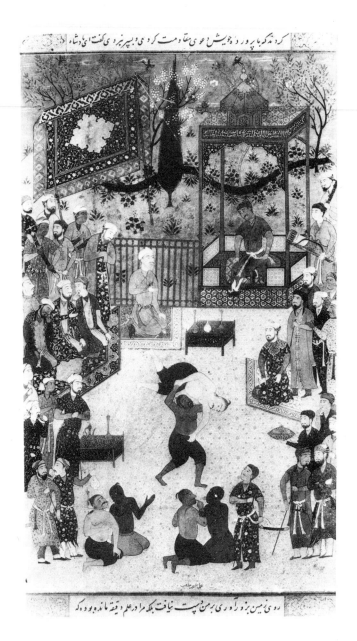

PLATE CXVIII

Two wrestlers, master and pupil, contending before the King on his throne, surrounded by the Court (see Plate CX); this painting is slavishly copied from an illumination in a book executed at Delhi for Akbar, Emperor of India, about 1560, and which was a replica of the one shown in Plate CX; in the same way the paintings reproduced in Plates CX–CXVII are slavishly imitated from those of Herat. This shows the non-existence at Bokhara of any independent school. The titles of Akbar, completely misunderstood, can be read on the front of the pavilion. (The Rose Garden, by Sadi of Shiraz. Bokhara, 1567. Brit. Mus.)

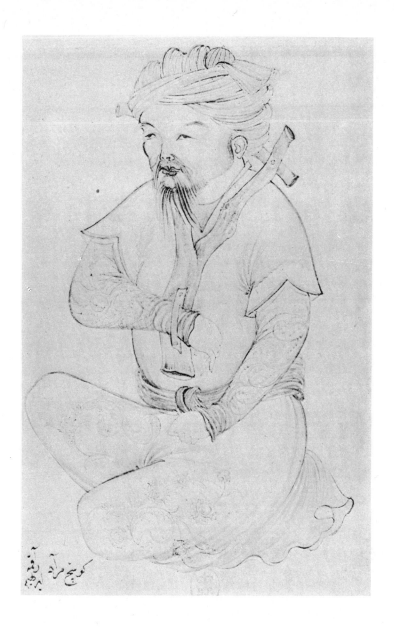

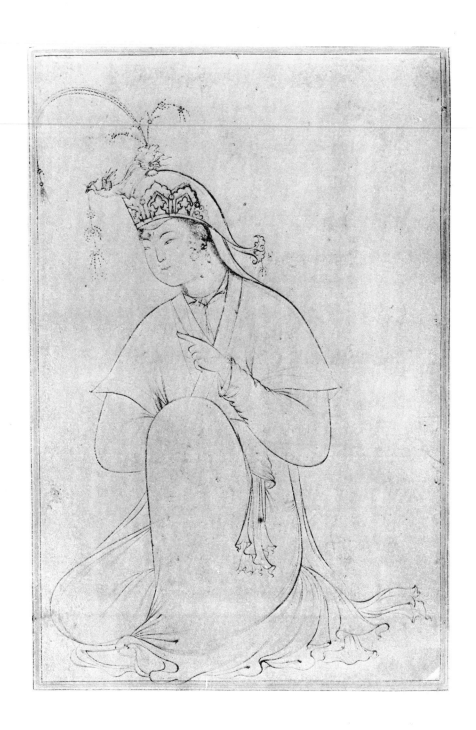

PLATE CXX

Portrait of a lady of fashion at the Court of Tabriz in the reign of Shah Isma'il I. She wears a tiara with a tail, a fashion which lasted throughout the sixteenth century and the early years of the seventeenth; it is decorated with the bird characteristic of the head-dress of Chinese Empresses in very early times. (Line drawing, Tabriz, about 1505. Louvre, Paris.)

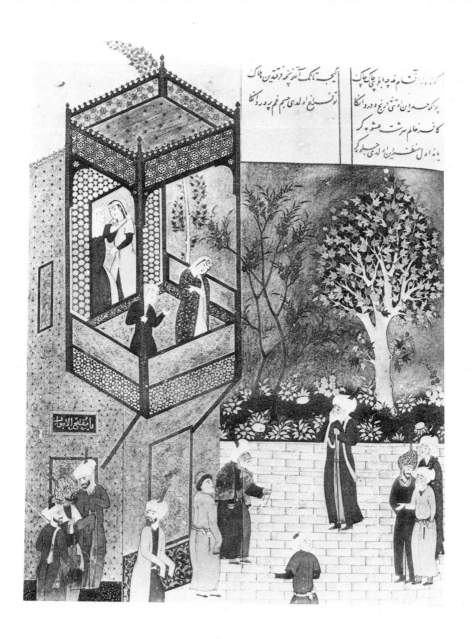

PLATE CXXI

The old Shaikh of Sanaan makes a preposterous declaration of love to a young Christian
lady of Antioch whom he saw in a dream when living at Sanaa in Arabia. (Works of
Mir Ali Shir Nawai. Herat, 1526. Bib. Nat., Paris.)

PLATE CXXII

Shirin, Princess of Armenia and wife of Khusrau Parviz, King of Persia, visits Farhad, the sculptor of the rocks of Mt. Bisutun, and finds him lying on the ground. (Works of Mir Ali Shir Nawai. Herat, 1526. Bib. Nat., Paris.)

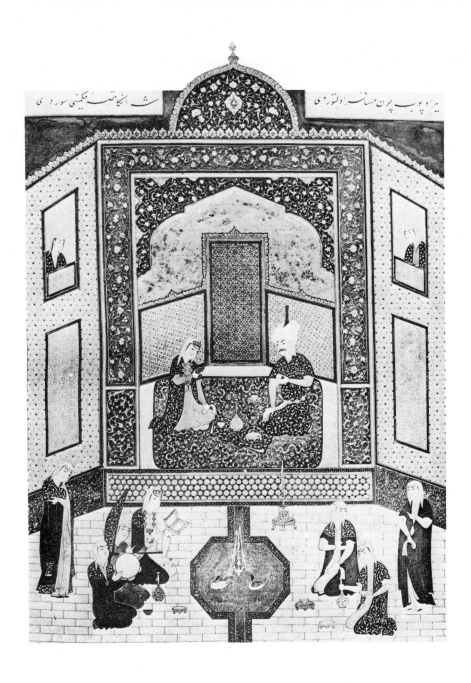

PLATE CXXIII

Bahram Gur, Sassanid King of Persia, sitting on a carpet with one of his wives in a building with a black dome. (Works of Mir Ali Shir Nawai. Herat, 1526. Bib. Nat., Paris.)

PLATE CXXIV

Bahram Gur, King of Persia, hunting the onager with his Court, while his favourite
Azada, mounted on horseback, plays the lyre (see Plate XCVIII). (Works of Mir Ali
Shir Nawai. Herat, 1526. Bib. Nat., Paris.)

PLATE CXXV

Battle between the armies of Alexander the Great and those of Darius, King of Persia.
(Works of Mir Ali Shir Nawai. Herat, 1526. Bib. Nat., Paris.)

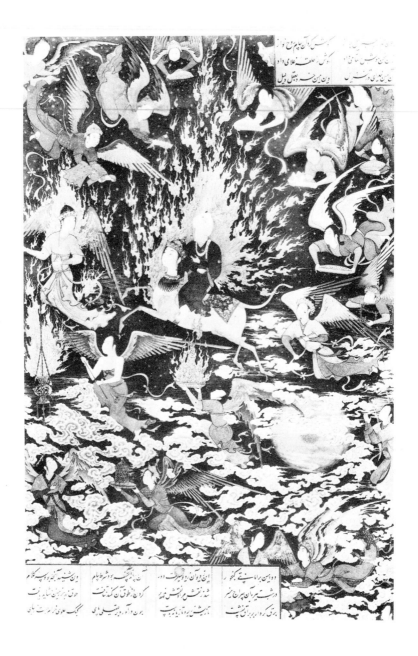

PLATE CXXVI

The Prophet Muhammad, with his face veiled, hovers in heaven on the mare Buraq, surrounded by angels and preceded by the archangel Gabriel (see Plates LXXX –LXXXIII, LXXXV). (Poems of Nizami. Tabriz, 1540. Brit. Mus., London.)

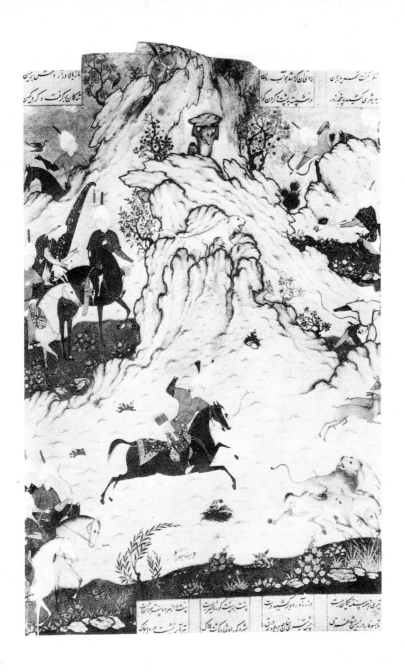

PLATE CXXVII

Bahram Gur, King of Persia, hunting the onager while his favourite, Azada, plays on the harp (see Plates XCVIII, CXXIV). This painting is attributed to a celebrated artist Sultan Muhammad. (Poems of Nizami. Tabriz, 1540. Brit. Mus., London.)

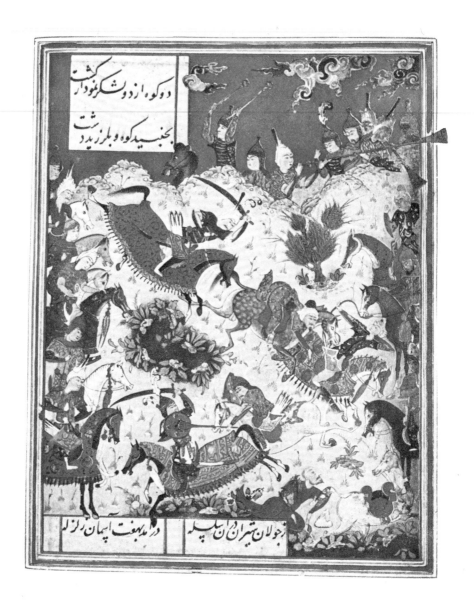

PLATE CXXVIII

Shah Ismaʻil I, King of Persia, sword in hand, pursues the Prince of Shirwan. The Prince and his troops are in flight. (History of Shah Ismaʻil, by Kasimi. Tabriz or Kazwin, 1541. Brit. Mus. London.)

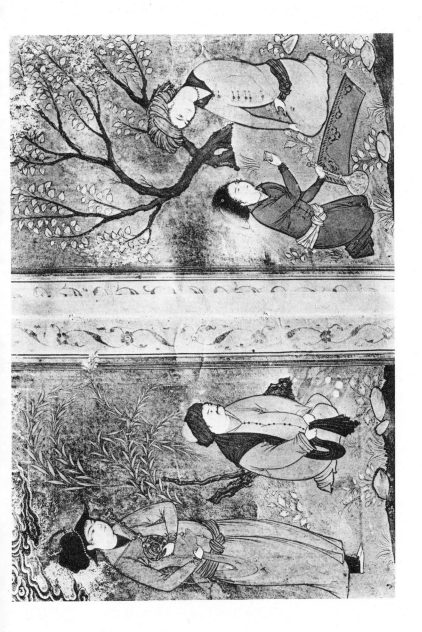

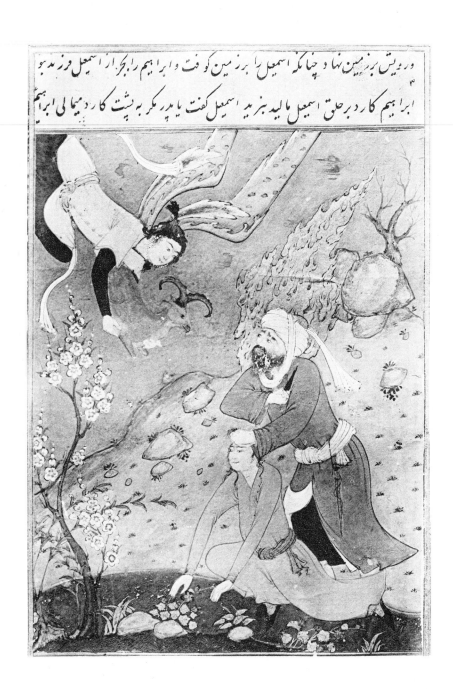

PLATE CXXX

The Sacrifice of Abraham. (History of the Prophets, by Nishapuri. Tabriz or Kazwin, about 1550. Bib. Nat., Paris.)

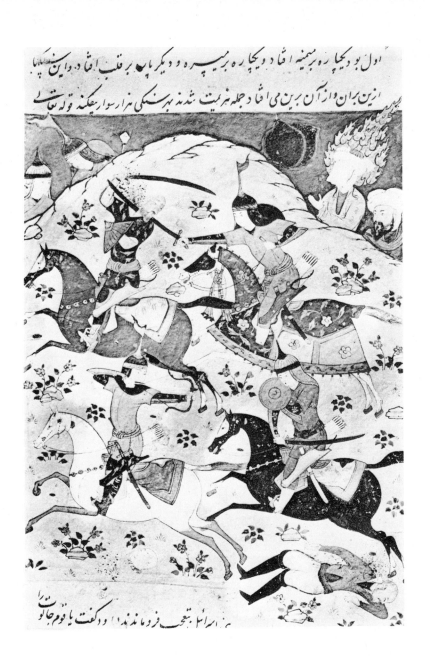

Battle between the troops of David, King of the Jews, and those of Goliath. (History of the Prophets, by Nishapuri. Tabriz or Kazwin, about 1550. Bib. Nat., Paris.)

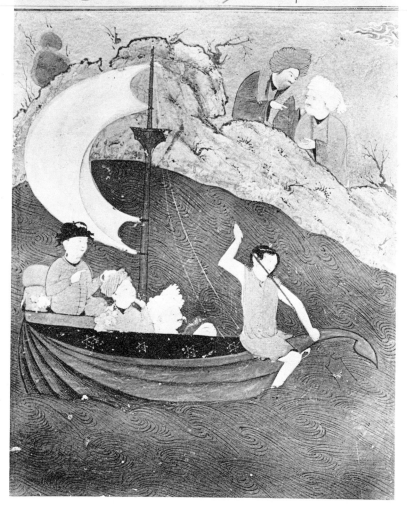

من صبر نیم حضر گفت اگر چنانست که مراش کردی کئی نهر کاری کم من علیّم کموی که چرا آرد
ناکه که من ترا خبر و سم قوله نه قال ان تبعتنی فلا تسألنی عن شئ حتی احدث لک

PLATE CXXXII

The prophets Khidr-Ilias and Moses observe on the sea a boat in which they propose
to embark. (History of the Prophets, by Nishapuri. Tabriz or Kazwin, about 1550.
Bib. Nat., Paris.)

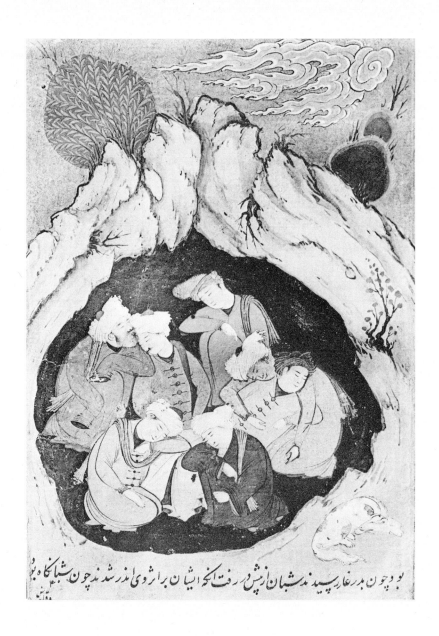

PLATE CXXXIII

The Seven Sleepers of Ephesus and their dog, imprisoned in the cave where they slept
concealed from the reign of the Emperor Decius to the time of Theodosius the Younger,
with whom they conversed and afterwards died. (History of the Prophets, by Nisha-
puri. Tabriz or Kazwin, about 1550. Bib. Nat., Paris.)

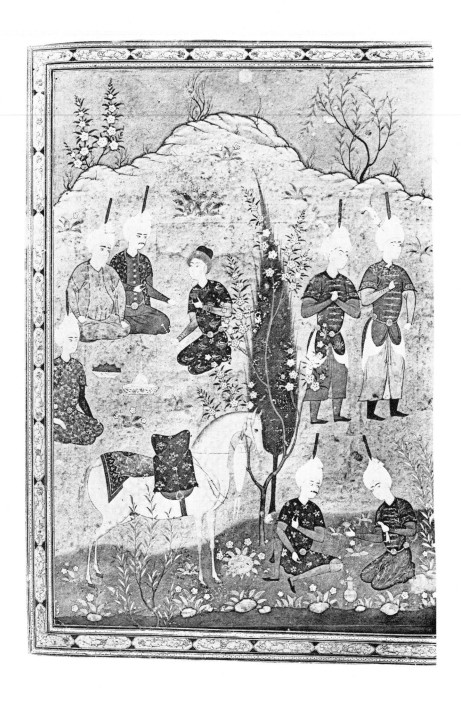

PLATES CXXXIV, CXXXV

Painting on two pages, representing the King of Persia surrounded by his Court in the gardens of his palace. (Book of the Kings, by Firdawsi. Tabriz or Kazwin, 1546. Bib. Nat., Paris.)

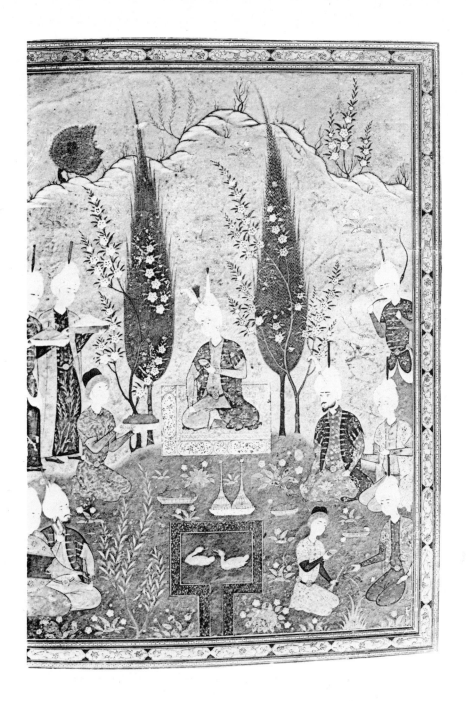

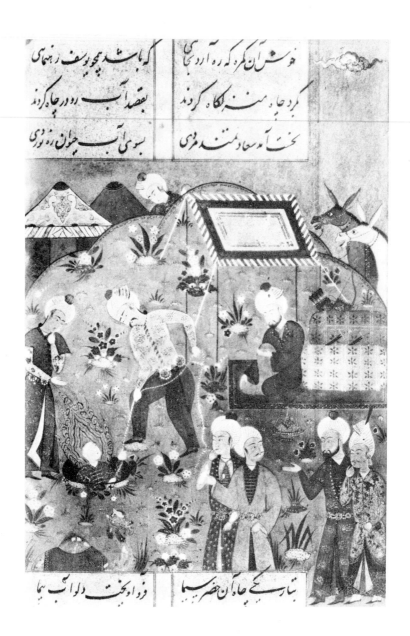

The prophet Joseph, wearing the nimbus of prophetic light, is drawn out of the well into which his brothers had thrown him. (Tale of the Loves of Joseph and Zulaikha, by Jami. Kazwin, about 1570. Brit. Mus., London.)

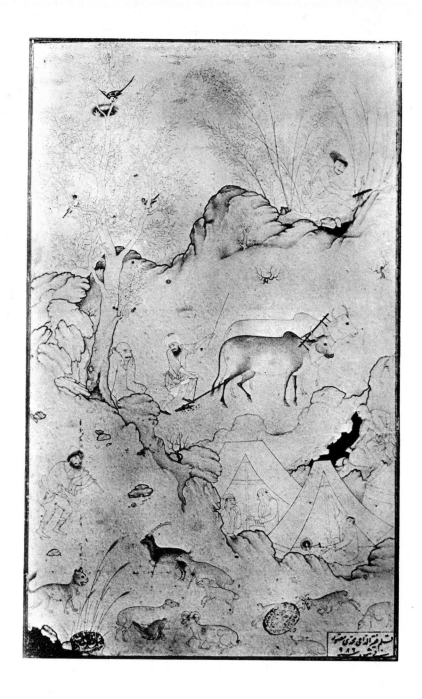

PLATE CXXXVII

Sketch for a picture by Muhammadi, a celebrated artist of the late sixteenth century, representing a dervish seated at the foot of a tree, watching some peasants at their work. This picture, which is signed and bears the date 1578, was painted at Ispahan (see Plate CLIV). (Louvre, Paris.)

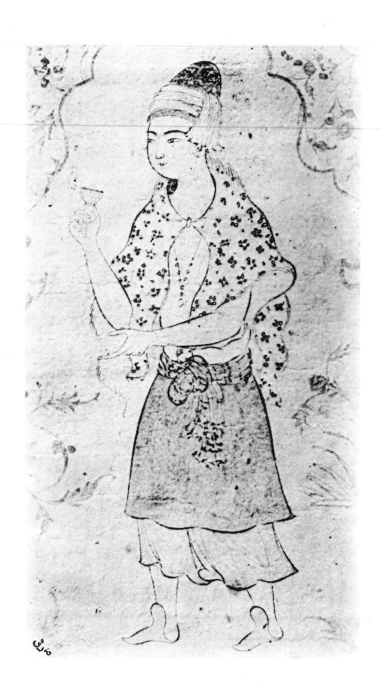

PLATE CXXXIX

A Persian noble and a Muhammadan monk amusing themselves in a garden; the noble offers the monk an orange. Line drawing in the style of Agha Riza and Sadik; made at Ispahan in the latter part of the sixteenth century. (Louvre, Paris.)

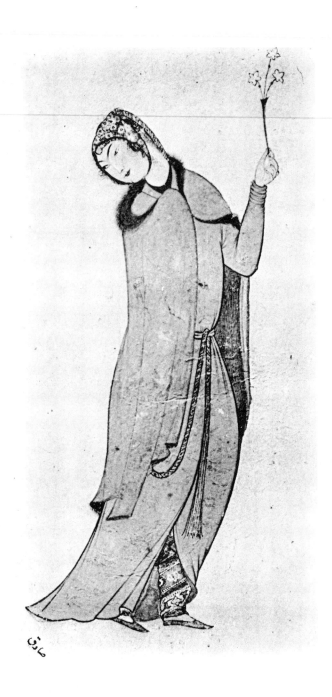

PLATE CXL

Portrait of a lady of fashion at the Court of Ispahan in the reign of Shah Abbas I; she holds a flower in her hand. Attributed to Sadik, late sixteenth century. (Bib. Nat., Paris.)

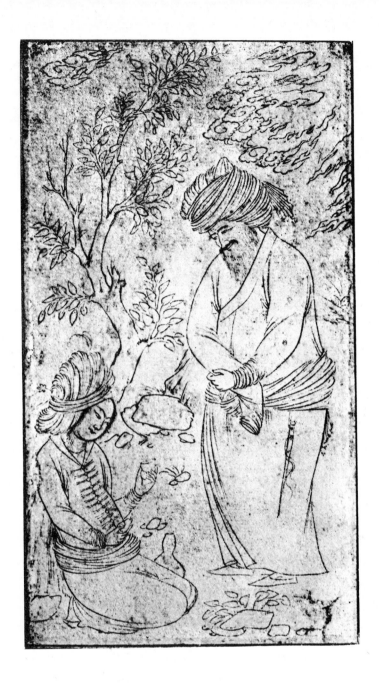

PLATE CXLI

A Muhammadan monk and a young page under a tree; the page holds a cup of wine and a pear. Line drawing of the end of the sixteenth century in the style of Agha Riza and Sadik; made at Ispahan in the latter part of the sixteenth century. (Pozzi Collection, Paris.)

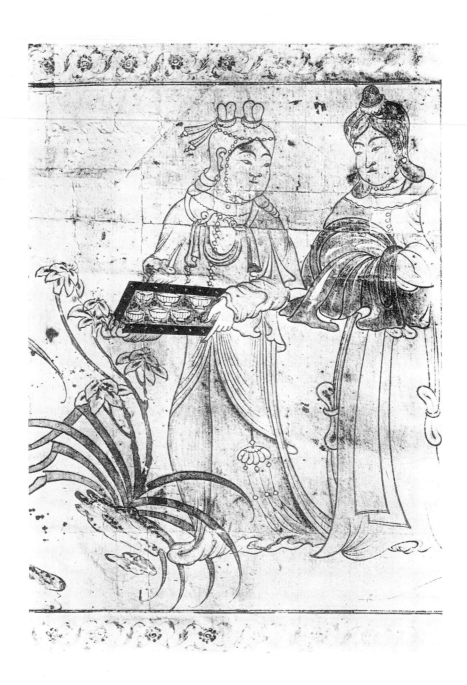

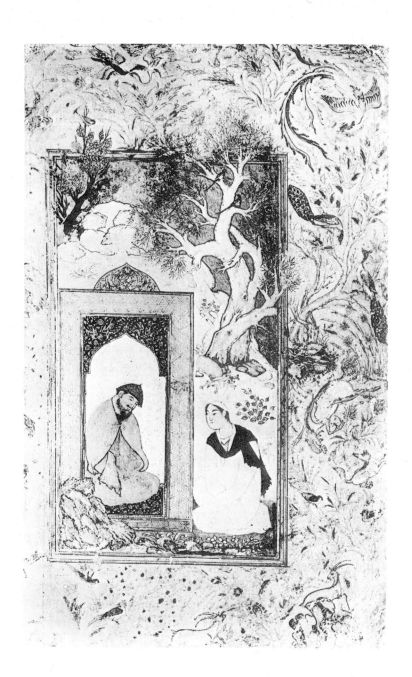

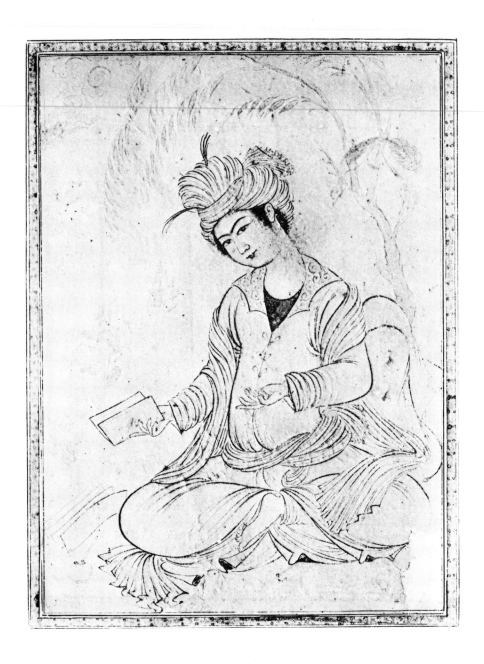

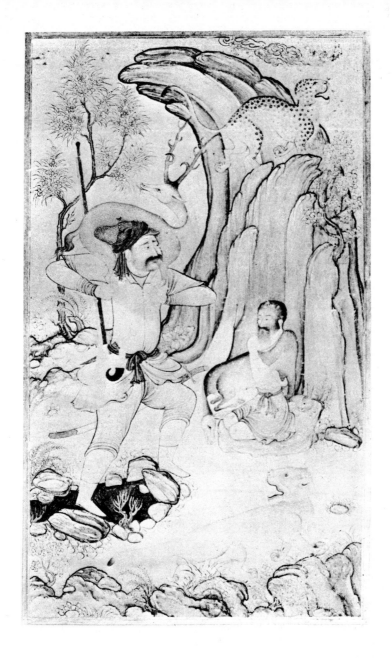

PLATE CXLV

Line drawing representing a Dervish seated under some rocks on which an ounce is climbing; a hunter passes in front carrying a stag on his shoulders. (Ispahan, late sixteenth century. Bib. Nat., Paris.)

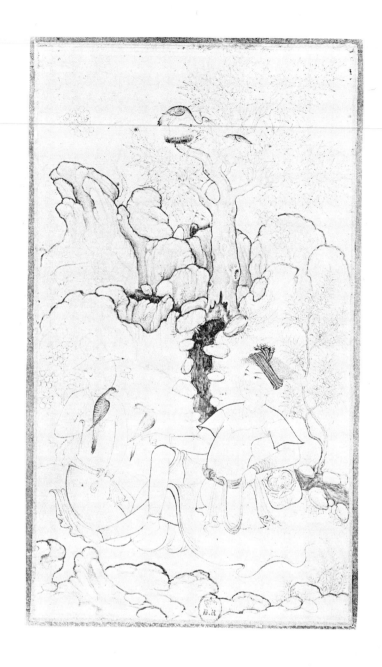

PLATE CXLVI

Line drawing representing a prince with an attendant, seated under some rocks, and holding hunting-falcons; this drawing, which is not finished, is by the same hand as the preceding one. (Ispahan, late sixteenth century. Bib. Nat., Paris.)

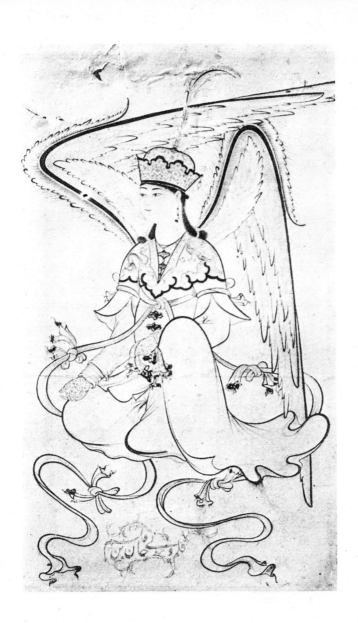

PLATE CXLVII

A Muhammadan angel; line drawing by Wali Jan; late sixteenth century, probably
executed in Constantinople, where this artist went to seek his fortune. The imitation
of Chinese style is visible in this composition, which bears the signature of Wali Jan.
(Musée Jacquemart-André, Paris.)

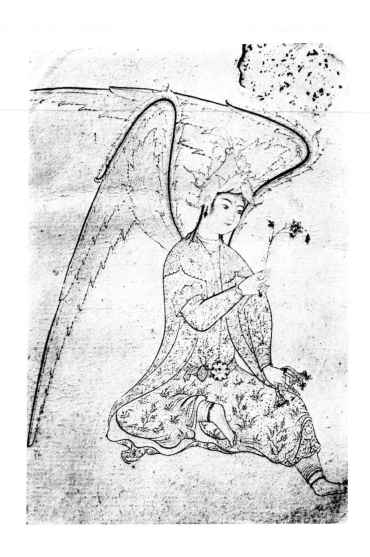

PLATE CXLVIII

A Muhammadan angel; line drawing by Wali Jan in the same Chinese style, but
without a signature. (Musée Jacquemart-André, Paris.)

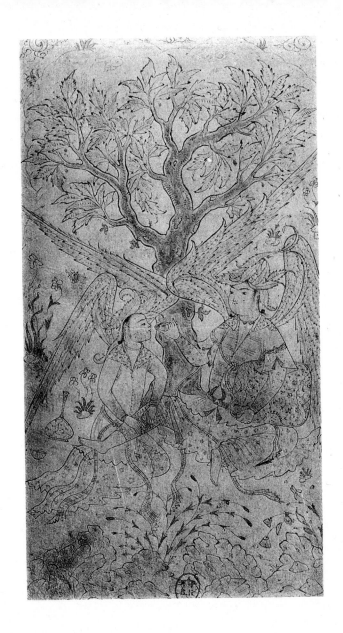

PLATE CXLIX

Line drawing representing two angels, with outspread wings, and feathers on their heads; in a style representative of the technique of Wali Jan, who made this drawing at Constantinople, at the end of the sixteenth century. (Bib. Nat., Paris.)

PLATE CL

Men loading a camel. Ispahan, late sixteenth or early seventeenth century.
(Brit. Mus., London.)

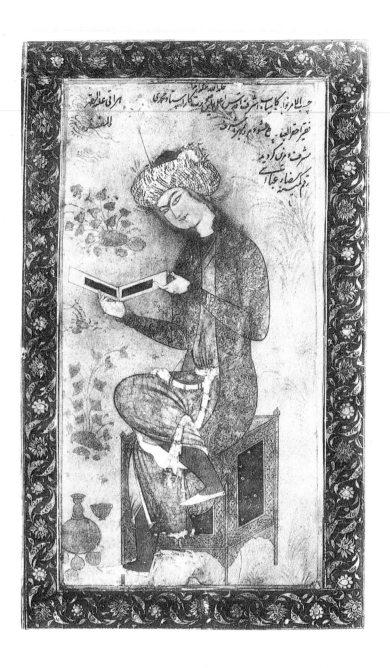

PLATE CLIV

Portrait of a young man reading a book ; the inscription in the upper part of the picture
tells us that Shah Abbas I ordered this copy of an original made at Ispahan about
1575 by Ustad Muhammadi Herati. The copy was made at Ispahan about 1620, by
Riza-i 'Abbassi (see Plate CXXXVII). (Brit. Mus., London.)

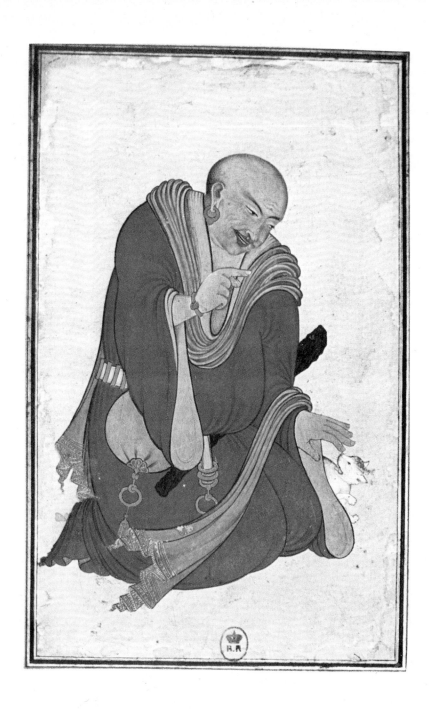

PLATE CLV

Copy of a Chinese painting representing a Buddhist or Taoist bonze playing with a cat;
made at Ispahan about 1620 by an artist of the school of Riza-i 'Abbassi. The colour
tone has been strengthened by the Persian artist, the colours of the Chinese paintings
being much less brilliant. (Bib. Nat., Paris.)

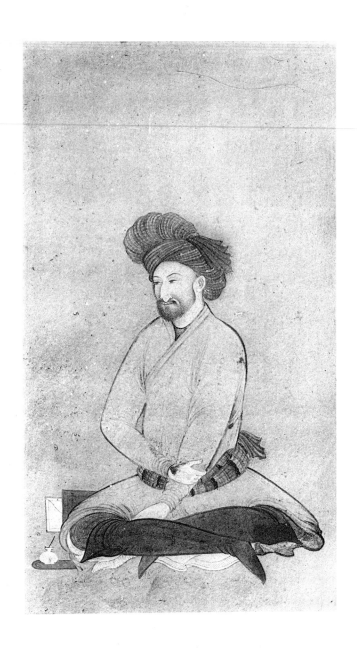

Portrait of a Persian secretary wearing fawn-coloured boots ; his inkstand is beside him. This painting by Riza-i 'Abbassi is in an unusual manner ; the signature of Riza-i 'Abbassi has been intentionally effaced. (Ispahan, about 1620. Bib. Nat., Paris.)

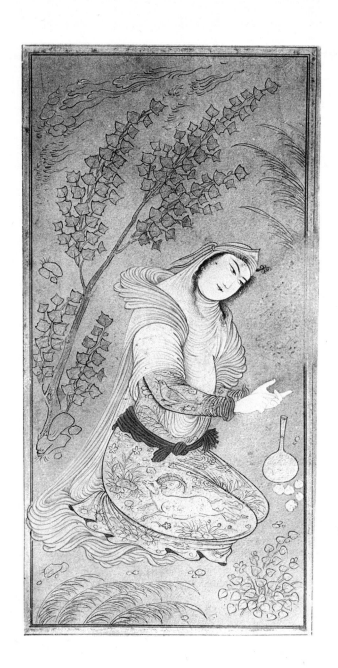

PLATE CLVII

Portrait of the wife of a minister of Shah Abbas I ; by Riza-i 'Abbassi ; but his signature and the lady's titles have been intentionally effaced. (Ispahan, about 1620. Bib. Nat., Paris.)

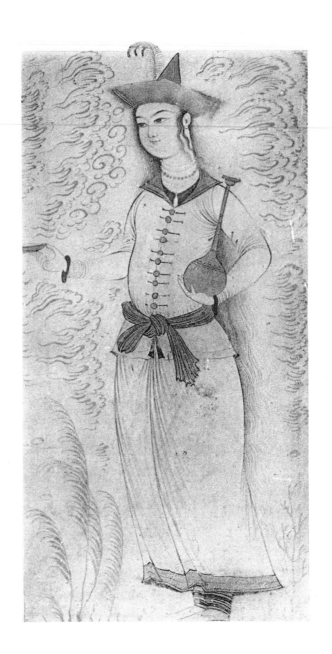

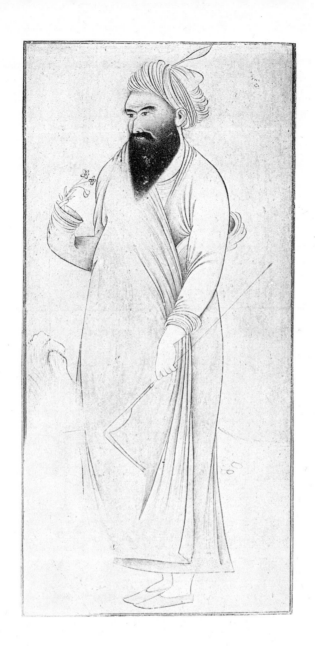

PLATE CLIX

A Dervish holding in his hand an elbow-rest, by a pupil of the school of Riza-i 'Abbassi.
(Ispahan, early seventeenth century. Bib. Nat., Paris.)

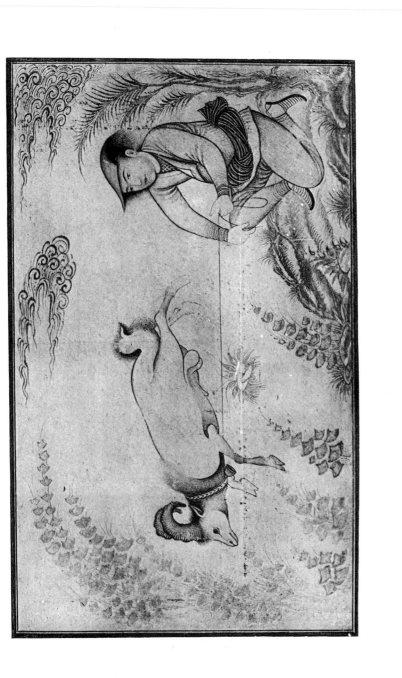

PLATE CLX

A figure holding a wild goat on a leash; this figure is clearly a copy of one in a European painting; his clothes and attitude show it. The Persian artist has given him the sort of head-dress worn by Catharine de' Medici or Mary Queen of Scots, at the end of the sixteenth century. (Ispahan, first half of the seventeenth century. Bib. Nat. Paris.)

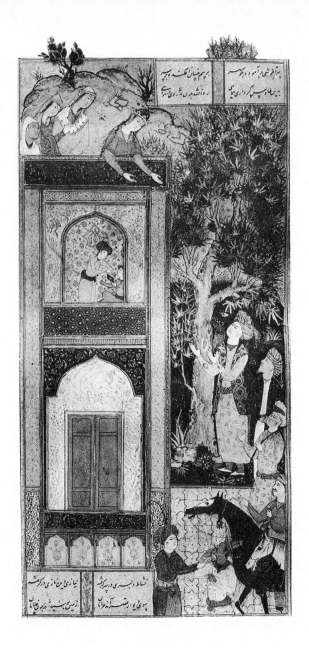

PLATE CLXI

Khusrau Parviz, Sassanid King of Persia, arrives before the castle where his love
Shirin, Princess of Armenia, has taken refuge; she holds out her arms to him. (The
Loves of Khusrau and Shirin, by Nizami. Ispahan, about 1624. Bib. Nat., Paris.)

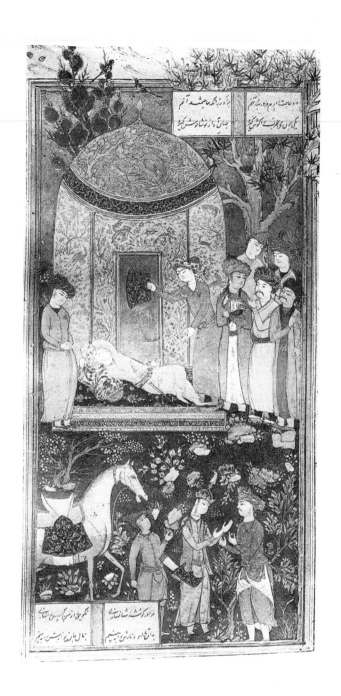

PLATE CLXII

Shirin arrives before a pavilion of brocade in which Khusrau Parviz is sleeping surrounded by his Court. (The Loves of Khusrau and Shirin, by Nizami. Ispahan, about 1624. Bib. Nat., Paris.)

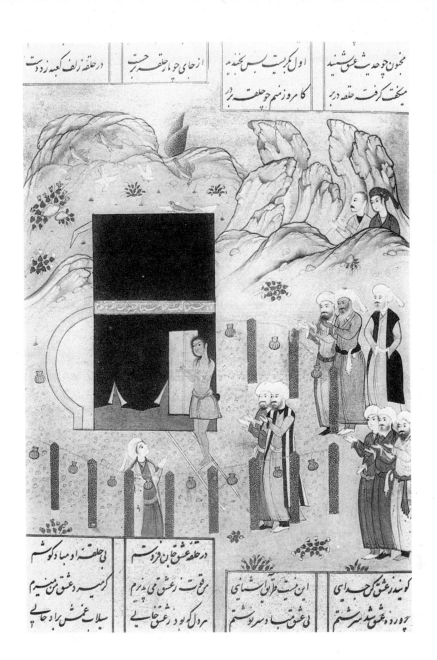

PLATE CLXIII

Majnun, on pilgrimage to the Black Stone of the Kaaba at Mecca; this painting, like the three following ones, is the work of an artist named Haidar Quli, who worked in the style of Riza-i 'Abbassi. (The Loves of Laila and Majnun, by Nizami. Ispahan, about 1624. Bib. Nat., Paris.)

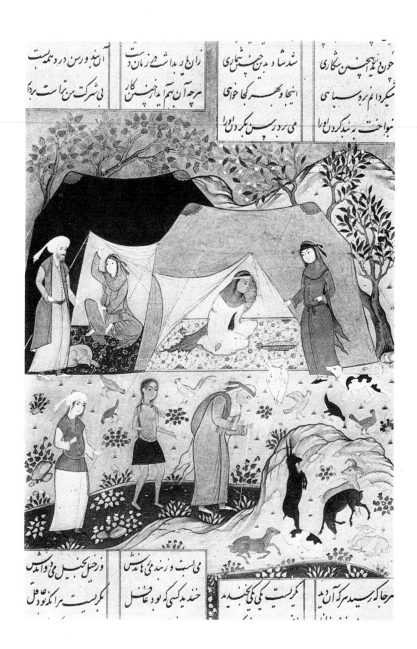

PLATE CLXIV

Majnum, wearing the golden chain of love round his neck, reaches Laila's camp; she can be seen in her tent, on the left of the composition; by Haidar Quli. (The Loves of Laila and Majnun, by Nizami. Ispahan, about 1624. Bib. Nat., Paris.)

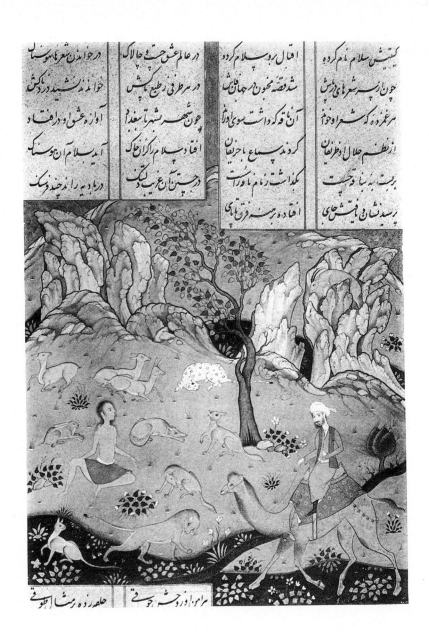

PLATE CLXV

Ibn Salam Baghdadi, the husband of Laila, arrives in the desert where Majnun, devoured
by his passion for Laila, lives in solitude, surrounded by wild animals ; by Haidar Quli.
(The Loves of Laila and Majnun, by Nizami. Ispahan, about 1624. Bib. Nat., Paris.)

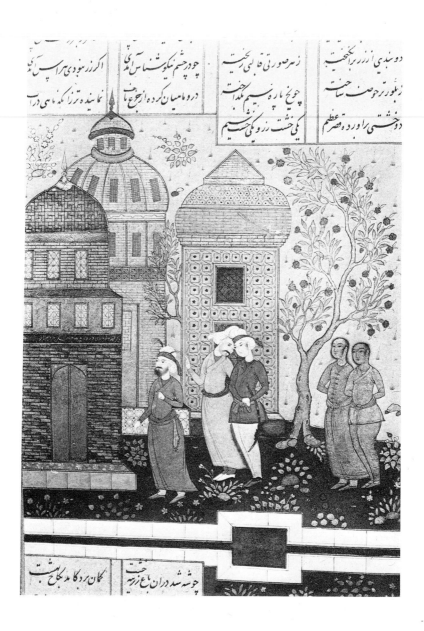

PLATE CLXVI

Alexander the Great, in India, enters an enchanted garden where the trees are golden and the temples have cupolas covered with gold, studded with precious stones; by Haidar Quli (see Plate CIII). (Legendary History of Alexander the Great, by Nizami. Ispahan, about 1624. Bib. Nat., Paris.)

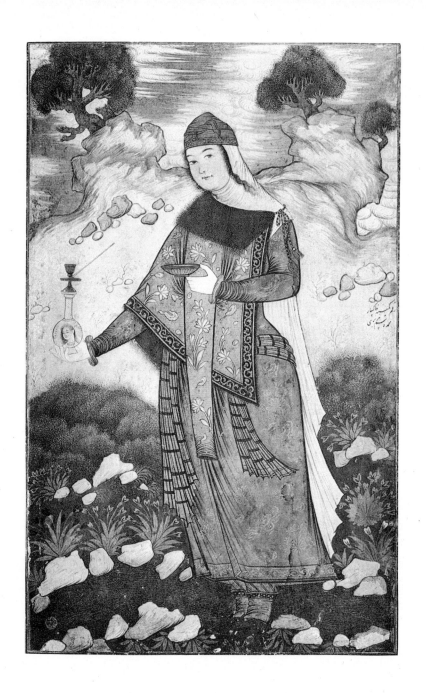

PLATE CLXVII

Portrait of a Persian lady of the Court of Ispahan, by Muhammad Kasim Tabrizi;
middle of seventeenth century. (Georges Tabbagh Collection, Paris.)

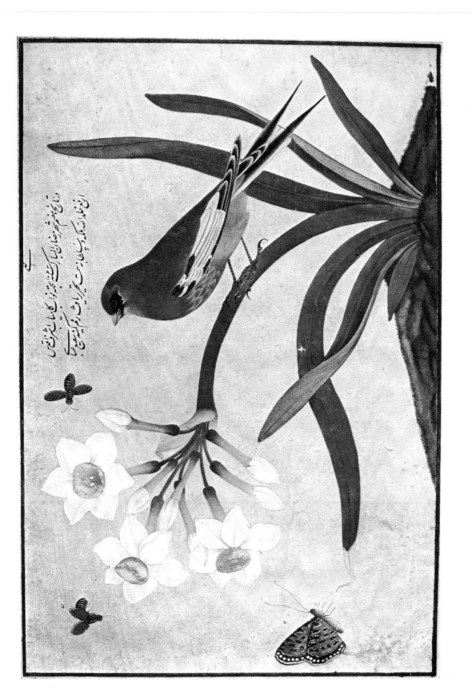

PLATE CLXVIII

A goldfinch on a stalk of narcissus in full bloom. The inscription tells us that this paint-
ing was made by Shafi-i 'Abbassi, a famous artist, to the order of Shah Abbas II, King
of Persia, for the King's private collection, and was finished at Ispahan, August 1st, 1653.

(Bib. Nat., Paris.)

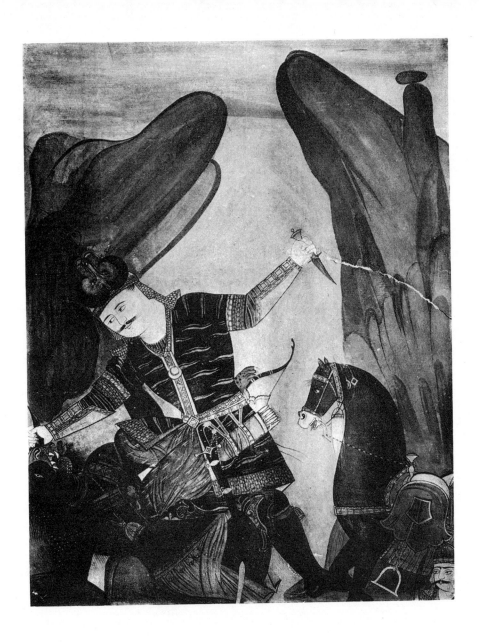

PLATE CLXIX

Rustam killing the white Demon. Contrary to the tradition of Persian iconography, the paladin Rustam is represented as a young man; the white devil is imitated from a Hindu rakshasa. (Book of the Kings, by Firdawsi, about 1760. Georges Tabbagh Collection, Paris.)

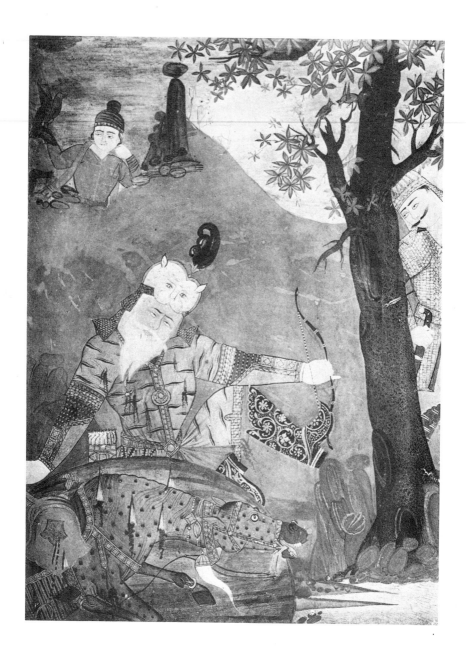

PLATE CLXX

The Death of the Paladin Rustam. Rustam, wearing his traditional head-dress, kills his brother Shaghad hidden behind a tree with an arrow which pierces both tree and man; then the Paladin falls into the pit where his horse Rakhsh is impaled. In some of the paintings in this Book of the Kings the demons with whom Rustam is fighting are dressed as soldiers of the British army in India; they wear the Scotch cap and uniform; one of them wears a Gurkha head-dress. As the uniforms of Iranian soldiers were purely Persian, these paintings are probably the work of a Persian artist who had seen English troops on the Afghan frontier. (Book of the Kings, by Firdawsi, about 1760. Georges Tabbagh Collection, Paris.)

PLATE CLXXI

Initial rose-shaped ornament, from the Collected Works of Mir Ali Shir Nawai,
containing in its circles the titles of all the works in the collection. (Herat, 1526.
Bib. Nat., Paris.)

PLATE CLXXII

Illuminated page; copied from patterns of Persian carpets from the beginning of a specially sumptuous copy of the Rose Garden of Sadi. (Bokhara, 1548. Bib. Nat., Paris)

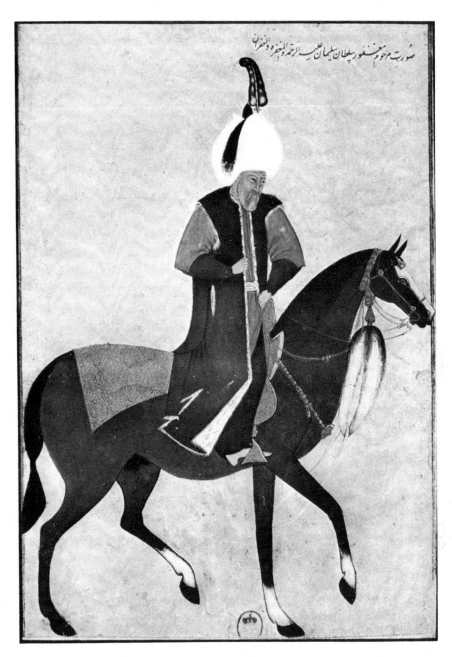

<div align="center">

PLATE CLXXIII

</div>

Portrait of Sulaiman Khan, Sultan of Constantinople, son of Sultan Salim Khan (1520–
1566). This magnificent portrait is of a type very unusual in the art of the Turks of
Constantinople. It was made at Stamboul, about 1560, and represents the Sultan of
the Turks at an advanced age. The Sultan is mounted on a horse with three white
feet, in accordance with the old saying : ' One white foot, good-for-nothing horse ; two
white feet, horse for a beggar ; three white feet, horse for a king ; four white feet, horse
for the knacker.' This tradition about the feet of a horse may have come from the
Crusaders. But the Turks, though, like the Arabs of the desert, they were excellent
horsemen, held other views on this point from those of the nomads, since the Sultan is
mounted on a horse with white on both fore-legs and on the left hind-leg. It must
also be remembered that the Prophet said : ' When thou desirest to go to battle, buy a
horse with a star on his forehead and white on each leg, except the right fore-leg, and
thou shalt be victorious.' The Arab profess the theory that white on both hind-legs is
a sign of good luck, but that white on the fore-legs has no such property, that diagonal
marks, i.e. white on the right fore-leg and on the left hind-leg, augur success, but that
the horse with four white marks bears his rider's shroud with him. (Bib. Nat., Paris.)

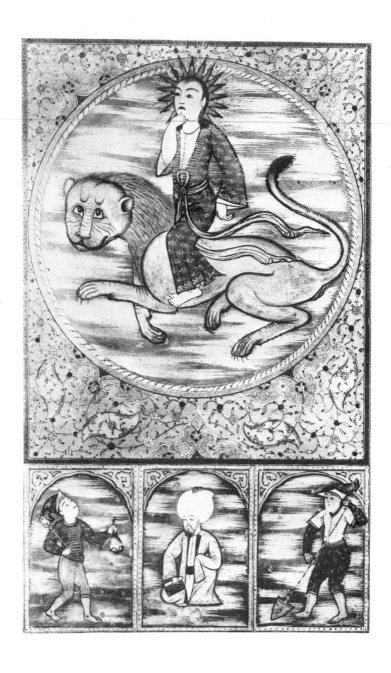

PLATE CLXXIV

The zodiacal sign of the Lion, represented as a woman with a nimbus riding a lion. Below are the three decans or divisions of ten degrees into which astrologers divide the signs of the Zodiac, each being under the influence of a particular planet; from right to left the decans of Saturn, Jupiter and Mars. This and the following painting are illustrations by a celebrated artist, Osman, in an illuminated book made for the Fatimid Sultan, daughter of Sultan Murad III. (Treatise on Astrology, by Muhammad as-Sooudi, Constantinople, 1582. Bib. Nat., Paris.)

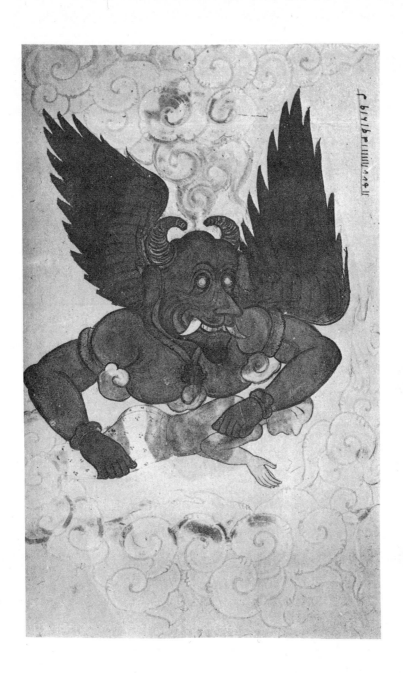

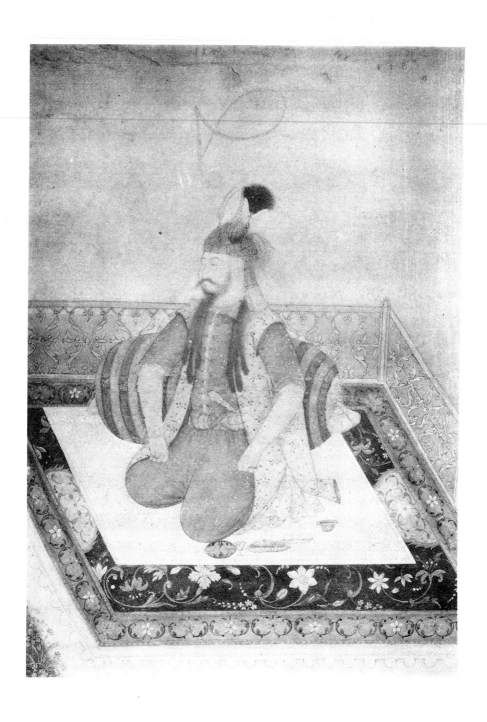

PLATE CLXXVI

Portrait of a Turkish officer belonging to the army of Nasir ad-Din Muhammad Humayun
Padishah, Emperor of India ; this portrait is in the Persian style. (Delhi, about 1545.
Louvre, Paris.)

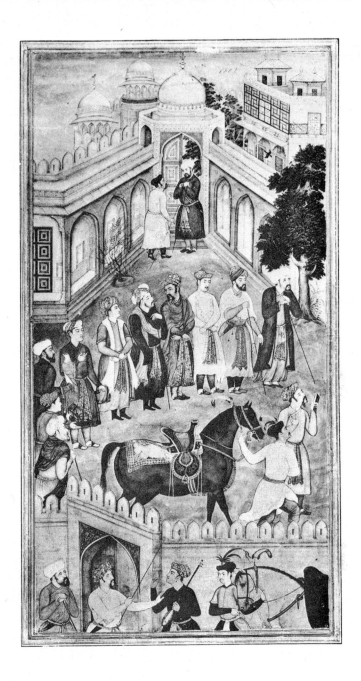

PLATE CLXXVII

Courtiers waiting outside the Imperial Palace to hear news of Akbar's health when, in 1561, he was suffering from chicken-pox. The Emperor's horse, in the courtyard, wears the high Turkish saddle such as the Cossacks use to-day. This painting is attributed to Manohar. Like those reproduced on Plates CLXXVIII–CLXXXVII, it was made for Akbar. Not one of these paintings is signed, but the attributions in the margins are certainly right. (History of Akbar, by Abul-Fazl, Delhi, late sixteenth century. Chester Beatty Collection, London.)

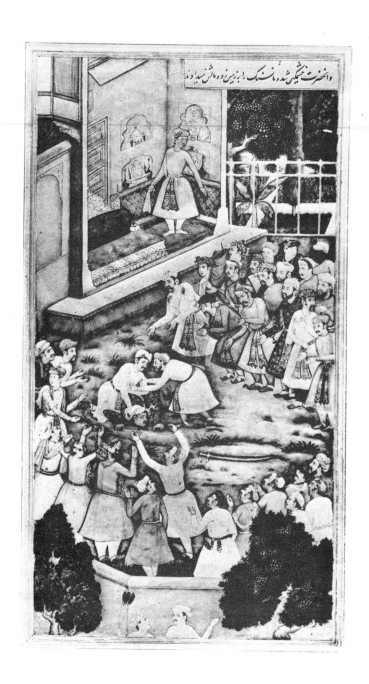

PLATE CLXXVIII

An incident that occurred at a select drinking-party when the conversation turned upon the bravery of the Rajputs. It was said that to show their contempt for death, two of them would run from opposite sides against the points of a double-headed spear, so that the points would transfix both of them and come out at their backs. Akbar apparently proposed to run upon his sword in a similar manner and had already fixed the hilt into a wall when Raja Man Singh knocked it down, but it cut Akbar's thumb and forefinger. In anger Akbar threw Man Singh upon the ground, but Sayyid Muzaffar rescued him from the Emperor's grasp by twisting his wounded finger and so making him loosen his grip of the Raja's throat. In the background is seen a room with shelves full of Chinese porcelain of the Ming period. This painting is attributed to Dawlat. (History of Akbar, by Abul-Fazl, Delhi, late sixteenth century. Chester Beatty Collection, London.)

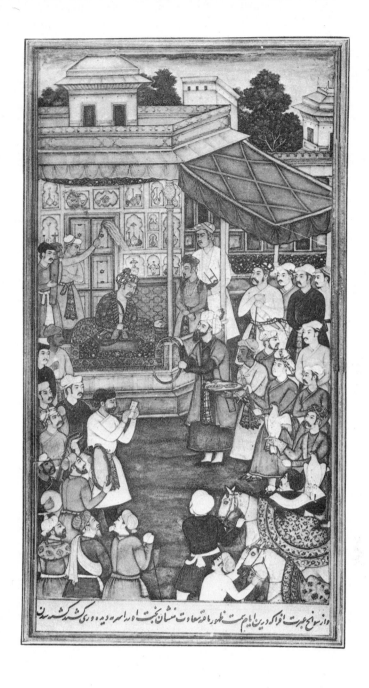

وازسوائح عبرت افلاک دین ایام ست ظهور یافتّه عادت نشان بختت اور اسره ویه وری کشه کشه رن

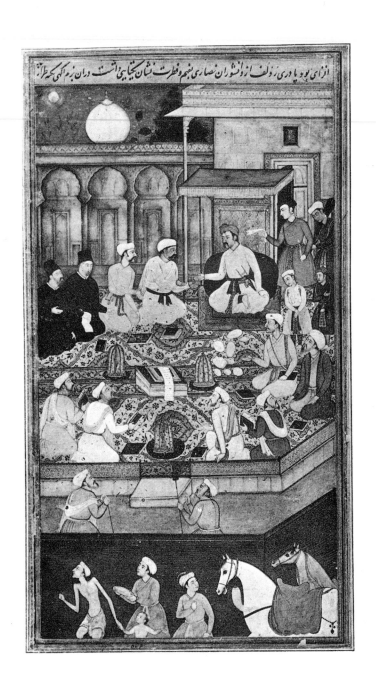

PLATE CLXXX

Ridolfo Acquaviva and another Jesuit, doubtless his companion Antonio Monserrate, sitting in the Ibadatkhana, or House of Worship, in the presence of Akbar, and offering to enter the fire with the Gospels in their hands if the Muhammadan theologians with the Koran would do the same. This painting is attributed to Narsing. (History of Akbar, by Abul-Fazl, Delhi, late sixteenth century. Chester Beatty Collection, London.)

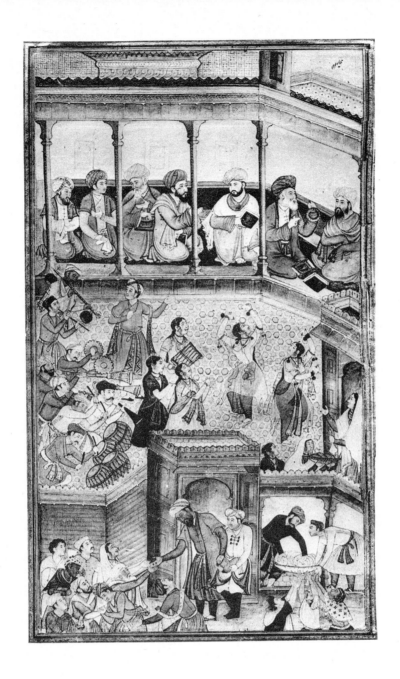

PLATE CLXXXI

Rejoicings in the Imperial Palace at the birth of Prince Salim, afterwards the Emperor
Nur ad-Din Jahangir Padishah ; money and bread are being distributed to the poor ;
dancing girls and musicians display their skill ; learned men and astrologers cast the
horoscope of the baby prince. This painting is attributed to Laal. (History of Akbar,
by Abul-Fazl. Delhi, late sixteenth century. Chester Beatty Collection, London.)

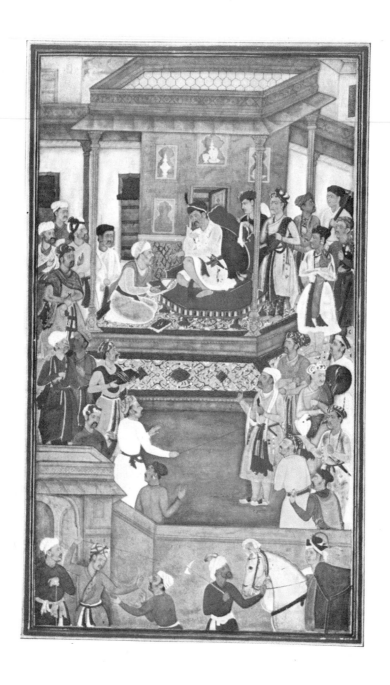

PLATE CLXXXII

Akbar receiving from Abul-Fazl ibn Mubarak the second volume of his work, the
Akbar Nama. Attributed to Govardhan. (History of Akbar, by Abul-Fazl. Delhi,
late sixteenth century. Chester Beatty Collection, London.)

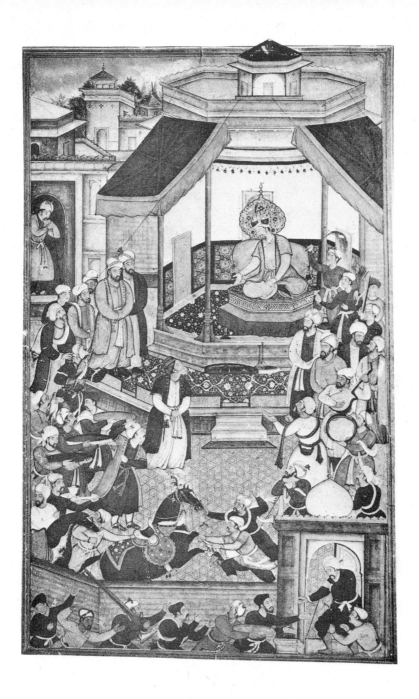

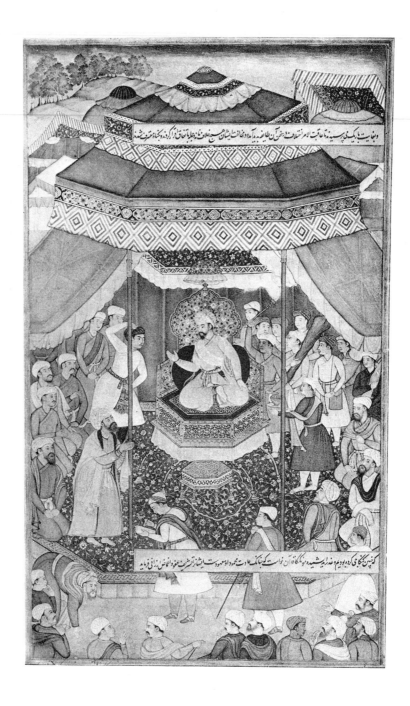

PLATE CLXXXIV

Mangu Khan, Emperor of the Mongols, conducting the trial of rebel princes and generals.
According to an inscription in the lower part of this painting the design is the work of
Tulsi, an abbreviation of Tulsidas, and the colour that of Bris. (History of the Mongols,
by Rashid ad-Din. Delhi, late sixteenth century. Pozzi Collection, Paris.)

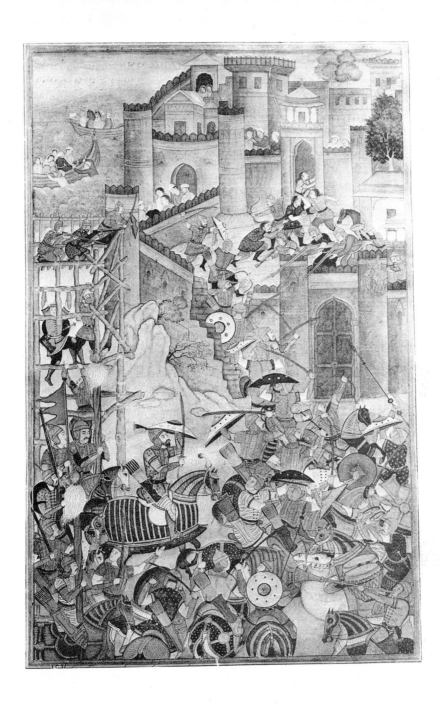

PLATE CLXXXV

The Mongol army besieging the fortress in which Ahmad of Fanaket, Vizir of the Great Khan Kubilai, had taken refuge after his rebellion. According to a note in the lower part of the picture, this fine painting is the work of three Hindu artists: Basawan made the drawing, Nanda of Gwalior coloured it, and Madhu drew the faces of the personages of high rank. (History of the Mongols, by Rashid ad-Din. Delhi, late sixteenth century. Pozzi Collection, Paris.)

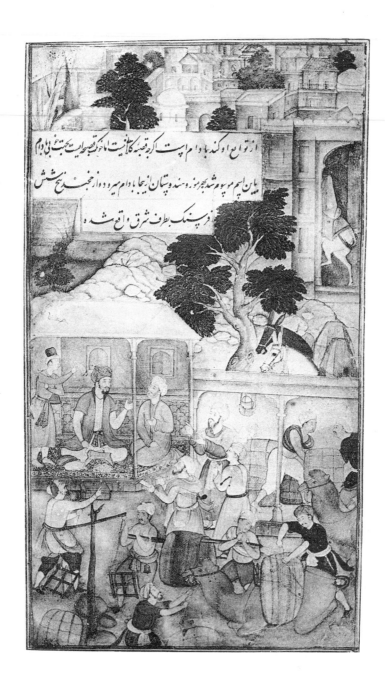

PLATE CLXXXVI

The walls of the citadel of Badam, five or six farsakh from Khojand in Farghana ; a caravan is bringing foreign wares to the fortress. (Memoirs of Babur Padishah, translated from the Turki into Persian, by the Khankhanan Abd ar-Rahim. Delhi, about 1590. Louvre, Paris.)

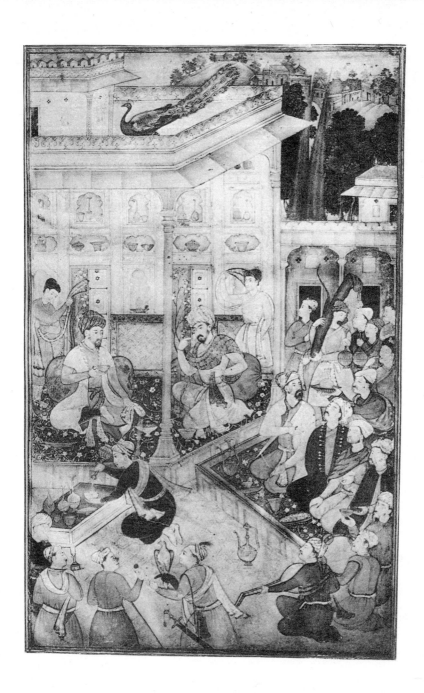

PLATE CLXXXVII

Babur Padishah holding a levee. (Memories of Babur, in Persian. Delhi, about 1590.
Louvre, Paris.)

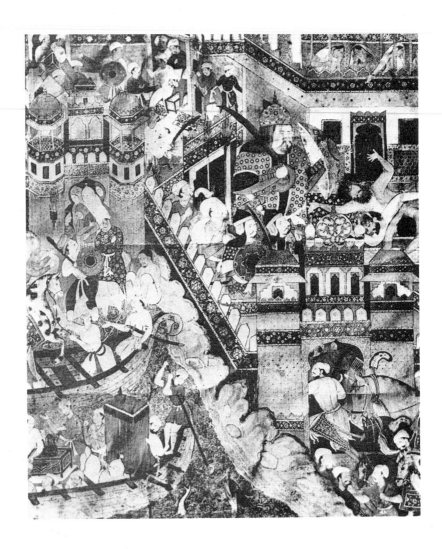

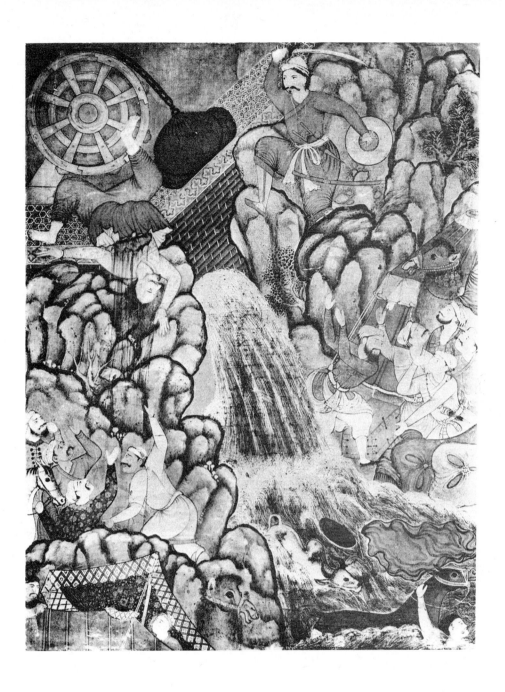

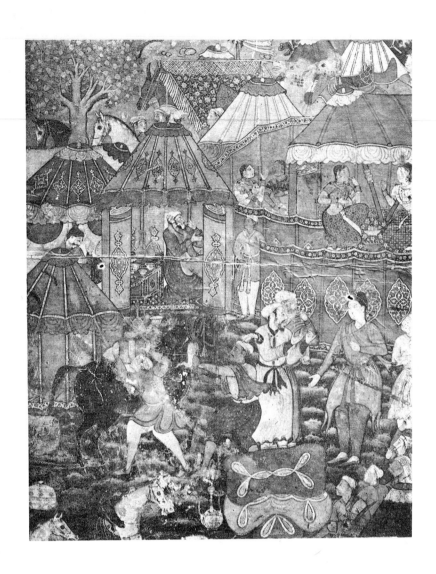

PLATE CXCI

Portrait of a Hindu noble reading a book among blossoming trees; this charming
composition imitates the style of a Persian picture, especially in the blossoming trees,
which are not Hindu motives. (Delhi, late sixteenth century. Brit. Mus., London.)

PLATE CXCIII

Jahangir, Emperor of Hindustan, conversing with a fakir in his cell; in the lower part
of the composition are officers of Jahangir's suite, one of whom is holding his horse. The
artist who painted this remarkable picture, more probably Bichitr than Hunhar, has
drawn in the background a town which is copied from an Italian picture, as is evident
by the Lombard domes. (Delhi, about 1615. Louvre, Paris.)

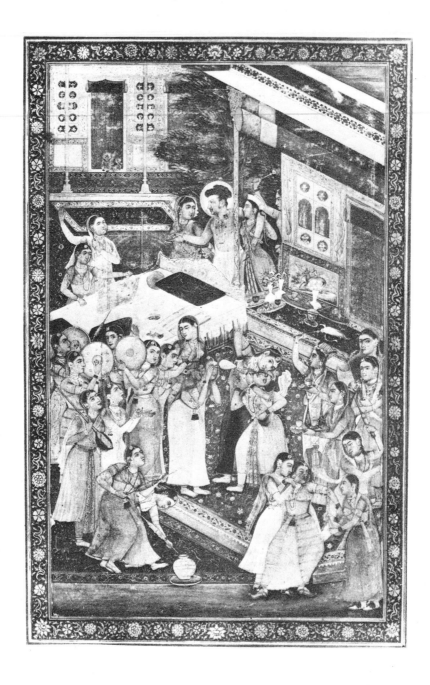

PLATE CXCIV

Jahangir, supported by two ladies of the harem, goes towards a bed of state, while the
women of the palace make music; the niches in the wall contain porcelain of the Ming
period. This painting is by the hand of a celebrated artist, Abul Hasan. (Delhi, about
1625. Album of Shah Jahan. Chester Beatty Collection, London.)

PLATE CXCV

Four dervishes in meditation ; one of them plays the vina, another has fetters on his
legs. The artist who painted this composition has shown in the background the walls
of a town of North-Eastern Europe, probably France or Flanders, copied from an oil
painting brought to Delhi. (Delhi, about 1625. Louvre, Paris.)

PLATE CXCVI

Portrait of an officer of the Emperor of Delhi ; signed by a well-known artist Muhammad
Nadir Samakandi, who lived in the reigns of Jahangir and Shah Jahan and drew their
portraits. (Delhi, about 1625. Louvre, Paris.)

PLATE CXCVII

Three Muhammadan ladies of Hindustan giving presents to a monk. (Delhi, early
seventeenth century. Pozzi Collection, Paris.)

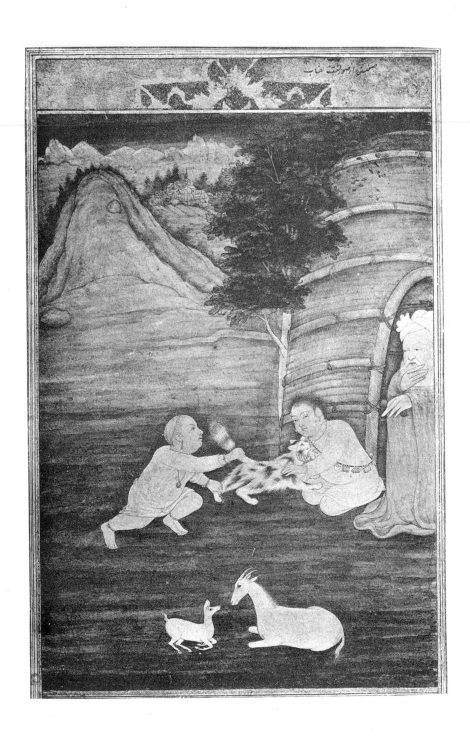

PLATE CXCVIII

Two children playing with a beautiful Persian cat before the door of a dervish's her-
mitage; the dervish gently scolds them; in the background, a mountain in a style
which recalls those painted in China in the thirteenth century by Chao Mēng-fu. Behind
the mountain the Indo-Persian artist has painted a little Swiss village; it can be recog-
nized by its pointed steeple. (Delhi, early seventeenth century. Pozzi Collection,
Paris.)

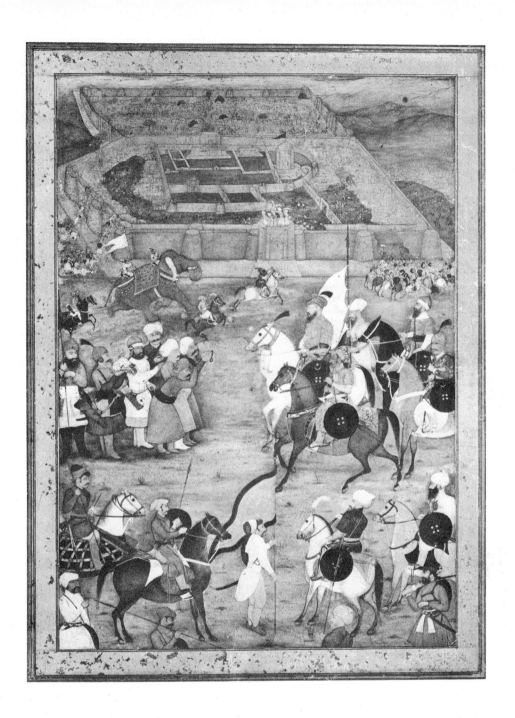

PLATE CXCIX

A general of the Emperor of Hindustan receiving the keys of a town which has surren-
dered. (Delhi, early seventeenth century. Pozzi Collection, Paris.)

PLATE CC

A malicious caricature of an ascetic Brahman by a Muhammadan artist. The old man is walking on stilts fastened to his gold ankle rings; he is carrying an incongruous assortment of objects, a pair of bellows, a glass jug, a common earthenware pot, as well as an Indian pot containing a Japanese doll. The jar is to draw water from the Ganges; the little broom—made in England ?—is to brush insects aside from his sacred steps; he begged these things from the native servants in English houses. The folds of his turban have been transformed into serpents. The English things carried by the old man date from the beginning of the nineteenth century; the page bears the royal seal used during the reign of King Louis-Philippe. (Bib. Nat., Paris.)